A MUSEUM OF THEIR OWN

National Museum of Women in the Arts

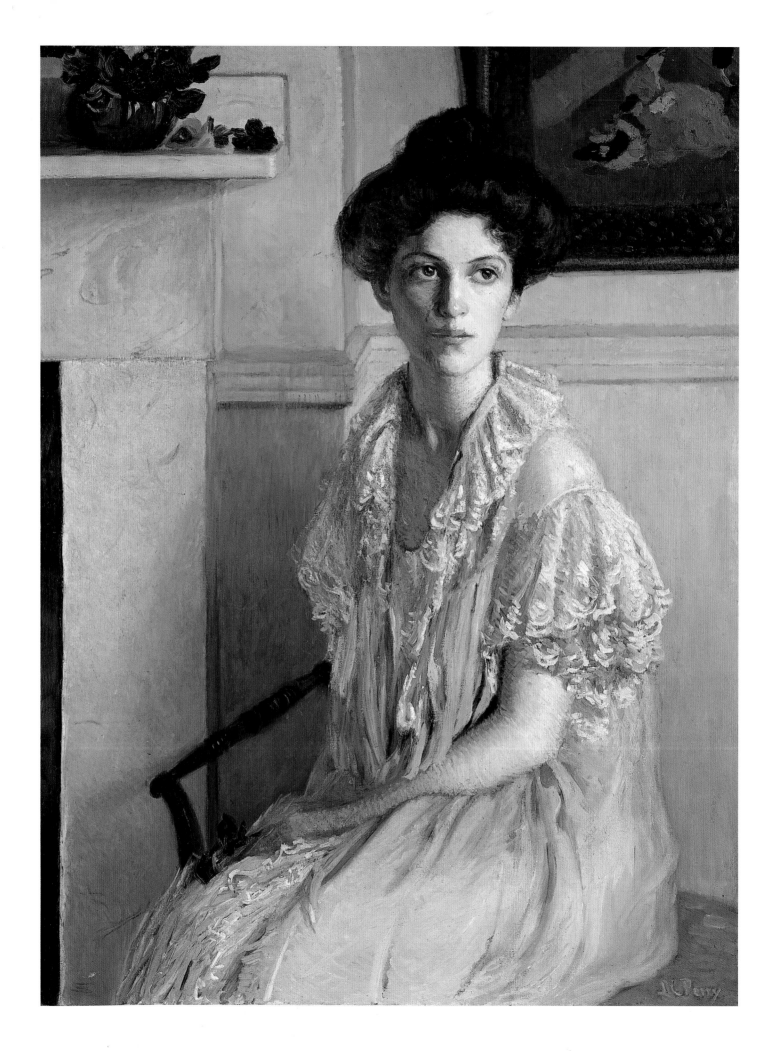

A MUSEUM OF THEIR OWN

National Museum of Women in the Arts

WILHELMINA COLE HOLLADAY

Founder of the Museum

Text Contributions by Philip Kopper

ABBEVILLE PRESS PUBLISHERS

New York • *London*

The copyright for artworks in copyright is held by the artists unless otherwise indicated here. Camille Claudel; Marie Laurencin; Suzanne Valadon © 2008 Artists Rights Society (ARS), New York / ADAGP, Paris. Anni Albers; Judy Chicago; Agnes Martin; Georgia O'Keeffe; Maria Helena Vieira da Silva © 2008 Artists Rights Society (ARS), New York. Sue Coe © 1995. Courtesy of Galerie St. Etienne, New York. Lee Krasner © 2008 The Pollock-Krasner Foundation/Artists Rights Society (ARS), New York. Grandma Moses © 1955 (renewed 1983) Grandma Moses Property Co., New York. Alice Neel © 2008 Estate of Alice Neel. Louise Nevelson © 2008 Estate of Louise Nevelson/Artists Rights Society (ARS), New York. Gwen John © 2008 Artists Rights Society (ARS), New York / DACS. Käthe Kollwitz; Sophie Taeuber-Arp © 2008 Artists Rights Society (ARS)/VG Bild-Kunst, Bonn. Emily Kame Kngwarreye © 2008 Artists Rights Society (ARS), New York / VISCOPY. Louise Bourgeois; Elizabeth Catlett; Valerie Jaudon © 2008 VAGA, New York, NY.

FRONT COVER: Wilhelmina Cole Holladay.
BACK COVER: Exterior, NMWA.
FRONTISPIECE: Lilla Cabot Perry, *Lady with a Bowl of Violets*.

NATIONAL MUSEUM OF WOMEN IN THE ARTS
EDITOR: Krystyna Wasserman
PICTURE RESEARCHER: Jason Stieber
PHOTOGRAPHER: Lee Stalsworth

ABBEVILLE PRESS
EDITOR: Susan Costello
COPYEDITOR: Samantha Shubert
PRODUCTION EDITOR: Megan Malta
PRODUCTION MANAGER: Louise Kurtz
DESIGNER: Patricia Fabricant

Copyright © 2008 National Museum of Women in the Arts. Compilation—including selection of text and images—Copyright © 2008 Abbeville Press and the National Museum of Women in the Arts. All rights reserved under international copyright conventions. No part of this book may be reproduced or utilized in any form or by any means, electronic or mechanical, including photocopying, recording, or by any information retrieval system, without permission in writing from the publisher. Inquiries should be addressed to Abbeville Press, 137 Varick Street, New York, NY 10013. Printed and bound in China. The text of this book was set in Monotype Baskerville.

First Edition
10 9 8 7 6 5 4 3 2 1

Library of Congress Cataloging-in-Publication Data
Holladay, Wilhelmina Cole, 1922–
 A museum of their own : National Museum of Women in the Arts / by
Wilhelmina Cole Holladay ; text contributions by Philip Kopper.— 1st ed.
 p. cm.
 Includes index.
 ISBN 978-0-7892-1003-6 (hardcover : alk. paper)
 1. National Museum of Women in the Arts (U.S.)—History. 2. Women artists—Museums—Washington (D.C.) I. Kopper, Philip. II. Title.

 N858.N36H65 2008
 704'.042074753—dc22
 2008021646

ISBN: 978-0-7892-1003-6

For bulk and premium sales and for text adoption procedures, write to Customer Service Manager, Abbeville Press, 137 Varick Street, New York, NY 10013 or call 1-800-ARTBOOK.

Visit Abbeville Press online at www.abbeville.com.

CONTENTS

Acknowledgments

It would have been impossible to write *A Museum of Their Own* without the generous help of the staff of the National Museum of Women in the Arts (NMWA). I am grateful to Krystyna Wasserman, Curator of Book Arts, for her encouragement and unwavering friendship and for believing in the importance of this book. Krystyna's memory served me well, as did her research skills—after all, she has been working with me as the Museum's librarian for more than twenty years. I am greatly indebted to Jason Stieber, Director of the Library and Research Center, for the hours he spent retrieving material from NMWA's archives and for his marvelous ability to find, collect, and forward images of works of art from the Museum's collection to the book publisher. He was assisted in this major task by Alan Francisco, Head Registrar; Shonda Davis, Assistant Registrar for the Collections; and Catherine Roberts, Editorial Assistant. I am also grateful to Alison Kent, my able assistant, for typing numerous drafts of the manuscript and helping with research. I thank the curators, beginning with Susan Fisher Sterling, who was Chief Curator at the time this book was written but is now NMWA's Director; Jordana Pomeroy, Chief Curator, Painting and Sculpture before 1900; and Kathryn A. Wat, Curator of Modern and Contemporary Art, for their assistance with the chapters related to the major exhibitions. Outside the Museum's staff, Lee Stalsworth deserves my gratitude for his beautiful photographs of art for this book. I also wish to express my gratitude to Mary Mochary, the President of the Board, and to Arlene Klepper, a member of the Board. I relied on their advice to resolve various matters pertaining to the book.

It was a pleasure to renew my friendship with Abbeville Press and Robert E. Abrams, the president and publisher. Their excellence and high standard in editing and design (which we had previously observed through the publication of several books with them) helped me select Abbeville Press as the ideal publisher of *A Museum of Their Own*. Our collaboration with Susan Costello, vice president and editorial director, was most enjoyable. Susan's brilliant ideas, advice, and gentle watch over deadlines are greatly appreciated. Samantha Shubert was a terrific copyeditor, and I am very grateful for her work on improving the manuscript. Patricia Fabricant did a superb job in designing this book, Louise Kurtz is to be commended for her skill in supervising its production, as is David Fabricant for his patience and guidance sorting out contractual matters. Finally, I wish to thank again and again my husband, Wallace, for his careful reading of the manuscript, his additions and corrections, and most of all his love and support.

Wilhelmina Holladay

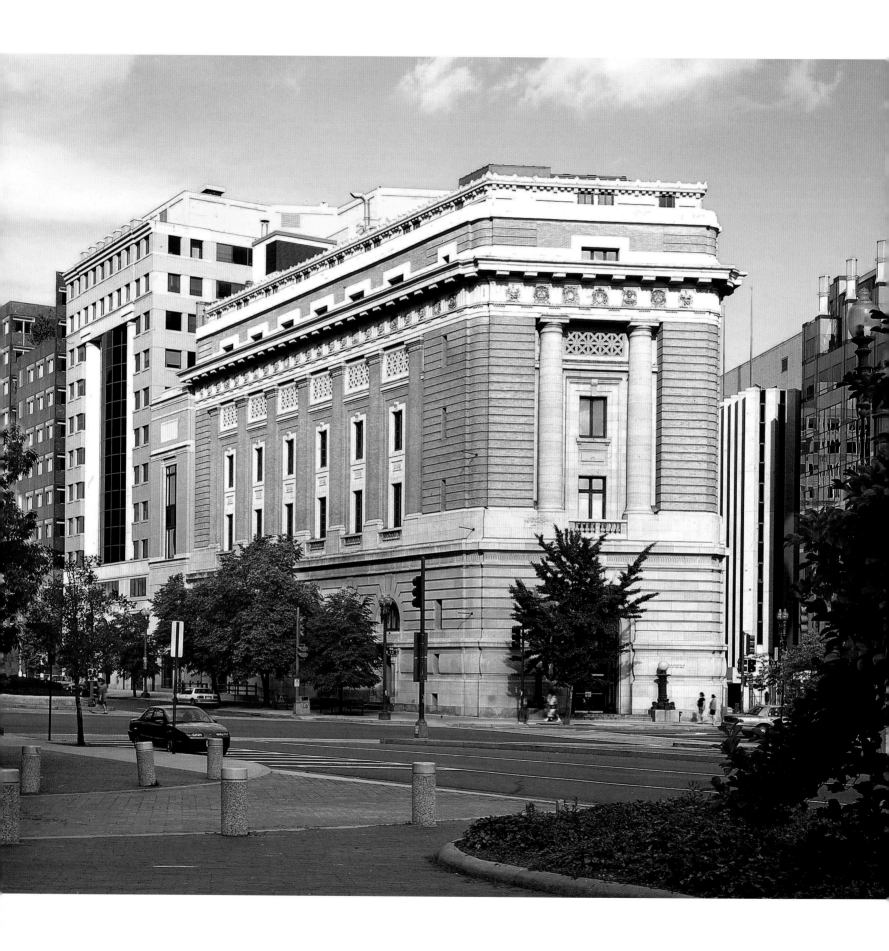

Introduction

THIS BOOK IS NOT AN AUTOBIOGRAPHY, because it is not a full and complete account of my life. This is certainly not a kiss-and-tell, because I have no intention of going into the private crannies of my life or anyone else's. It is not a day-by-day reconstruction of what happened, because even if I had the permanent records to support such an endeavor, I doubt I could take the time to write it all down, and very few readers would want to wade through it. This is not even a complete accounting of every twist and turn in the course of the National Museum of Women in the Arts' journey.

This is a memoir. It is my account of the National Museum of Women in the Arts' conception, founding, and first twenty years of operation in its magnificent home in the nation's capital, three blocks from the White House. Others are entitled to their opinions and viewpoints; forgive me if they differ from mine. As far as NMWA's founding and early years are concerned, I have a certain advantage: I was there at the creation, and I have been there up until now. So I write as best I can and offer this account of our odyssey as I remember it.

THE NATIONAL MUSEUM OF WOMEN IN THE ARTS opened to the public on April 7, 1987, one of the most exciting and fulfilling days of my life. This splendid event required the cooperative and individual efforts of an army of women and men. The opening celebration was held outside the Museum building. Anne Radice, the Museum director, and I welcomed the guests, including many artists, scholars, and Museum members from as far away as Paris, London, San Francisco, and Saint Petersburg, Florida. Effi Barry, the wife of Washington Mayor Marion Barry, and Frank Hodsell, chairman of the National Endowment for the Arts, delivered celebratory speeches. Under a blue sky Barbara Bush, the vice president's wife, cut the

On April 7, 1987, the National Museum of Women in the Arts (NMWA) opened to the public in Washington, D.C. A former Masonic temple was transformed into a temple of women artists.

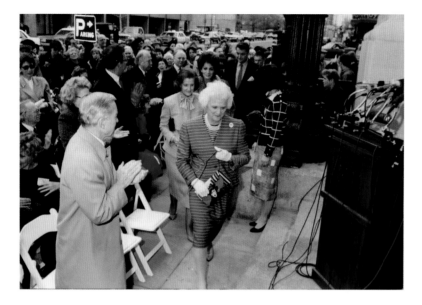

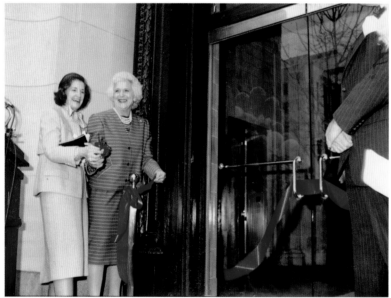

bright red ceremonial ribbon and declared, "The Museum will enrich our city, our nation, and the lives of Americans for generations to come. God bless the National Museum of Women in the Arts." The audience applauded enthusiastically. Red, blue, and white balloons floated high into the sky. The crowd pushed its way inside the building to view the Museum's inaugural exhibition, *American Women Artists: 1830–1930*, and the permanent collection of works by women artists from the Renaissance to the present.

I can't possibly name all the individuals who worked on that wonderful debut, but some must be recognized even now for their sterling contributions. Ruthanna Weber was the general chair; Marjorie Nohowel organized the black-tie dinner for founding members, who had pledged to give at least five thousand dollars over the

TOP LEFT: *Barbara Bush followed by Wilhelmina Holladay; Effi Barry, wife of Washington Mayor Marion Barry; and Frank Hodsell, chairman of the National Endowment for the Arts, on the way to the podium. All delivered celebratory speeches for the opening of NMWA.*

BOTTOM LEFT: *Barbara Bush cut the ceremonial ribbon.*

TOP RIGHT: *I savored the occasion with Dr. Eleanor Tufts (the curator of the inaugural exhibition,* American Women Artists: 1830–1930*).*

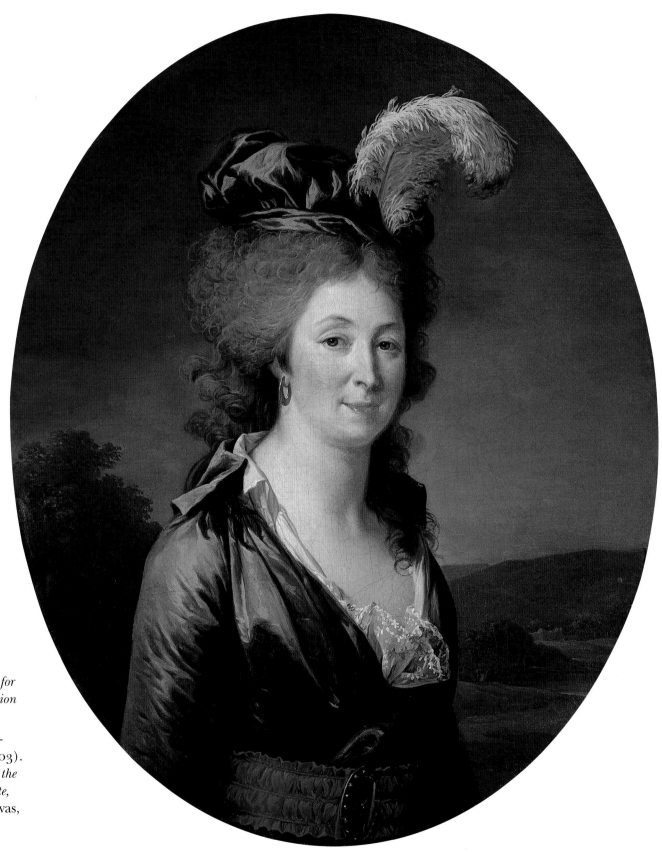

One of the early paintings purchased for the permanent collection was this work.

ADÉLAÏDE LABILLE-GUIARD (1749–1803). *Presumed Portrait of the Marquise de Lafayette,* c.1790. Oil on canvas, 30¾ x 24¾ in. (78.1 x 62.9 cm).

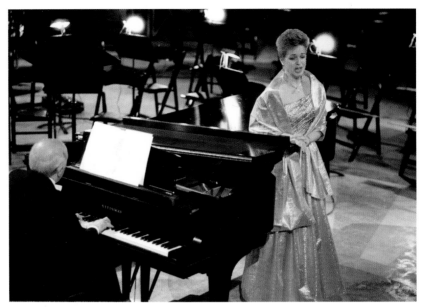

OPPOSITE: *In honor
of the opening events,
Ellen Taaffe Zwilich had
composed her* Concerto
for Two Pianos and
Orchestra, *inspired by five
paintings from NMWA's
permanent collection.
One of them was* The
Abandoned Doll.

SUZANNE VALADON
(1865–1938). *The
Abandoned Doll,* 1921.
Oil on canvas, 51 x 32
in. (129.5 x 81.3 cm).

ABOVE LEFT: *Martha
Dippell, pictured here in
the blue dress, with another
current board member,
Ruthanna Weber, chaired
our inaugural gala in
1987.*

ABOVE RIGHT: *Mildred
Tyree, a prominent opera
star, sang works by women
composers at the opening
gala.*

course of five years. Martha Dippell chaired our debut gala, and Roma Crocker hosted a splendid cocktail party beforehand.

Our inaugural concert featured *Concerto for Two Pianos and Orchestra,* which we had commissioned from Ellen Taaffe Zwilich, the first woman to earn a doctorate in music composition at Juilliard and the first to win a Pulitzer Prize for Music. It was a feather in our cap that Frank Hodsell awarded us a grant of fifteen thousand dollars from his discretionary fund to support that commission. Gerald Lowrie, a board member and head of the Washington office of AT&T, made it possible to engage the National Symphony Orchestra, which performed with pianists Jeanne Rees and Stephanie Stoyanoff in the Museum's Great Hall. My goddaughter, Mildred Tyree, a prominent opera star in Europe, sang classical works by women composers including Clara Schumann, Lili Boulanger, and Alma Mahler.

The opening of the National Museum of Women in the Arts filled several days of Washington's cultural calendar and attracted worldwide press coverage. A few articles included the old argument about "ghettoizing" women, but the fact of controversy, whether genuine or faux, made us newsworthy and continued to raise our profile, generating more press coverage.

Still, there's a fact that headlines tend to obscure. In my view—call it contrary or politically incorrect or simply dated if you like—art is about beauty. Art reflects our shared humanity, the traits, talents, and qualities that make us human. Art transcends politics, gender, color, religion, age, and nationality. Art is the great unifier. Controversy might be useful from a public relations standpoint, but as far as aesthetics and beauty are concerned, controversy is best ignored.

As I write today, two decades after the announcement of our intentions, some people still question whether there ought to be a museum for art by women because

on the one hand it might segregate women artists, and on the other, as someone wrote rather foolishly, next we'll need a museum for bottles made by left-handed glassblowers. I admit that I was pleased that the great feminist artist Judy Chicago loaned us *Through the Flower* for the opening. When asked her opinion she came down on the side of NMWA: "It's important to protect and preserve women's art. My preference is that art by women be preserved by existing institutions, but they don't have a very good track record. Mrs. Holladay's museum doesn't have to conform to my standards. The real issue is taking care of the work."

I was amused that John Wilmerding, deputy director of the National Gallery of Art, joined the media-led conversation by reporting, somewhat hastily it seemed, that the Gallery had organized two shows by women, *Berthe Morisot—Impressionist* and *Georgia O'Keeffe 1887–1986*. (Need I remind anyone that until NMWA's opening there had been only four solo exhibitions of women artists in the Gallery's history.) In any case, Dr. Wilmerding was quoted in a *New York Times* article as saying: "I think we can't help but support a new museum devoted to a specialized area of human creativity. Yet in the long run, there are lots of arguments whether a museum should be devoted to race or sex. We like to consider art in terms of its merits rather than its makers."

In the same *Times* story, Lowery Sims, who was then a curator at the Metropolitan Museum of Art, said: "One wants to believe that there is already enough integration of women and minorities into the art establishment. However, there remains a lot to be done. As a specialized institution, like the Studio Museum [Harlem, New York] and the Museo del Barrio [New York], the Women's Museum could find talent that might be overlooked. So I think it's an exciting venture."

Our hometown art critic, Paul Richard, offered both a snide remark and substance that still gives me pride. He wrote in the *The Washington Post* that the National Museum of Women in the Arts

> has an aura so genteel you'd think it might be called the National Museum of Ladies in the Arts. . . . The museum, like a debutante, honors the traditional and accepts the rules of etiquette. Many women, many artists, snarl at the establishment, but this museum seeks a place within the art world's aristocracy. . . .
>
> The spirit of the place in many quiet ways suggests a sort of demure sweetness. But do not be misled. Washington's Wilhelmina Cole Holladay, the museum's founding president, has accomplished something radical. No player in the art scene here has a deeper understanding of power and of money and of how our system works. Despite her white-glove graciousness, hard-working Billie Holladay is a warrior and a winner.
>
> Primarily by strength of will she has called into existence a national museum of vast potential influence. She has built an institution of remarkable effectiveness— it's like a high tech tank wearing a corsage.

Judy Chicago, one of the best-known feminist artists, was an early supporter of NMWA. She loaned us her painting Through the Flower.

JUDY CHICAGO (born 1939). *Through the Flower*, 1973. Acrylic on canvas, 61 x 61 x 1⅞ in. (154.9 x 154.9 x 4.8 cm). On loan from Elizabeth A. Sackler.

Links in a Golden Chain

L ET THERE BE NO DOUBT ABOUT ONE IMPORTANT FACT: I could not possibly have developed the National Museum of Women in the Arts without the love, constant support, counsel, and inexhaustible good humor of my husband, Wallace F. Holladay. Even now, some twenty-five years after the idea of NMWA was born and became the focal point of my life, Wally often accompanies me to the evening events I must attend. Occasionally he bows out because he still goes to the office every morning at 7:30 A.M., years after most men his age have long since retired.

Wally makes me laugh. One night, not long ago, he was already asleep when I came home, and I must have awakened him when I got into bed. He mumbled, "You kicked me!" I said, "Oh, Wally, I'm so sorry. I didn't mean to." I could almost hear his eyes blink open and his grin broaden. A moment later he sang in his monotone, "I get no kick from champagne . . . but I get a kick out of you."

Wally's good nature has opened many doors and eased many situations; he always has something pleasant to say, and he is famous among our friends for disarming a tense situation with his wry wit or a sly remark. The many things we share include a love of flowers, an interest in food—his bread is delicious—and an appetite for travel. Over the years we've traveled widely and decided that we wanted to see the whole world before we die. After sixty years of marriage, I never tire of our adventures in dining, at home, and everywhere in the world that our travels take us. Of course one of the things I love most about Wally is his love of art and his wonderful eye, which homes in on the best at any gallery show. It was his knowledge and curiosity, after all, that augmented my interest and led us to discover what was then the art world's most astonishing blind spot.

Wallace and I have been happily married for more than sixty years. He is funny, and he makes me laugh.

In the early 1970s in Vienna's Kunsthistorisches Museum we came upon some wonderful paintings by Clara Peeters, a name that was new to us in spite of our having studied in the field. Days later we moved on to Madrid, and in the Museo del Prado we saw more canvases of a painter by the same name. If Peeters were sufficiently important to hang in two of the world's great museums, how was it that we did not know of her? European museums were notorious in those days for their minimal signage and lack of interest in educating or even informing the visitor. As a result, we left Europe knowing as little about this artist as we had before we arrived, but her works had made an impression.

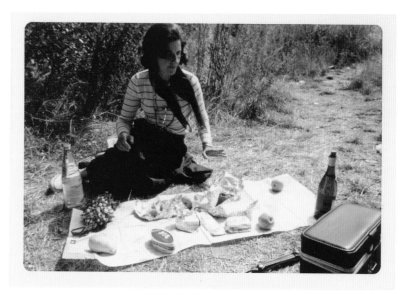

When we returned to Washington, I consulted our research library, such as it was—several dozen volumes of art histories, surveys of certain periods, and standard reference works. First we turned to H. W. Janson's *History of Art*, which appeared in 1962 and became every American art history student's bible. Nothing on Clara Peeters. She was not mentioned in any of the other half dozen standard references on our shelves. Disappointed and frustrated, but determined, I went down to the library at the National Gallery of Art,

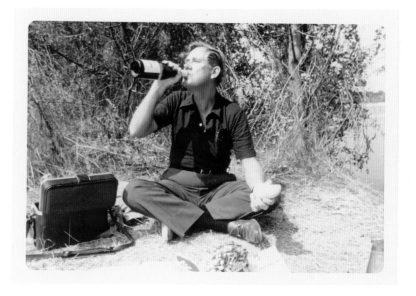

where I had worked when I was young, and found a very small amount on Peeters. The scarcity of information confirmed Wally's amazing observation that there was not one woman artist in Janson, the leading American art history text, not even Mary Cassatt or Georgia O'Keeffe.

Over the years we have traveled to many places. Here we are having a picnic in France's Loire Valley. I took Wally's picture, and he took mine.

In the fall of 1972, I received some splendid advice from a celebrated connoisseur, Richard Brown Baker, with whom we frequently traveled. Richard was a born collector; he began by collecting coins as a child, then books at Yale in the early 1930s. A member of one of Rhode Island's most distinguished families and a former Rhodes Scholar, he went to work for our ambassador to Spain on the eve of World War II and helped get refugees out of Europe. He spent the duration of the war in the OSS (the wartime intelligence agency and predecessor of the CIA), much of that time in England, where he cracked German codes. After the war he served for a

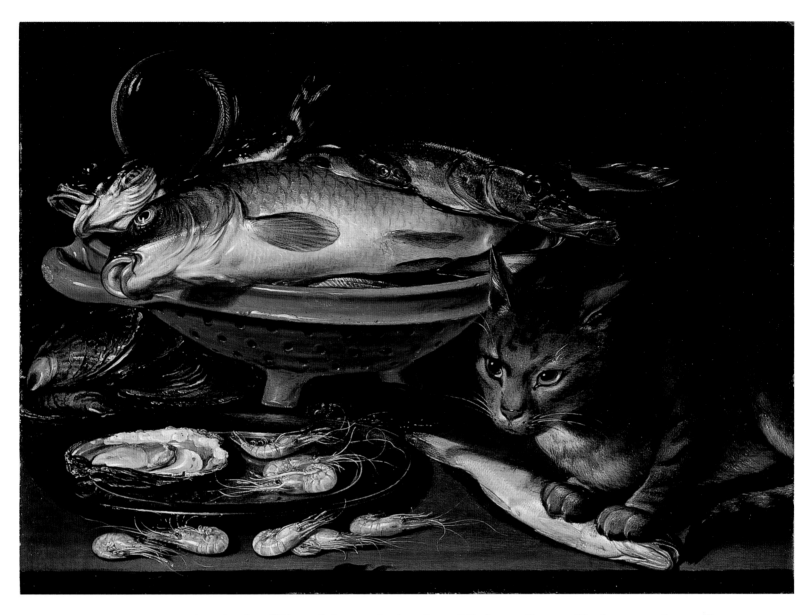

We bought this painting by Clara Peeters for our collection after seeing and falling in love with her paintings in the Kunsthistorisches Museum in Vienna and later in the Prado in Madrid.

CLARA PEETERS (1594–c. 1657). *Still Life of Fish and Cat*, n.d. Oil on panel, 13½ x 18½ in. (34.3 x 47 cm).

time in the CIA and then retired to be a full-time collector. Having started to collect art before the war, he decided to buy the works of living artists, partly because they were less costly than Old Masters and partly because he loved modern art, which he collected with a touch of genius. For example, he bought Roy Lichtenstein's *Blam!* for a thousand dollars and Jackson Pollock's *Arabesque* for barely twice that amount in 1955. Forty years later, when he gave much of his collection to Yale, the pictures and objects alone were valued at twenty-five million dollars.

He noted that Wally and I were starting to buy art. We certainly didn't consider ourselves collectors; we were buying a few paintings that we liked for our walls. Richard told us that collecting would be more interesting for us and for others if we had a focus. Later I received an essay from him that I treasure, including the principles of collecting that guide me still:

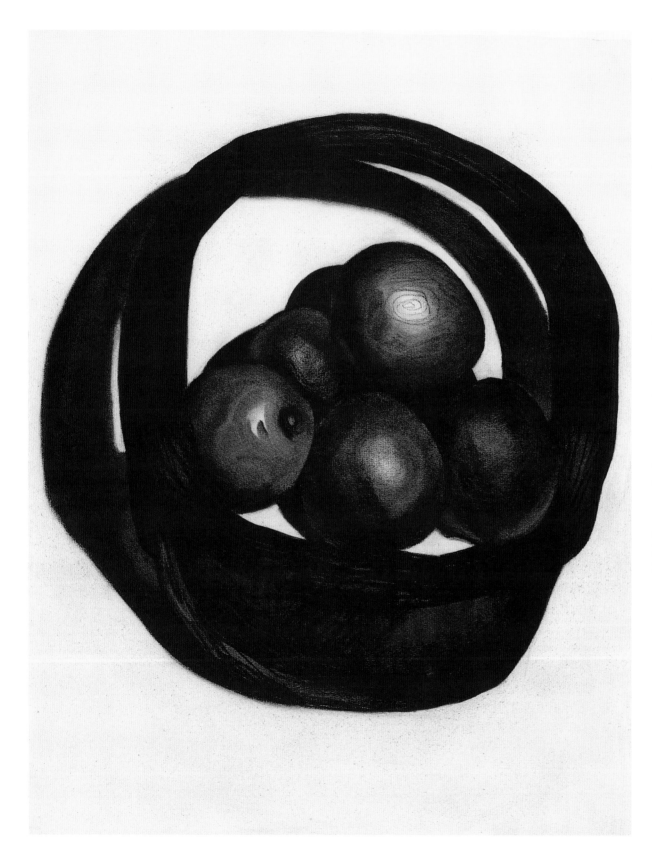

In 1962 the major art history textbook by H. W. Janson did not include a single woman artist, not even Mary Cassatt or Georgia O'Keeffe. We were very pleased to discover and purchase this early charcoal drawing by O'Keeffe. I was eager to challenge Janson's implicit assumption that women's contributions to the history of art were negligible.

LEFT: GEORGIA O'KEEFFE (1887–1986). *Alligator Pears in a Basket,* 1921 Charcoal on paper, 24⅞ x 18⅞ in. (58.4 x 48.3 cm).

OPPOSITE: MARY CASSATT (1844–1926). *Maternal Caress,* 1890–91. Drypoint, aquatint, and softground etching on paper, 14½ x 10⁹⁄₁₆ in. (36.8 x 27.1 cm).Gift of John and Linda Comstock in loving memory of Abigail Pearson Van Vleck.

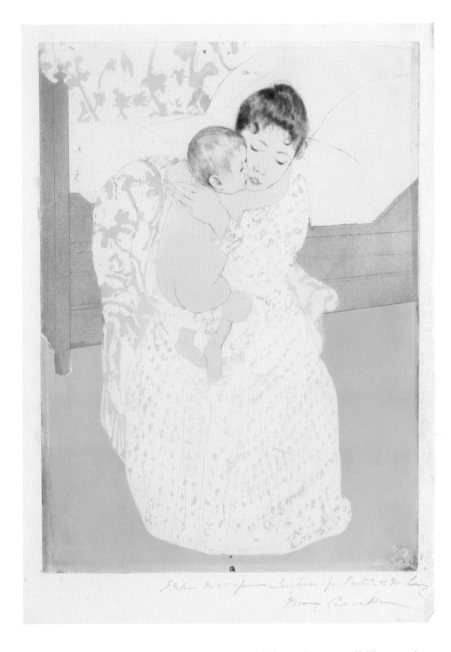

Dear Billie,

We did scatter at Dulles like sere leaves in a high wind, didn't we? But I knew we would; there's no taming the homing instinct once the customs barrier is hurdled.

I am flattered that you took note of my idea (not original to me, of course) that a collection, whether personal or even institutional, gains power through sharpening its focus. Enthusiasm being the fuel that keeps a collection building, the first necessity is to hit upon a goal that generates enthusiasm. You can't gain and sustain momentum if, for example, your grandfather bids you to collect horseshoes and they bore you. Somehow a collector must arrive at a virtual personal interest—a line of acquisition that really sends him. I think you're very wise to go slow until you've sighted the goal, and the ultimate choice must be something you arrive at largely on your own. Imagination and self awareness probably help in determining the line to follow; imitation of others probably deadens the prospect of awakening real enthusiasm. Those elements that every great collection needs in some strength—time, money and judgment—usually can't be controlled fully by the collector, but there are additional factors that can be weighed, and one of them is accessibility to the market. If you told me you wanted to collect (and who doesn't?) 20th century acupuncture [needles] . . . I'd remind you there's no US market in which to acquire them, and maybe it isn't easy even in Peking to make satisfying new acquisitions. And that's one of the important aspects of collecting: to be able to make new acquisitions. Certain kinds of collectors, like bibliophiles, value the idea of completion. Last winter I heard an Oxford scholar say, "I can't imagine anyone collecting pictures. All one can do with pictures is assemble them." For him the collector's job, I presume, is to bring together every last item on a theme—maybe like getting clean fine copies of every novel, in every edition ever published in any language, of the traveler's friend, Agatha Christie, Whew!

Well the book collectors have the help of booksellers' catalogues and ordering by mail. The assembler of items to be priced principally for their authentic merit has to go around doing a lot of looking, of visual concentration, and to be a 1,000 miles from art museums and commercial galleries would indeed be a handicap. I went the other afternoon to the N.Y. Historical Society to hear Marvin Schwartz talk on "Collecting Americana" and came away (after several post conference cocktails in the Director's study) bemused by the realization that someone some-where soon is going to begin collecting (the Oxford scholar would say assembling) American cocktail shakers because they seem already to belong to the recent past now that "on the rocks" is in fashion, and if one wants to get in on the ground floor before moneyed rivals force prices up by their greediness, aren't these disused articles (some quite handsome) lying on pantry shelves a real prospect, such as Tiffany glass was to the early birds a quarter of a century ago?

I should love to meet with you and talk further on these subjects. If and when you're in New York, I'll squire you to some contemporary art galleries if you like. Come for a drink to my dusty flat and gape at those of my art treasures that are not out on loan (as many of my best are).

With all the best,

Dick Baker

Thus Richard Brown Baker's principles:

- *A collector must have enthusiasm, in addition to time, money, and taste.*

- *A collection must be focused.*

- *There must be an accessible market.*

- *And, almost as an aside, it doesn't hurt to get in on the ground floor.*

Dick and I were such close friends that I later heard some people thought we were having an affair; they couldn't have known either of us very well because infidel-ity is not in my repertoire, and conventional romance was not in his. More important, I shall always be grateful to Richard Brown Baker as the person who advised us to choose a particular focus for our collection, which is really what enabled it to become the core of a museum.

IT SEEMED MOST SENSIBLE TO WALLY AND ME to start collecting in an area that wasn't chic, that hadn't been bled dry. It seemed much more affordable, and even practical, if we were to assemble a collection of distinction. Even in our informal col-lecting, we knew the market in the visual arts could hardly be more accessible to us.

Further, if we used good judgment, particularly about what we would pay for new acquisitions, we could afford to collect art with a focus. We then discovered a focal point for our collecting, a focus that no one else seemed to have discovered or chosen. We would collect great art by women. We could build a collection within boundaries that had been ignored by the notable collectors of the past, by the chic and trendy gallery-goers of the present, and by the critics and scholars of the history of art, the arbiters of intellectual taste for several generations. We would focus on paintings by women, especially paintings by eminent artists who were women and had been inevitably neglected. We would aim to show women's contribution to the history of art.

The women's movement was gathering steam, and perhaps that helped us. But it was really coincidental. We decided to collect women's art because great works of art that happened to be by women had been overlooked. Perhaps a part of the neglect was caused by an old-fashioned assumption that a woman couldn't make a great painting, just as it was supposed that a woman couldn't be a great diplomat or jurist. I simply hoped we might draw attention to a neglected body of art through the ages.

In Greece with Lady Bird Johnson and Laurance and Mary Rockefeller.

MANY OF THE EVENTS THAT LED TO THE FOUNDING OF OUR MUSEUM—and many that have followed—were connected, like so many links in a golden chain. I believe that the National Museum of Women in the Arts was inevitable; I believe its founding was simply meant to be. Looking back, the number of "accidental" connections and events seems miraculous.

One arose from the infant offspring of the Smithsonian Institution, which since the 1960s had profoundly affected Washington's central area, a part of town that would become NMWA's home. Under S. Dillon Ripley, the Smithsonian's gifted chief executive (loftily called "the Secretary"), this scholarly and scientific organization redesigned its museums and enlivened the National Mall—all in a dynamic effort to honor the second part of its original purpose: "for the increase and *diffusion* of knowledge." Responding to popular tastes, it became a mecca for hoi polloi as it offered the sciences and arts to the people; then it brought people to the arts in a host of ways, such as by sponsoring trips, which is how Wally and I became involved, through a program known as Smithsonian Associates.

We took several Smithsonian trips just for the pleasure of traveling with a pleasant intellectual focus in mind and with a group composed mostly of interesting, like-minded people, including many who became good friends. One of our very early trips was to the Soviet Union—Moscow, Leningrad, Kiev—where the food was inedible, the plumbing unspeakable, and the art wondrous. It was here that we met Richard Howland, who was a special assistant or "counselor" to Secretary Ripley. Richard, who helped arrange the trips and became a friend, was an elegant gentleman of esoteric knowledge and sophisticated tastes.

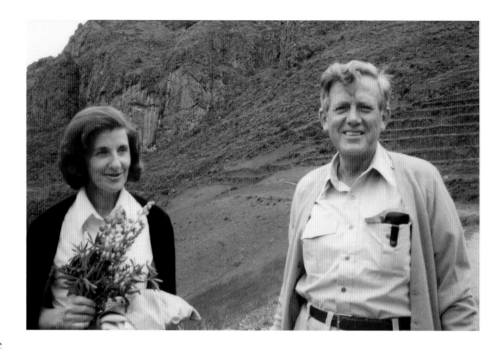

ABOVE: *With Wally in Machu Picchu, Peru.*

OPPOSITE: *The choice of this self-portrait by Marie Laurencin as the cover image for NMWA's first collection catalogue, published in 1987, was Helen Ziegler's idea.*

MARIE LAURENCIN (1885–1956). *Portrait of a Girl in a Hat,* c. 1950. Oil on canvasboard, 15 x 11¾ in. (38.1 x 29.8 cm).

Wally and I were young then, but I suppose we were attractive, and we were certainly curious about cultural things. We must have passed muster in some way, because Richard introduced us to an English friend of his, Ian McCollum. As director of the American Museum in Britain, Ian periodically took small, select groups of people on extravagant trips to choice destinations. This was travel at its finest in terms of amenities, arrangements, destinations, and participants.

So the chain of "accidentals" proceeded like this: The Smithsonian trip introduced us to Richard Howland, who introduced us to Ian McCollum, who introduced us to Richard Brown Baker, who really started us on our way to founding a living institution. Links in a golden chain of memorable friendships.

On one trip abroad with the American Museum in Britain we met Helen Ziegler, who was a tournament bridge player and had many friends in the art world. She became actively interested in NMWA when it was still just an idea. Seeing its potential clearly, she would come down from New York to offer us her expertise, when we were under way, in many areas of connoisseurship and common sense. For instance, when we were finishing work on our first collection catalogue, we were confronted with a problem: What should go on the cover of the book? Our natural instinct was to feature something like Lavinia Fontana's fabulous *Portrait of a Noblewoman* or Lilla Cabot Perry's *Lady with a Bowl of Violets.* The debate arose because the earlier of those masterpieces would identify the catalogue (and the Museum) with the Italian Renaissance, while the Perry would link us to Americana. Helen suggested the more unusual *Portrait of a Girl in a Hat* by Marie Laurencin, for the disarming reason that this charming self-portrait is not instantly identifiable as

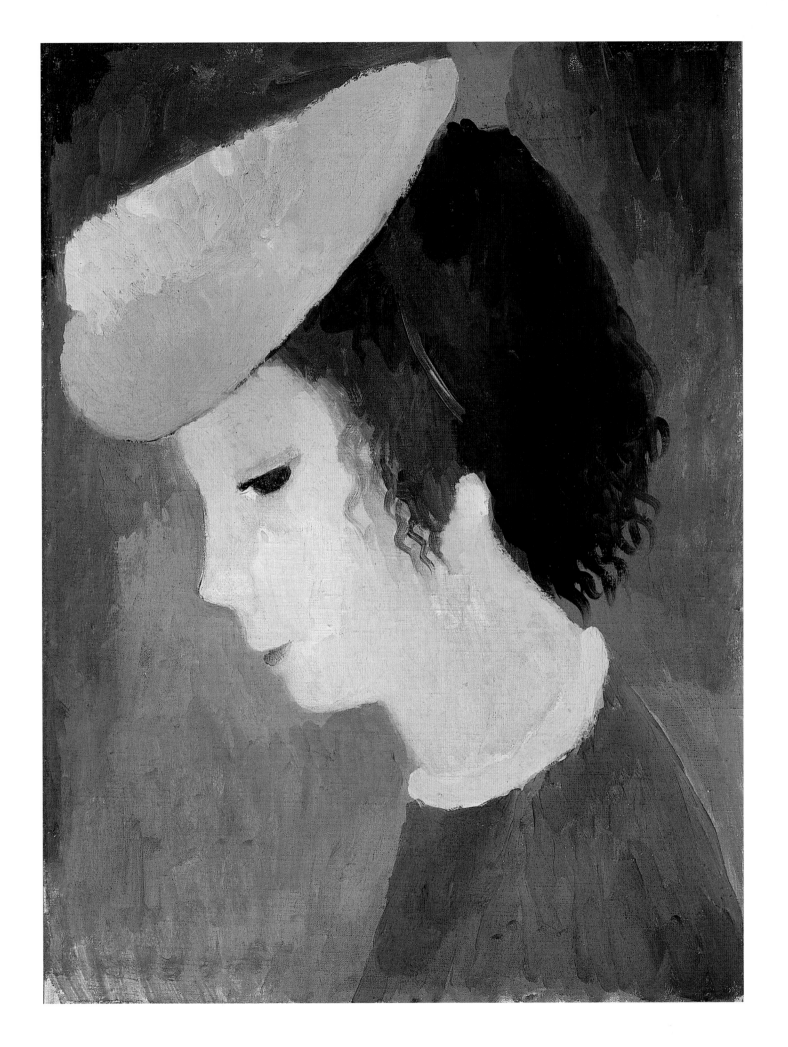

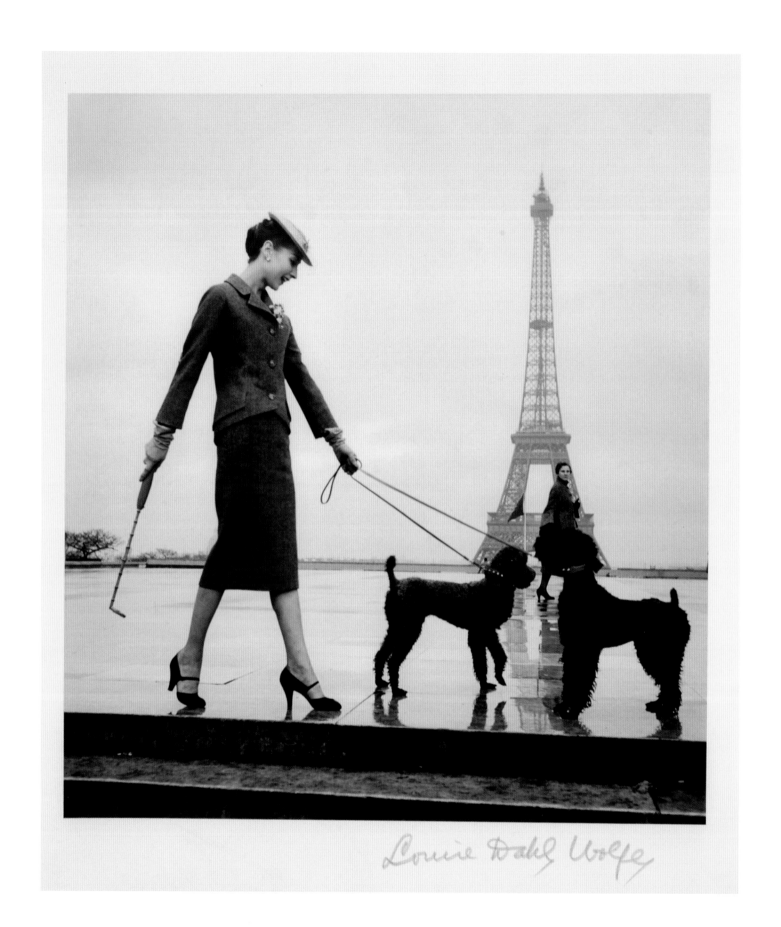

Louise Dahl-Wolfe

Later, Helen Ziegler donated to the Museum her collection of photographs by Louise Dahl-Wolfe, among them these outstanding prints.

OPPOSITE: LOUISE DAHL-WOLFE (1895–1989). *Model in Dior Suit, Walking Poodles in Paris,* c. 1940. Gelatin silver print, 10½ x 9½. (26.6 x 24.1 cm). Gift of Helen Cumming Ziegler.

NEAR RIGHT: LOUISE DAHL-WOLFE (1895–1989). *California Desert,* 1948. Gelatin silver print, 10 x 9⅜ in. (25.4 x 23.8 cm). Gift of Helen Cumming Ziegler.

FAR RIGHT: LOUISE DAHL-WOLFE (1895–1989). *Lauren Bacall in Helena Rubinstein's Bathroom,* 1943. Gelatin silver print, 11¼ x 9¾ in. (28.6 x 24.8 cm). Gift of Helen Cumming Ziegler.

 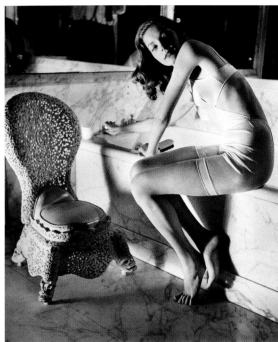

being of any particular period but instead appears to be outside of time. It was the perfect solution—a cover that let the potential reader's imagination explore—and it was the cover we chose.

Helen was well connected; she had many creative and cultured friends, among them Louise Dahl-Wolfe, the woman who first made fashion photography into a high art. Louise in turn became interested in NMWA and allowed us to borrow a selection of her best photographs, which we displayed in a splendid 1987 exhibition that was very well received and the opening of which Louise attended. Helen later gave many of her photos to NMWA. A charming and understated hostess, as well as a music lover, Helen always welcomed me in her Manhattan apartment with champagne on ice and classical music playing on an enormous antique music box that I greatly admired. Again, one thing led to another, and one person to another, as right as charms on a bracelet. It did indeed seem as if the Museum had its own continuity and its own momentum.

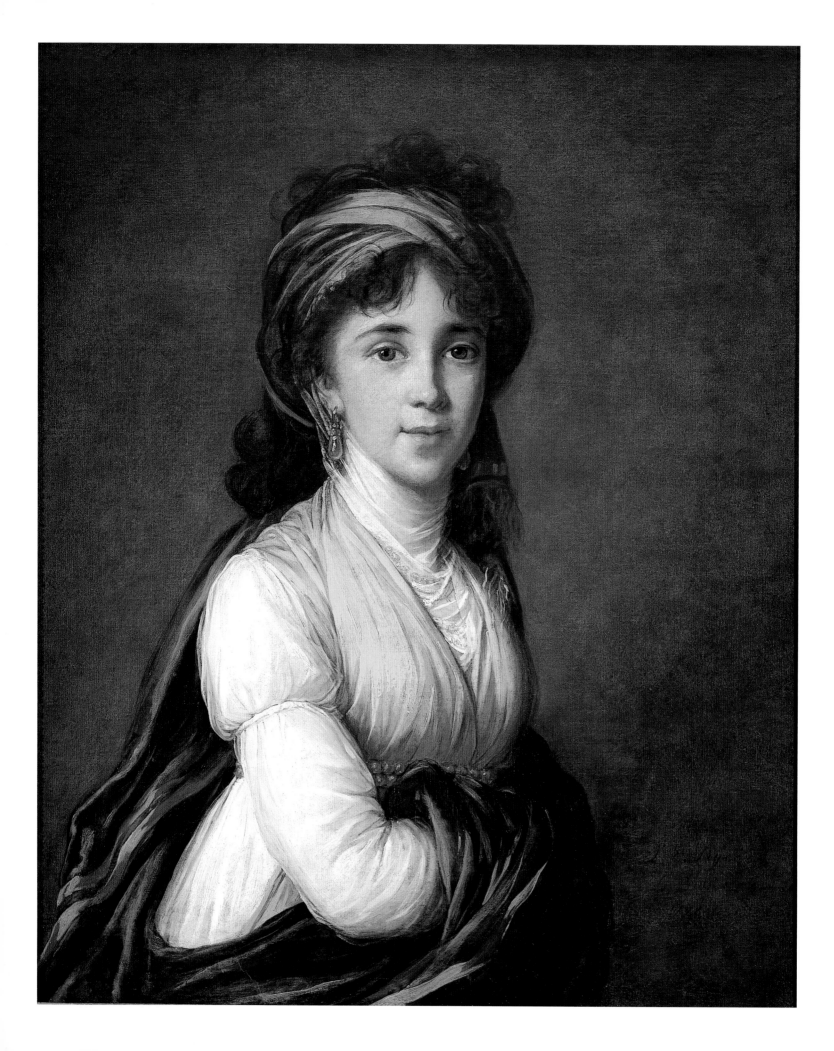

Preparing the Canvas for My Life's Work

I OFTEN WONDER, AND AM FREQUENTLY ASKED, what in my background led me to become deeply interested in art and education, and in discovering and preserving what has been forgotten. Inevitably, many early experiences gave me some of the skills that would be useful in addressing the tasks ahead. I like to think of myself as a person with clarity of vision, but I am aware of how frequently I call on others to work on the minute details.

I was born in 1922 in a small town in upstate New York. My grandparents, Gertrude and Charles Henry Strong, lived across the street; they had given our house to my parents as a wedding present, so we were very close in more ways than one. Every morning I had breakfast with my grandfather, as we were both early risers, but Grandmother was the person who influenced me the most. It was she who taught me aesthetics, who instructed me to welcome and cultivate beauty in my life. She would say, "Always be aware of beauty. Be aware and sensitive to the beauty around you." She would pick up an orange or a flower and say, "Why is this beautiful? Is it the color? Is it the smell? Is it the smooth, soft finish when you touch it?"

I had three girl cousins my age, and they were all beautiful, and I was not. I would say to my grandmother, "I want to have curly hair like Corine. Joyce and Gloria are so pretty, and I am plain. I want to be like them," but she would say, "No, no, my dear, you are lucky. You are smarter and have a born sense of style." I began to think about beauty, and my grandmother would say, "Beauty is something that moves you and affects your life, and you must understand it."

Grandmother was certainly aware of the beauty around her, and she created it in her own home, in the fabrics, the wall coverings, the china, and her own stylish attire. We lived very comfortably—Grandfather's uncle had helped finance Eastman

I wish we owned Elisabeth-Louise Vigée-Lebrun's self-portrait with her daughter, which is in the Louvre. But I cannot complain. Three beautiful paintings by the same artist, among them Portrait of Princess Belozersky, *are in NMWA's collection.*

ELISABETH-LOUISE VIGÉE-LEBRUN (1755–1842). *Portrait of Princess Belozersky,* 1798. Oil on canvas, 31 x 26¼ in. (78.7 x 66.7 cm). Gift of Rita M. Cushman in memory of George A. Rentschler.

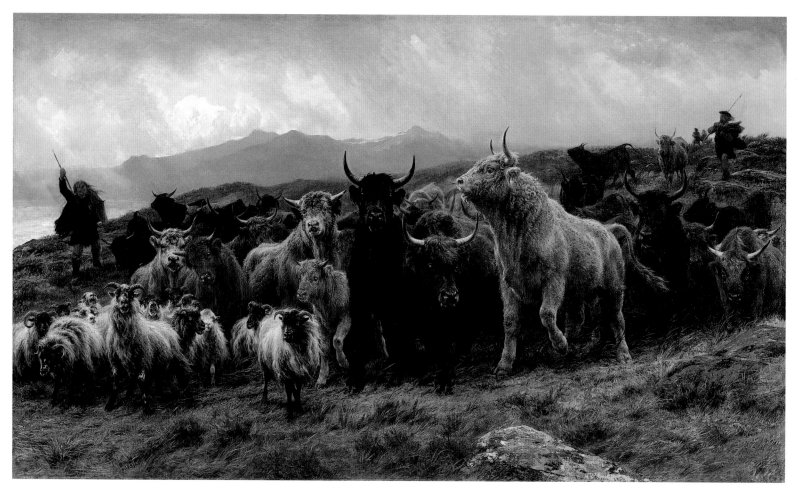

Kodak—until the stock market crash, after which everybody felt the pinch. Before that, Grandmother Strong had a chauffeur and the first automobile in the neighborhood, a Rickenbacker in which she took me for rides. It had wheels with wooden spokes, and little vases to hold fresh flowers in the passenger compartment. She was an elegant lady, her clothing usually black and always pure silk.

The first work of art I ever really knew was in my grandmother's house. It was an engraving of a painting by Rosa Bonheur. She was apparently popular in those days, when few women artists were even known. She painted large landscapes, typically with peaceful animals in the foreground and the sea in the distance, and those bucolic scenes must have struck a chord in Victorian America. Another picture I remember was a print of a double portrait by Elisabeth-Louise Vigée-Lebrun— actually a self-portrait with her daughter. I liked it simply because it was beautiful; the two charming faces and their dresses in luscious fabrics were images of beauty. I wasn't aware of the artist then, only of the picture itself and its absorbing appeal.

My grandfather also had an influence, but it was quite a different one. If Grandmother instilled an appreciation for beauty, he taught my cousins and me the value of perseverance. My mother came from a large family, with twenty grand-

Rosa Bonheur's The Highland Raid *demonstrates the talent of this French artist, who often kept live animals (the subjects of her paintings) on the balcony of her Paris apartment.*

ROSA BONHEUR (1822–1899). *The Highland Raid,* 1860. Oil on canvas, 51 x 84 in. (129.5 x 213.4 cm).

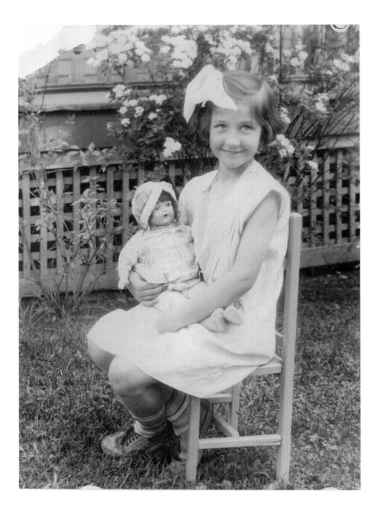

Here I am with my doll at the age of five.

children. As soon as he felt we were old enough, he would take some of us for the month of July and some for the month of August to his cottage on Lake Keuka. Grouped by age rather than gender, we learned to sail and swim. His rule was you could never swim alone until you had swum the almost two miles across the lake; he would tie one end of a rope around your waist, put the other end in his rowboat, and start to row until you couldn't swim any farther, and then he would pull you into the rowboat. The trick, he said, was to catch your "second wind," which I never seemed to do, so I kept giving up and climbing into the rowboat, always feeling a little shameful. One summer day I caught my second wind, and I thought I could swim forever. At his urging I had kept on trying, and finally I did it.

Another person I remember from my childhood years was my brother, who was really quite remote. He was much older than I and terribly bright—he graduated from high school when he was sixteen. For some reason, my mother made him take me to the golf course, though naturally he hated having me along. He would warn me, "Say one word and you have to leave. You must be quiet on a golf course. And don't you move an eyelash when other people are hitting." Needless to say, I learned golf rules because he was so strict. That was how I learned that there are different standards of behavior, and that every setting has its own set of requirements and manners.

Mother was a free spirit, always on the move, always going somewhere. She had one of the first cars, a black Essex, which she drove herself, and she was gone in that car all the time. I remember that in the evenings her brothers and sisters would come to our house to play cards, which Grandmother wouldn't allow in her house, and I would stay up to watch. They would say, "Isn't it past Billie's bedtime?" And Mother would say, "If she's tired, she'll go to bed." I think Mother taught me to be responsible for myself, to make my own decisions. She wasn't a "clean your plate" person.

I have no complaints about my childhood, and obviously it contributed a lot to the person I became—aware of beauty thanks to my grandmother, disciplined in a certain way thanks to my brother and grandfather, somewhat independent thanks to my mother, and spoiled totally by my father.

After my graduation from Elmira College I lived in Rochester, New York. It was there that I saw an excellent performance of Eva Le Gallienne in Chekhov's Cherry Orchard.

BERENICE ABBOTT (1898–1991). *Eva Le Gallienne*, c. 1927. Vintage silver print, 3½ x 4½ in. (8.89 x 11.43 cm).

After graduating from high school, I went to Elmira College, where I majored in business and the history of art. I took all the art history courses offered by Professor Donald Lord Finlayson, who had taught at nearby Cornell. Elmira required every student to take a speech course, which taught me a little about elocution and projection—how to be comfortable standing before an audience and saying something pleasant. I also took some drama courses, which had a lasting effect, and I was active in the student theater. I had a lead in every play; I was Crystal in *The Women*, and I had the title role in an adaptation of Twain's *Huckleberry Finn*. I got an A+ in drama class. I could somehow project myself into the role and forget about the audience, forget about everything.

When I was graduated in 1944 I wanted to go to New York, but the family frowned on that and allowed me to go only as far as Rochester, where many of the family lived. I had had a journalism professor, Dawn Ludington, whose father was the head of a stock brokerage firm. He hired me to work in his office and act as his social secretary. I stayed with the Ludington family in their beautiful house until I got settled in. This was a very useful experience, because I was out of the family fold, so to speak, but still in a secure situation as I tested my wings.

In the office I was exposed to business and learned a lot about the stock market and securities. In my job as Mr. Ludington's social secretary, I arranged for him to entertain clients at his house. I made dossiers on the important clients, so we would have their favorite brand of liquor on hand or serve a roast if they were meat eaters.

After a time, two other classmates came to Rochester, and we moved into a mansion-turned-boardinghouse run by a woman named Mrs. Hull. My roommates and I shared a big bedroom, with a fireplace, in what had once been the library—repurposed when Mrs. Hull felt the pinch of the Depression, perhaps. All the other roomers were students at the Eastman School of Music, so music was all around us, a fantastic experience, and our friends were all musicians. In fact, Rochester was also a lively place in terms of the performing arts, with a professional theater that offered memorable plays, like Chekhov's *Cherry Orchard* with the great young actress Eva Le Gallienne and *Othello* with Paul Robeson.

My roommates had a sense of adventure, and when two of them took a trip to Buffalo, I went along for the ride. One purpose of the trip was to date three boys at the university there, but my friends also wanted to take a test for jobs in Washington. I enjoyed what I was doing in Rochester and joined them only as a lark. My friends failed the test, but I passed it; only then did I find out that anyone who passed the test had to go to Washington. It was wartime. In effect I was drafted. I went to work at the Pentagon for General Hausman, the head of the Readjustment Division of the Air Force, in January 1945. I disliked the job intensely, and I kicked myself for getting into it. It was tedious, exhausting work, keeping constant track of the fighting in order to be certain troops had necessary equipment. Without the benefit of e-mail or fax machines, complicated letters had to be drafted to cancel contracts and create new ones. For example, when the fighting moved from the arid plains of Africa to the boot of Italy it was imperative to replace desert fighting equipment with arms suitable for the terrain of Europe. My boss was stiff-backed and humorless. We worked six days one week, then seven days the next—one day off every two weeks.

When my Rochester friends decided to come to Washington and find jobs in the private sector, my luck changed. Through my mother's cousin, a congressman from upstate, we found a small apartment—great good fortune at a time when housing was scarce. One of my roommates, beautiful Marion Campbell, took a job with the office that processed the "dollar-a-year men," experts in various fields from all over the country who worked pro bono to help the war effort. Through her job Marion somehow met some Chinese diplomats, among them a man named Jen Zien (or "J. Z.") Huang. He was very personable, spoke good English, and asked me what I was doing at the Pentagon. I told him, "I'm working myself to death and not doing anything I'm interested in." He said, "Why don't you come work for me?" I was excited about the possibility. When I gave notice, my boss was upset, told me the law barred private employers from hiring personnel away from essential war-effort jobs, and said he wouldn't let me go. I informed him that a foreign embassy would be unfazed by his disapproval because of diplomatic immunity. I happily said good-bye to him and the Pentagon.

J. Z.'s job at the Chinese Embassy was to lobby for Chiang Kai-shek's Nationalist government by cultivating important people in Washington, an assignment that covered a multitude of sins. Years before I worked for him, for example, he had enrolled in a police academy, allegedly to pass his new knowledge on to police departments in China. What he really did was make friends with police cadets, who were later assigned to precinct houses and rose through the ranks all over Washington. By the time I worked at the embassy, they were captains. He was able to intervene when any of his influential friends needed a traffic violation fixed or got in a scrape. I saw what power—the power of contacts, the power of access— could do in Washington. I also learned the power of the chip, because one of J. Z.'s tasks was to organize poker games for senators and other important officials at the home of General P. T. Mao. I became aware that the Chinese hosts determined in advance how much money these American VIPs would win! It was cunning and seemed unbelievable to a naive young woman. While many people in Washington looked down on them or dismissed them, the Chinese played a skillful game, and I learned that being underestimated can be an important asset.

When General Douglas MacArthur was ordered to visit Chiang Kai-shek's government in China, preparation for the visit was thorough. I was instructed to find out what kind of sheets he and his wife liked on their bed, what kind of food they preferred, and what kind of reading material. I was sent down to North Carolina, where they lived, in order to gather the information!

Earlier, Madame Chiang had visited Washington and addressed a joint session of Congress—at that time, only the second woman ever to do so. Now, she took up residence in Westchester County, outside New York City, and I was put up in the Waldorf Towers to act as social secretary. If Madame Chiang was going to entertain, I would go to the public library and prepare a dossier on every guest so that, for example, she could say to the gentleman on her left at dinner, "I understand your daughter goes to Wellesley; I went to Wellesley also." Madame Chiang was very demanding, but I loved being in New York, where I could go to the theater, the museums, and the fashionable stores.

Back at the Chinese embassy in Washington, I met Taylor Simmons, an officer just getting out of the Army. He had been invited to take over the large and elegantly furnished apartment of a family friend. Taylor acquired a couple of roommates and decided to throw a housewarming. I drove to the party in the embassy's Packard, a car with diplomatic plates that I was supposed to use only for official business, and asked one of Taylor's roommates to park it safely out of sight in the garage. At the party I found the other roommate, Basil Crabster, very appealing. We were flirting, and halfway through the party he invited me out to dinner, and I accepted. While he was getting me another drink, the roommate who had parked my car came over and said quite directly, "You look like a nice girl," which

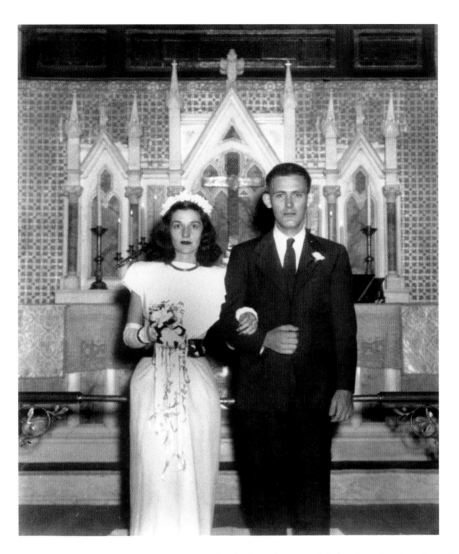

Wally and I were married in Washington, D.C., on September 27, 1946. Big weddings were out because of the war, so we had a modest celebration.

pleased me, of course; "I hope so," I replied. Then he said, "Have you met Basil's fiancée? She's here, you know." I was shocked and said, "Good heavens, he asked me to dinner. I would have declined his invitation if I'd known he had a fiancée." This roommate saved the situation by suggesting that all four of us go out to dinner together, and he became my date. His name was Wallace Holladay.

Wally was a Virginian, and a Navy officer at the time. He was just getting out of the service, intending to go back to Virginia Polytechnic Institute, where he had earned his B.S. and M.S. degrees in architecture and engineering, to prepare for his architectural registration exam. He had a wonderful sense of humor, and he was very interested in art, as was I; we got along just fine.

I appreciated both his warm persona and his ability to handle almost any situation. Once, for example, we both had a little too much to drink—in those days *everybody* drank—and I had a fender bender, in my embassy car, near the Capitol. When a Washington police officer came over to investigate, pausing to look at the diplomatic plates, Wally had an inspiration. He gave the officer the opportunity to ask only one question, in response to which we pretended not to speak English.

We began to see each other constantly, and then he fell in love. I said, "Don't get serious, I'm going abroad. I want to travel and see the world." But Wally asked me to marry him and just wouldn't stop. He proposed to me every single day for a year. Then one night—I remember we were smooching on the sofa—I simply said yes. He couldn't believe it. He got up, walked out, closed the door, and came back ten minutes later. "Did you say yes?" Then he wanted to get married the next day!

Big weddings were out of fashion because of the war so we had a modest celebration in Washington, and my family came down for the occasion. Almost as a remarkable wedding present, a year later Wally received an invitation to study architecture on a fellowship with Walter Gropius at Harvard. We thought we were all set and would go up to Cambridge. Then I discovered I was pregnant, and I felt I had

ruined Wally's life. But he said, "Who needs a doctor's degree in architecture? I'd probably end up teaching, and I don't even want to teach. . . . If I'm going to be a father, I'm going to make money." And that's exactly what he did. As it turned out, Wallace Fitzhugh Holladay, Jr.—nicknamed "Happy"—proved far more rewarding than a doctorate.

In what we thought was an interim job with the Federal Housing Administration, Wally met Ian Woodner, who was building a big hotel in Washington. They got to know each other through their mutual interest in art; Woody was an architect himself and had worked with Salvador Dalí at the 1939 World's Fair. Wally went to work for him, designing, dealing with other architects, managing developments, arranging loans. At one point, Woody became ill, and his doctors ordered him to stay away from the office for an extended time. He left Wally in charge. When Woody returned he saw that his business was prospering and in good hands. Woodner was so pleased that he told Wally—who had worked long hours, often six days a week, and who had never even asked for a raise—to write his own ticket, take half of the business, whatever. Wally declined, saying, "I want nothing, except I'm giving you one year's notice, and then I'm going into business in competition with you." Woodner never forgot what Wally had done on his behalf. He treated him like a son and ever after would praise him in front of others.

As always, Wally was good to his word. He began developing real estate in his own right. He started off with a bit of a bang, because so many people knew him from his time with Woodner. For several years all went well, and although we made several million, we saved every penny. Then a project fell flat. Wally had borrowed three million dollars from a bank to finance it. Other men would have wriggled out of the debt, but Wally took the money we had saved and paid it off. This made such an impression that the banks would do anything for him afterward. He became successful, and his integrity and honesty were, and still are, widely known and respected. Just let's say that Wallace Holladay is truly brilliant and very good at his job.

WHEN WALLY AND I WERE FIRST MARRIED, we lived in an apartment complex in Virginia, but with a child we thought it wise to acquire larger quarters. Being an architect, he wanted to design and build a house for us. The question was where. When asked what my favorite site would be I, being a city lover, suggested a penthouse on the roof of Garfinkel's, at that time the spiffiest department store downtown. Wally said he would try to come close. Finally, he announced that he had found land he wanted to build a house on—not quite downtown—and wanted to show it to me. We drove and we drove and we drove and finally, in what was certainly country to me, there was a hill covered with beautiful trees.

Building our first house in McLean, Virginia.

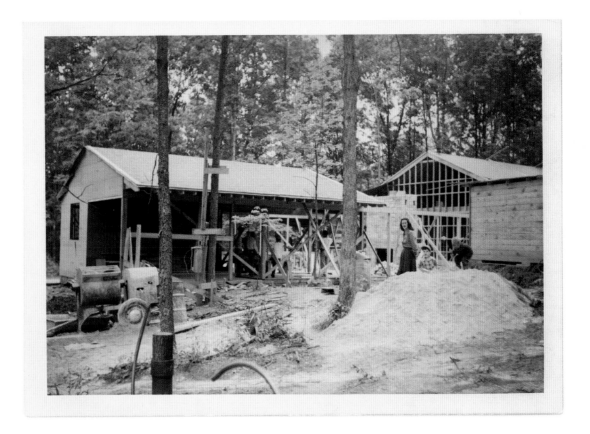

McLean, Virginia, was then truly rural. I very much wanted to please Wally, but I don't like the country and have a ghastly fear of snakes. We had become friends with a wonderful couple who were neighbors in the apartment complex, and they agreed to buy a part of the land and have Wally design a house for them too. We were godparents of each other's children, and having them near made the idea more appealing. Years later those dear friends, Samuel and Marjorie Maize, would encourage and support me in founding the Museum.

Living in the country brought odd experiences almost weekly. The adjacent property was owned by a black farmer named Mr. Boston, a man of great dignity. He was our watchman while the houses were being built. After we moved in, he made my little boy, who loved to explore, feel welcome and taught him many things about animals and life in the country. But one day our dog killed some of Mr. Boston's chickens. He came to me and said, "I cannot have the dog kill my chickens. They are my livelihood. Will you give me permission to teach the dog to stay home?" I said yes, and he told me, "The next time he comes over, I will shoo him home, and when he is on his way I will hit him in the backside with a BB gun. It won't really wound him, but he won't come over again. I'm an excellent shot." The very next day I heard the dog yelping and saw him racing for home with Mr. Boston in the distance. He never went after the chickens again.

Since it had worked so well, I said to Mr. Boston, "Your hound dog comes over

Samuel and Marjorie Maize were our closest neighbors and friends in McLean. Later, Marjorie became one of the first founding members of the Museum.

and wets on our bushes in front of our entrance. They turn yellow and die. Could we train him to stay at your place?" He readily agreed and said, "I'll bring you the BB gun, and the next time the dog lifts his leg on the landscaping out front you hit him with the BBs." I had done some skeet shooting with my grandfather, so the idea of the gun didn't bother me. A few days later his big hound approached my favorite plantings in front of our house. I was somewhat apprehensive, and it took me a while to find the gun. Finally, I went to the door, opened it, and gasped. There on the doorstep was the Episcopal minister coming to visit. He paled when he saw me with the gun. I was horrified and tried to explain by saying, "I was going to shoot the dog." He got a baffled and frightened look on his face. It was a most awkward moment.

Life in the country was not all bad, but I definitely wasn't suited to it. One day Wally and I were out, and when we returned the maid said she had seen a snake in the house. I left to stay in a hotel. Wally called a team of exterminators, who closed up the house, fumigated it for days, and sealed every possible crevice and cranny. Only then would I set foot in the house again.

We joined the Washington Golf and Country Club in Arlington, Virginia, and St. John's Episcopal Church in McLean. Years later the wonderful friends we made

in both these places helped and encouraged me in starting the Museum. My favorite golf partner was a woman named Virginia Tyree. One of her daughters, Mildred, who had a beautiful voice, was to make her opera debut in Barcelona, Spain. Marge Maize, Virginia, and I traveled there to attend her debut. Mildred was beautiful, and her long blonde hair was a hit, but she was frightened of her first moment in a starring role on a prominent stage. We kept her with us at the hotel, shampooed her hair, and reassured her. The performance received top reviews, and she went on to sing in Germany, where she enjoyed a long and outstanding career. When Mildred sang magnificently at the 1987 opening of NMWA, the Tyrees and Maizes, who were founding members of the Museum, were in attendance. It was a big moment for many reasons, but having old friends close made it especially meaningful to me.

HAPPY ENTERED A BRAND-NEW KINDERGARTEN, which was to become Langley School. Parents willingly helped run the school, which grew one grade at a time, because in 1952 the schools in Fairfax County were a disaster. So many people were moving in that classes were put on half time in order to handle the number of students. This was where I gained my first experience as a volunteer willing to take on responsibility. To make money for Langley, I initiated the first large school fair, which became a yearly community event. The result of this major involvement led me to join the board. I worked hard and became president of the board. It was in that role that I had my first chilling assignment: to tell a meeting of the parents that we were going to have to raise the tuition. I told them persuasively, it seems, because nobody walked out, but I was so nervous that when it was over I stepped into the ladies' room and became ill.

The next day I sought out Hester Beall Provensen, whose Capital Speaker's Club offered a speech course for the select women of Washington, mostly wives of members of Congress (like Lady Bird Johnson), federal officials, and ambassadors. She gave a wonderful course and was a hard taskmaster. She taught me lessons in public speaking that I've never forgotten: Be disciplined and focused. If you're nervous, pause, pretend you're wearing gloves, and slowly remove them. Use your hands for emphasis; don't clench them behind your back as if you're afraid. Body language speaks as loudly as words. Organize your thoughts into three parts: an introduction, a presentation, and a conclusion. Never, never go over your allotted time.

Having persuaded the Langley parents that we simply couldn't continue to educate the children for the pittance they were paying, I presented the idea that we had to have a new building. That meant launching an impressive fundraising effort, which took an enormous amount of work. But we reached our goal, thanks largely to the board I had behind me. It included Theodore Sorensen, who became

President Kennedy's speechwriter, and Joel W. Macy, Jr., who was head of the Civil Service Commission. That experience taught me that when your cause is right and you have a dedicated board, you can reach goals that seem impossible.

During those years, Wally was spending a great deal of time on business in the Midwest, and I was lonely when he was gone. We had good help, so I went down to the National Gallery of Art in search of a useful job. I took a test, passed it, and was hired—to work in the gift shop. That part-time position involved some surprising tasks. In those days the institution was much smaller and less compartmentalized than it is today. I led short tours of the exhibitions on weekends when the curators weren't there; I answered questions that visitors had, because the shop was the closest thing to an information desk. And, every night before leaving, I and others in the shop had to check every painting in the museum to make sure it was hanging in its place before the guards turned off the lights.

All in all, it was a fascinating experience, and an important one, because it enhanced my interest in art and certainly broadened the knowledge I had gained at college and later in Paris, where I studied art history. I learned more about European art from the Renaissance through the early twentieth century—just about the National Gallery's only holdings then. I began to develop a more discriminating eye and start to have some favorite painters. At about this time— during the 1950s—Wally and I would visit art exhibitions and galleries for the simple pleasure of it. We even began to buy a thing or two that we happened to like—for very modest sums. I still remember the first time I spent two hundred dollars—what now seems a pittance—on a work by an artist I admired. It was minor in the scheme of things, but it was an original print by Renoir. That was a small beginning and instructive, because it proved—or I proved to myself—that we could own quality art by important artists.

I went to Harry Lunn's gallery in Georgetown, which was a very forward-looking establishment since Harry saw photography as art long before it became widely regarded as such. This paid off years later, because Harry alerted me to photographs by important women, like Berenice Abbott's portraits of avant-garde pioneers and rebel figures, including Coco Chanel. Those were purchased much later and given to the Museum.

I was invited to become a board member of the Corcoran Gallery of Art. My experience at the Corcoran taught me an important lesson about the attributes of a good museum director. Peter Marzio was possibly the best museum director I have ever seen in action. His success lay in the variety of his talents—scholar and visionary, diplomat, fund-raiser, spokesman, financial watchdog, personnel manager, even handyman—and in his ability to handle any situation. If a curator was having trouble mounting a show, he was there to straighten the paintings; if a donor had ruffled feathers, he got on the phone with soothing words; if a light blew out, he was

Coco Chanel's simple and elegant design exemplifies women's independence and self-assurance.

BERENICE ABBOTT (1898–1991). *Coco Chanel,* c. 1927. Vintage silver print, 3 x 2¼ in. (7.6 x 5.7 cm).

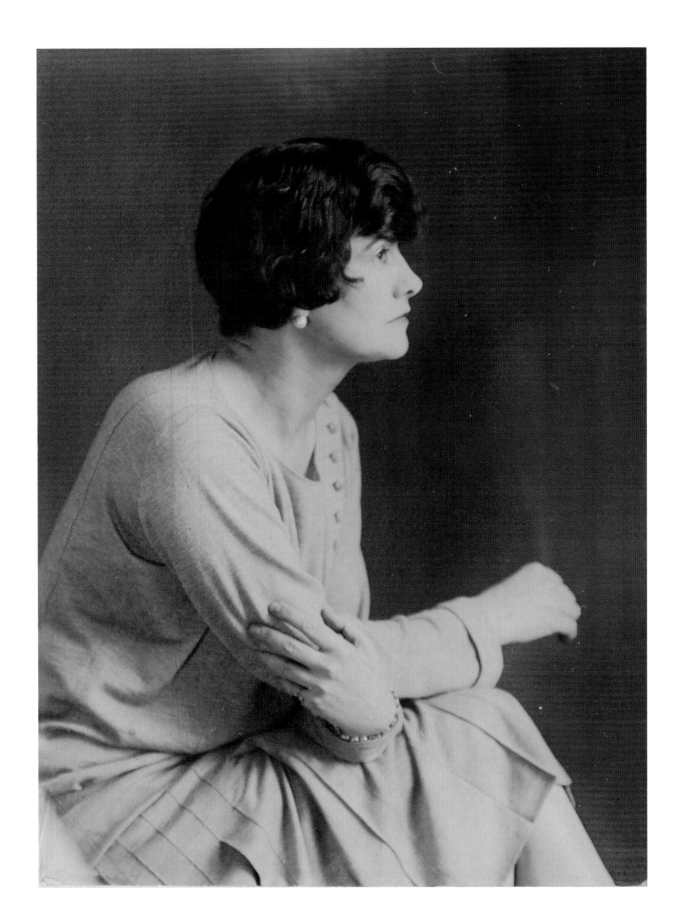

on the ladder with a new bulb. NMWA has had some very able directors, as have many Washington museums, but Peter was a man for all seasons. Lucky Texans hired him away, and he still reigns supreme at the Houston Museum of Art.

Dorothy Height was another highly gifted leader. I had the enriching experience of working with her at the YWCA, where I served on the local board and she was the guiding light as director of its national Center for Racial Justice. Dorothy led the effort in which the Y adopted the elimination of racism as its first imperative. While we as a nation have made some progress on that front, another perpetual goal of the YWCA was the empowerment of women, and it was here that I learned an especially tragic lesson.

One of the Washington Y's ongoing efforts was to identify girls from poor households who had special abilities and to give them a hand through mentoring and activities. The father of one of our little prodigies, we learned, got drunk and raped her. She was twelve years old when she realized she was pregnant! I took her to a distinguished obstetrician to terminate this beastly pregnancy—the fruit of the worst criminal act there is. The doctor was sympathetic, but said abortion itself was a crime at that time, and he just couldn't do it. He offered, instead, to see the child through her pregnancy pro bono. We accepted that as the best option in a tragic circumstance, given the antediluvian laws then in effect, and he was as good as his word. The child carried her baby to term, but because she was so young and her body not fully mature, she and the baby died during birth. I knew then, as I know now, that there are circumstances in which abortion is necessary and the most moral choice. Anyone who says otherwise is, in my eyes, evilly ignorant, and I will do whatever is in my power to oppose the reversal of *Roe v. Wade*. A member of Congress challenged me on one occasion, saying that "Choice" is immoral. I told him men can prevent the need for abortion if they feel so strongly. They can have a vasectomy or sleep only with their wives. Enough said.

Serving on one other board taught me a lesser but still important lesson that would help me in the years ahead. The American Field Service does important work by bringing young people from all over the world to the United States, where each child spends an academic year, lives with a local family, and learns about all things American. When I joined that board, one of the first orders of business was to deal with a chronic deficit. I looked at the financial statements and saw that AFS's capital, including endowment funds, were in ordinary savings accounts. In a time of inflation and high interest rates, I knew we could earn 9 percent on certificates of deposit. I, the newest member, boldly questioned the investments in low-earning accounts. We soon took appropriate steps to better handle the funds. I still recall my sudden realization that a nonprofit organization must invest its assets wisely and properly. This made me acutely aware of a basic aspect of true stewardship, which, of course, is important in one's private affairs, but crucial when one has responsibil-

ity for the security of a nonprofit institution. Good stewards should get the biggest bang for their buck for the organizations that they have the privilege to oversee.

Clearly, most of my working life has involved unpaid employment—the hard work of volunteering for good causes and leading nonprofit organizations in order to advance their worthy missions. In addition, I have had conventional jobs, and the one most worth remembering is my tenure as the director of the Interior Design Division at Wally's principal company, the Holladay Corporation. This position was most interesting and productive in the development facet of the enterprise, when Wally and his associates were building and marketing residential properties like houses, apartment houses, and condominiums. After the architectural plans were complete, my staff and I would commission a scale model of the building, then plan the interior design of a few model units for the sales force's demonstration purposes. When a property was in the luxury category, my work was straightforward and pleasant; I might furnish the place in a traditional mode as I would my own home, or in a contemporary fashion as the dwelling of a prosperous young couple with trendy tastes. Less expensive properties, especially those designed for low-income families, were interesting in another way. Then the challenge was to plan eye-catching, comfortable, tasteful interiors that could be created on a strict budget and explained by brokers to prospective buyers. In these instances, I chose items like the mass-produced "butterfly" chair, put a colorful canvas seat on it, and used that color to paint unfinished bookshelves and the like. The rule I discovered here was that one can always increase sales through aesthetics, and that good taste exists in many styles and has universal appeal.

It was a small step from using that article of faith in a commercial context to applying it in the world of the museum. It is clear to me that art—the aesthetic—has been treasured everywhere, in all eras, by persons of every sort (and both genders), and that the preservation and presentation of art is a universal good cause. It is why I have insisted from the beginning that everything the Museum undertakes must be done in the best possible way. People are aware of and appreciate quality and striving for perfection.

NMWA—What's in a Name?

Nancy Hanks, distinguished chair of the National Endowment for the Arts, was a relative of Alice Baber. Paul Jenkins, Baber's husband, donated this beautiful painting, thanks to Nancy.

ALICE BABER (1928–1982). *For a Book of Kings,* 1974. Oil on canvas, 77 x 58 in. (195.6 x 147.3 cm). Gift of the estate of Alice Baber.

F RANKLY, I CANNOT REMEMBER the moment that the specific, concrete idea of a museum came into being. An idea does not have a birthday; rather its development evolves, and in this instance it became a living concept that totally absorbed me. I can surely identify the idea's godmother: Nancy Hanks, a friend of mine who became a practical adviser.

Nancy had been the most distinguished chairman of the National Endowment for the Arts; she was a regent of the Smithsonian Institution and a Duke University trustee, and she earned many other honors. She visited our house and was intrigued with our reasons for becoming interested in women artists. At first she questioned my premise that women artists had been neglected and their work was not valued equally with that of men.

One day Nancy said, "You have certainly raised my interest. When I visit a museum now the first thing I ask is: 'What art do you have by women?'" She was astonished by the results of her informal survey and exclaimed, "Have you any idea how few women artists museums have, how rare it is that they have even one work of art?" (Nancy was related to the well-known artist Alice Baber, who had been married to Paul Jenkins and died in 1982. Later, Nancy would kindly arrange for the Museum to receive a beautiful oil, *For a Book of Kings,* from the artist's estate.)

Another person who helped us early on was Dr. Ann Sutherland Harris. She had made a great contribution by co-curating with Linda Nochlin an epochal exhibition, *Women Artists, 1550–1950,* which rocked the art scene when it opened at the Los Angeles County Museum of Art in 1976. (Though long out of print and hard to find, the show's catalogue is a gold mine of information. Early editions of Janson's *History of Art* were to male artists, the Old Masters in particular, as Harris and Nochlin's catalogue was to women artists, the Old Mistresses.)

Ann was a colleague who advised me about living women artists and introduced me to the contemporary art scene in New York. While I knew the realms of classical art, I was grateful for her knowledge. Without Ann, and Dick Baker, I could hardly have found my way in the women's art world of my own time. And while Ann was a crusader in the cause of women artists, and a devoted ally in our quest to build a museum for art by women, the idea to found a women's museum evolved out of the collection I built with Wally and out of my conversations with Nancy Hanks.

Alice Fordyce was a delightful woman and an early Museum supporter. She loved flowers and for many years would send a beautiful monthly bouquet to NMWA. Here she is collecting wildflowers in Machu Picchu, Peru.

I WAS ALSO HELPED BY ALICE FORDYCE, whom Wally and I met on another trip sponsored by the American Museum in Britain. She was a delightful, accomplished woman with many interests. Alice ran her sister Mary Lasker's famous Lasker Medical Foundation, which awards prestigious prizes in medicine.

About the time I was getting serious about establishing the Museum, Alice invited me to go to the Green House, a luxury weight-loss spa in Texas, with her and Mary. Mary and Alice had the spacious two-bedroom suite; the other guests stayed in beautifully decorated singles. Breakfast was served in one's room, and the rest of the meals were in the dining room, with the exception of Mary's suite, where dinner was privately served. She invited me to share the evening meal with her and Alice, a delightful treat. Mary knew famous people all over the world; presidents would take her calls. Thanks to her campaign, the American Medical Association instructed all doctors to take patients' blood pressure readings no matter the reason for their visits, a measure that saves two hundred thousand lives a year.

One night Alice said, "Tell Mary about the Museum." Mary became interested and said, "It is a worthwhile endeavor, but you must be incorporated," which would give us nonprofit status and allow us to receive gifts tax-free. She phoned and asked her lawyer, Bill Blair, to take care of that, and he and I made a date to meet when I got back to Washington.

I had to come up with a name quickly while drafting the incorporation papers. I called it plainly the National Museum of Women's Art, and so it was incorporated on November 24, 1981. The name troubled me from the start. As our first group of advisers discussed the Museum and its "program" in the largest sense, and as our vision expanded, we agreed that the original, straightforward name was wrong. It was limiting, misleading, and troublesome. Many people objected to the apparent implication that we presumed to be champions of "women's art," something that did not exist; art is art and belongs to the world. One can say only that women or men created it. Others thought the phrase implied needlework and watercolors.

My friendship with Alice Fordyce led to the first large gift we received after our incorporation. Two of her gentlemen friends frequently escorted her to events in New York. One evening she had them for cocktails and asked me to tell them

about the plans for a museum. Surprisingly, they offered to help and suggested we meet Jack Dreyfus, a prominent businessman with a beautiful office high up in the General Motors building overlooking Fifth Avenue. During lunch in his office suite, Jack responded warmly to plans for the Museum. He still loved his ex-wife, an artist whose work, he thought, had been unfairly ignored. When we were about to leave, he said, "Yesterday I received an unexpected sixty thousand dollars. It is yours for the Museum." He instructed his secretary to write the check. When I came back to Washington and told Wally about what had happened, he was incredulous. Shaking his head, he said, "I think you just may pull this whole thing off." After all these years I still get a fruitcake and card each Christmas from Jack.

Remember that the early 1980s followed an era when new values were being formed, framed, and tested by many Americans even as others championed old values with equal determination. In particular, feminism and the Women's Liberation Movement were on the rise. I hadn't joined the movement because I was busy and gave it little thought. I had a loving and supportive husband with whom I shared an active home and social life. I was busy as a wife, mother, and involved volunteer, sitting on several boards and serving as president of the trustees of my son's school. When I got around to considering the merits of the women's movement, I discovered that I shared many sympathies with the sisterhood. I have always thought it unfair that women could earn less than men for doing the same work, and I am vehement in believing that abortion should be legal.

The Women's Museum—as we often called it informally, and call it still—had become the cause that I would devote my life to. I had no intention of being distracted from that cause or allowing the Museum itself to be dragged into any political arena unnecessarily. On the contrary, I intended the Museum to welcome all comers, to be a uniting, cohesive, all-embracing organization, an umbrella for all in its eventual efforts to celebrate the artistic achievements of women in many fields: letters and music as well as the visual arts. "Women's lib" had become a distinctly political issue by the time I was deeply involved in developing the Museum; consequently, it was divisive at a time when I was determined to establish an institution that would be uniting. In short, I had no intention of letting politics entangle the young Museum and perhaps strangle it at birth.

At first we thought exclusively in terms of a museum of art, but as the idea grew we saw that it could and should have a broader view. Why not embrace forms of creativity beyond the visual arts? We wrestled with various names in an effort to reflect that the Museum was broader than any fad and more progressive than a genteel acceptance of the status quo. A better name appeared quite spontaneously and naturally, just as the Museum's mission eventually would develop and grow in directions we had not anticipated. Informally, we began using the name National Museum of Women in the Arts; as a dividend its acronym, NMWA, was easy to say

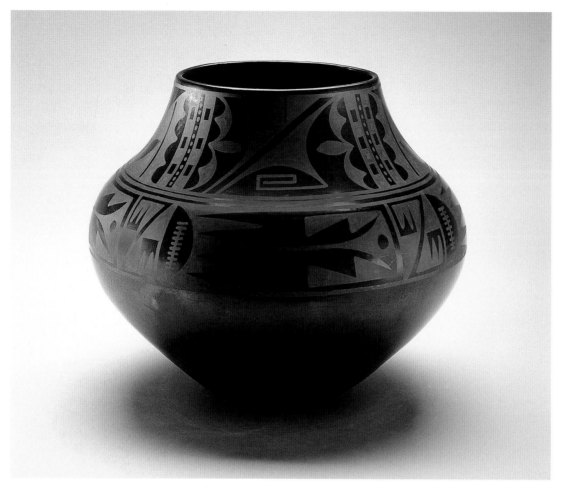

Maria Montoya Martinez revived the art of black pottery.

MARIA MONTOYA MARTINEZ (1887–1980). *Jar,* c. 1939. Blackware, 11⅛ x 13 in. diameter (28.3 x 33 cm diameter)

("nim-wah") despite its awkward-looking initials (which, fortunately, were the same as the original's). That name would be made official in amended articles of incorporation on July 3, 1985.

"National Museum of Women in the Arts" said it all, or almost all. We could be a museum of many arts. The use of the plural was important; while we would show the works of visual artists from the Renaissance to the present, we would embrace other forms of women's creativity as well. That led us to launching a music series that has become an outstanding success under the brilliant co-leadership of Linda Hohenfeld Slatkin, wife of maestro Leonard Slatkin, and Gilan Corn. In time we would celebrate remarkable women potters. We would show the work of Margaret Tafoya, the matriarch of the Santa Clara Pueblo potters; Maria Montoya Martinez, of the San Ildefonso Pueblo, who revived the art of hand-building black pottery; and Lucy Lewis, the great potter of the Acoma Pueblo. We would hold an exhibition of textile artists, from the lace makers of the Low Countries to the rug makers of Persia. We would honor artists who work in metal, including eighteenth-century English silversmiths, and visual artists whose works employ rocks, sand, and tree bark, as in our 2006 exhibition of aboriginal painters from Australia. NMWA

Alice Bailly, the Swiss Cubist painter whose Self-Portrait *can be seen at NMWA, is little known by American museum-goers.*

ALICE BAILLY, (1872–1938). *Self-Portrait,* 1917. Oil on canvas, 32 x 23½ in. (81.3 x 59.7 cm).

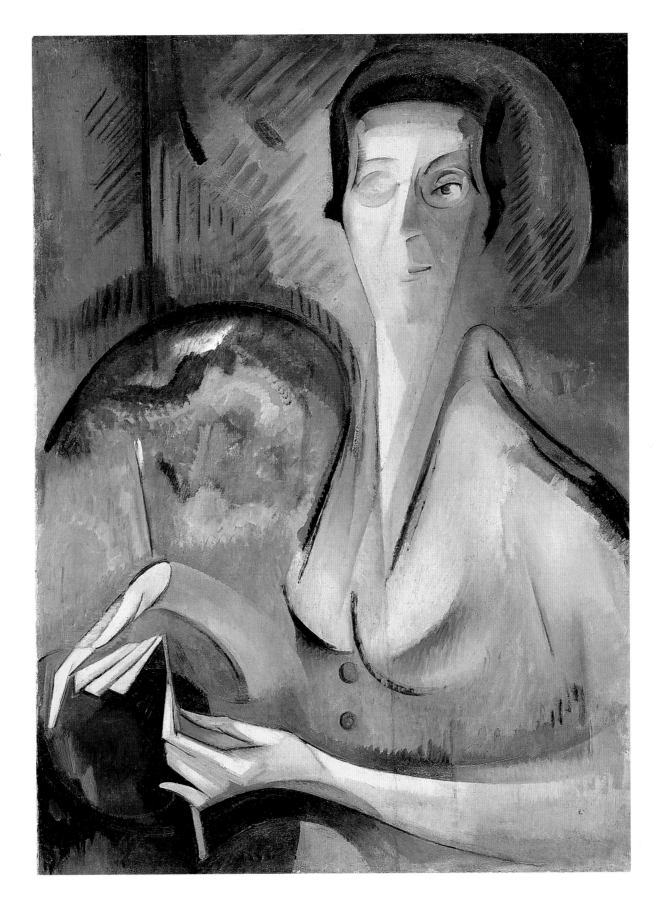

Julie Taymor: Playing with Fire, *a 2000-2001 exhibition of theatrical design, was the most popular show in the Museum's twenty-year history. Here is a scene from* The Lion King.

One of the artists neglected by art historians is the great Bolivian sculptor Marina Nuñez del Prado, whose Mother and Child *is in NMWA's collection.*

MARINA NUÑEZ DEL PRADO (1912–1995). *Mother and Child,* 1967. White onyx, 16¾ x 13¼ x 10 in. (42.5 x 33.7 x 25.4 cm). Gift of Mr. and Mrs. Kenneth G. Clare.

is the only museum that since its inception has collected and exhibited artists' books. We would champion the great theatrical and film design of Julie Taymor, and the music of the avant-garde composer Ellen Taaffe Zwilich.

Detailed goals aside, the mission statement defined our general purpose as follows: "The National Museum of Women in the Arts brings recognition to the achievements of women artists of all periods and nationalities by exhibiting, preserving, acquiring, and researching art by women and by teaching the public about their accomplishments. To fulfill its mission, the museum cares for and displays a permanent collection, presents special exhibitions, conducts education programs, maintains a Library and Research Center, publishes a quarterly magazine and books on women artists, and supports a network of state and international committees. NMWA also serves as a center for the performing and literary arts and other creative disciplines." It was specific enough to describe our mission and broad enough to allow room for growth.

THE PROPOSAL FOR A MUSEUM devoted to the best works by artists who are women was an idea of huge importance and perfect timeliness. Wally and I built our personal collection on the premise that great artworks by women artists deserve recognition. In so doing we set out to correct the error that had been made collectively by the arts establishment for generations. As we explored the ramifications of that simple discovery, we discussed the problems of established art history with more expert people. Together we generated ideas that stimulated small events—our purchase in Paris of Lavinia Fontana's *Portrait of a Noblewoman* and the gathering of guests to see our pictures in Washington—events that snowballed into the decision to found a museum.

Of course, we were not living in a vacuum. The importance of our idea was highlighted by the times, and it is certainly possible that if we hadn't hit on the plan to establish a museum for women artists, someone else would have, just as political historians theorize that if Thomas Jefferson hadn't stepped forward to frame ideals for our new nation, someone else would have taken that role.

While I had absolute faith in the museum we conceived, I was still bowled over by the initial response to it. A very perceptive journalist, and a gracious and ebullient Southern lady, Sarah Booth Conroy covered the arts and cultural news for *The Washington Post*. I will always be in her debt for seeing the promise of our idea, then adding perspective through good old-fashioned reporting. She wrote the first big article, which appeared on November 4, 1982, and began: "A museum devoted to art by women—probably the only one in the world, according to the American Association of Museums—is expected to open in Washington in the next three or four years . . ."

Conroy went on to report that we had already received pledges of $1.5 million; that we had chosen a building, and that it would be called the "National Museum of Women's Art" as indeed we then intended. She quoted me as saying, "Women's art is a gap to be filled in the history of art," and then described Wally's and my encounter with the overlooked genius of Clara Peeters in the august museums of Vienna and Madrid eighteen years earlier. My next quote voiced what some readers took as a fact and others as a challenge, "It's not that we want to compare [women artists] with men, or say they are lesser or greater, but that they are. They exist."

We were thrilled to see the article get prime play in the *Post*, but we were not prepared for what happened next. The *Post's* wire service piped its articles to papers throughout the country. Within a week, it seemed that most of its client newspapers picked up Conroy's article—and ran with it. Her report got banner headlines in newspapers from one side of the continent to the other. Our idea struck a chord—or a nerve.

The response from readers was electric. Within the month I received letters from virtually every state in the union, letters of inquiry from young women wanting to work for us, letters with contributions enclosed, letters offering art or information, and letters of good cheer that said, more or less, "You go, girl!"

The responses were not all positive (and I would become concerned by some of the opposition we faced and surprised by the occasional vehemence we encountered). There were some conservatives who thought we were simply off base, that art history could not have overlooked an entire class of gifted and important artists. There were others who thought that founding a museum for art by women was foolhardy, that supporting one would create a ghetto. There were dedicated feminists who thought our intention to found a museum to celebrate art by gifted women was somehow a betrayal of feminism. Then there were those who simply muttered the common sense that there was no such thing as women's art, then made the leap in illogic that there was no good purpose in focusing on the undiscovered or forgotten work of artists who happened to be women.

WHAT PERPLEXED ME MOST was how some people opposed the NMWA idea before they even knew what it was in any detail—cultural titans and hoi polloi alike. One of the former was J. Carter Brown, a real powerhouse in Washington as longtime director of the National Gallery of Art and chairman of the Fine Arts Commission.

I wanted to sound out Carter, because, given his eminence, he could be very, very helpful to us. One of our incorporators, a board member, and a very early backer, Roma Crocker traveled in rarefied social circles (among other things riding to the hounds with Paul Mellon, whose father had founded the National Gallery of Art and who himself was then president of the Gallery and its most generous benefactor). I asked Roma to arrange a meeting with Carter, but in so doing she made the big mistake of telling him what we wanted to discuss.

All smiles and charm, Carter welcomed us to his ceremonial office, with a magnificent view of the Capitol. Before we had a chance to tell him our plans, he enunciated his judgment of what would be wrong with a museum for art by women. Roma and I sat there, and he held the floor. It would be a ghetto, he warned. There was little hope of raising enough money for such a venture, he said sympathetically. In essence, he said, "Billie, I want you to give me your collection—donate it to the National Gallery of Art—and we will introduce women into the mainstream."

While he had been pontificating, one idea after another piled up, and I just let them all out. I said, "I know you are not sympathetic to the idea that fine art by women has been neglected. If you were, you would have more women on your staff and board. You barely have any art by women in the museum's collection. You have held only four exhibitions of work by women in your whole history. Don't tell me you're going to do something for women artists!" And I walked out!

A week or so later we received an engraved invitation to a black-tie dinner at the Gallery, one of the elegant events at which new exhibitions are unveiled. In spite of what had happened, Wally and I accepted. I could not wait to see what Carter would do. The moment we arrived, a Gallery officer presented himself and offered to show us the exhibition. When dinner was announced Carter asked if he might escort me in; I was seated next to him. Charming as ever, he apologized for presuming that I would consider just giving our collection to the Gallery, and offered rather lamely, "You never gave me a chance to say what was on my mind."

"What did you expect me to do?" I asked.

"Well I didn't expect you to walk out," he answered.

Then I said: "Carter, I don't believe you understand the enormity of the problem—the huge omission that art historians and critics have created and perpetuated for generations. By accident or intent, they have excluded women from the canon of Western art." Then I turned to the table at large—besides us, there were eight sophisticated and learned people with proven interests in art. I called for their attention and asked, "Can anyone tell us, who was Rachel Ruysch?" None of them could answer.

RACHEL RUYSCH (1664–1750). *Roses, Convolvulus, Poppies, and Other Flowers in an Urn on a Stone Ledge,* c. 1745. Oil on canvas, 42½ x 33 in. (108 x 84 cm).

This was a variation of what became my stand-up question to audiences small and large: "Who can name five women artists from the Renaissance onward?" That always stumped people. Someone would name Mary Cassatt and perhaps Georgia O'Keeffe. Then Berthe Morisot or Grandma Moses might be added. Had people not learned a canon that omitted women, had not this huge void violated the notion

This print by Mary Cassatt portrays a timeless scene of a mother bathing a child. Even though the mother seems to be preoccupied with her thoughts, she makes sure that the water temperature in the tub is right.

MARY CASSATT (1844–1926). *The Bath*, 1891. Soft-ground etching with aquatint and drypoint on paper, 12⅜ x 9⅝ in. (31.4 x 24.4 cm).

of our comprehensive appreciation of human creativity—well, then, there would not have been a need for our Museum.

After the banquet, Carter and I parted on cordial terms, of course. He really was a gentleman. He never recanted and never acknowledged the chronic neglect of women artists by established museums. He expressed his opinions most clearly in a letter to his ex-wife, Constance Mellon, a friend of mine. A member of the extended Mellon clan, Connie was very interested in the idea of a museum of art by women from the start. I had told her about the ill-fated meeting, and she in turn called Carter and complained about his actions. She forwarded his response to me.

Dear Connie,

I wish Billie well in her undertaking. I think you know me well enough to know that I have never wanted to rain on somebody else's parade. I was only too happy when you got the RKM [Richard King Mellon] Foundation to help the Corcoran, and I have shown a keen interest in the new Capital Children's Museum, encouraging the Cafritz Foundation to help it out, and done a variety of kindness for the National Portrait Gallery . . . the National Museum of American Art . . . the Hirshhorn, the Phillips, the Textile Museum, the New National Museum of the Building Arts, Octagon House, and the various properties of the National Trust. The more, the merrier, has always been my theory.

I have to confess, at the same time, that I am somewhat saddened by all that energy, goodwill, and fundraising skill going to an idea with which I am philosophically uncomfortable. I spend so much of my time trying to keep the arts pure, and safe from politicalization. Art has so much to give on its own terms, and so much of its force depends on it being the one branch of activity that can be justified on its own terms, and not as a means towards some other end. Socialist realism in the Soviet Union, or Hitler's idea of art serving the state, are good examples of what happens when that great ideal is lost sight of.

I am intrigued that the women professionals on our Gallery staff, and people at the trustee levels such as Ruth Carter Johnson of Fort Worth, or Katharine Graham on one of our committees, all feel so strongly opposed to the idea of a museum of women's art. As I have tried to explain to Billie, my own view is that it demeans women as artists. By patronizing them, and giving them their own ghetto, it takes their contribution away from the mainstream, to which it was presumably directed in the first place.

There is plenty of space for museums devoted to other subjects than art. I have supported the establishment of a museum of the Holocaust here in Washington. A museum on the contributions of women in all fields could perhaps help raise the people's consciousness of a very lively current topic. But to single out art as created by any group, minority or majority, ethnic or sociological, goes against my personal and professional grain.

Hubert de Givenchy escorted Bunny Mellon to our first gala, in 1983.

In spite of all this, I can't help liking both the Holladays enormously. They have been helpful to the Gallery, I hope they will in the future, and they represent so much of what is best about our country . . .

Carter Brown could always be counted on to be persuasive and to argue with elegance. Intuitively or unconsciously, he understood that the need for a women's museum reflected poorly on himself and every other museum director at the time. He took umbrage.

But times would change—and they did when we held our first gala in 1983. I wracked my brain thinking about the event and planning it. Knowing how important it is to have a distinguished honorary chairman at a major Washington charity occasion, and knowing just what the right name on the invitation could do for the response, I aimed as high as I dared. I sent a handwritten note to Paul Mellon's wife, Bunny, explaining our mission and asking whether she would honor us—honor the Museum, really—with her support.

Mrs. Paul Mellon was a queen in Washington society. When her husband began taking an interest in the National Gallery, she was more than a helpmate, she was a guiding light. In particular she turned the Gallery's previously lackluster exhibition openings into stellar banquets with magical touches; for a dinner to mark the opening of an Alexander Calder retrospective, she used the maquettes of his mobiles as table centerpieces. Famously, when a junior senator from Massachusetts married and brought his shy bride to Washington, it was Bunny who took her in hand and taught Jacqueline Kennedy how to become a chic hostess and fashion plate.

When I wrote to Bunny Mellon, lightning struck in one of those sublime coincidences that make me believe in fate. She called me a day or two later and began the conversation with her famously girlish salutation and laugh, "Billie, Billie, we have the same stationery!" We chatted about shopping at Tiffany's and such. Then I explained more about the Museum, and something I said must have caught her fancy, because she interjected, "Well, I'll do it—if we can have white linen tablecloths." I said, "Of course."

So NMWA's first gala was held on February 22, 1983, in the newly rededicated Andrew W. Mellon Departmental Auditorium on Constitution Avenue, a glorious room with stately columns. The celebration included an exhibition of thirty years of Hubert de Givenchy's fashion designs. Givenchy, who escorted Bunny Mellon to the gala, was after all Grace Kelly's, Jackie Kennedy's and Audrey Hepburn's favorite designer, and Bunny's too. I was dressed in one of his elegant gowns, and the couturier was visibly pleased. It was a roaring success.

Years later, when the queen of Norway came to visit and a large reception was held at NMWA, Carter attended and in an aside to me, said, "You are on a roll."

From the Temple of the Masons
to the Temple of Women Artists

FROM THE BEGINNING, we dreamed that NMWA would be a real museum with a proper home. While we hadn't come to grips with the necessity of purchasing, renovating, and installing artwork in a building, the need was there. An experience with a new neighbor brought it to a head.

In 1970 we moved from McLean, Virginia, to a house in Georgetown. A young woman who had come to study at Georgetown University moved into the house next door to ours on R Street N.W. Claire, who turned out to be an attractive girl; her fiancé, a former member of the Peace Corps; a darling three-year-old boy; and their Great Dane brought to our quiet street a lively household. A couple of days after they moved in, the dog left its calling card on our driveway. Wally, on his way to work, inevitably stepped in the wrong place. Infuriated, he paused to think of a fitting response to neighbors we had not yet met. He fetched a garden spade from the garage, shoveled up the mess, placed it on the doorstep next door, and went about his business, saying nothing to me or them. That evening the doorbell rang, and there on the threshold stood two sweet young things, almost in tears. "We're so sorry," Claire blurted out. "We just want to be good neighbors. We just want to be good neighbors." They introduced themselves and, not knowing what had happened, I said, "That's nice. I'm sure you are good neighbors," and asked them to come in. They declined, and I wished them well. When Wally told me what he had done, I was dismayed, but I had to laugh because it was so like him to have said nothing about it to anyone.

We hardly met again until one day Claire came running from next door and rang my doorbell, clearly in a state of panic. Her little son had fallen down, cut his head, and needed a doctor, but Claire didn't yet have a pediatrician. Could I suggest one? Of course, I said. I called the wonderful doctor who took care of my grandchil-

In 1970 we moved from McLean to a house in Georgetown.

dren, Beale Ong, and advised that Claire and her son would be arriving in minutes. The child's injury proved not to be serious, but it was the beginning of a friendship.

As I was driving out one day, she stopped me and said, "What are you doing, neighbor? You come and go so often." I told her briefly about the Museum. She said she was interested, so I invited her to come for a meeting of a young committee that we had formed to talk with the foreign embassies and to find out more about women artists in other countries. Claire attended, became excited, and declared, "A building is needed." I replied, "Some day, my dear."

When she had to leave early to attend a class, I saw her to the door. She said, "I want to help, I really want to help," and so I invited her to be on the committee. When I rejoined the group one of the members said, "Is that Claire *Getty?* As in J. Paul?" It had never occurred to me. I realized then that my new neighbor had a more serious interest in art and more substantial resources than most young students at Georgetown. Her grandfather, J. Paul Getty, had given a fortune to establish a great museum in Los Angeles. After a talk with her financial adviser she pledged one million dollars to start our building fund, and she persuaded her sister, Caroline, to pledge another million.

As a move to proper quarters became more imperative and more likely, we searched for sites all over Washington. I remember touring a loft building with a lovely facade near the National Portrait Gallery; it had probably served a grand cause in the early nineteenth century, but it was now a shell. In a better part of town, gracious and expensive Embassy Row, I was shown a down-at-the-heel townhouse complete with ballroom and scuffed parquet floor. This was where Alice Roosevelt Longworth, President Theodore Roosevelt's daughter and the wife of a Speaker of the House of Representatives, had held court as the sharp-tongued and quotable doyenne of Washington society for most of the twentieth century. There were other buildings as well, and we tried dealing with the owners with no success.

Both Michael Ainslie, head of the National Trust for Historic Preservation, and a broker friend of Wally's suggested we look at the old Masonic temple.

The building was a landmark located in a squalid part of downtown that had fallen so far it had to be on its way up again. It was about a block away from both of the city's long-distance bus depots, and the surrounding blocks were occupied by empty storefronts, rough bars, a sex shop, a low-end movie house, and vacant buildings frequented by drug addicts and drunks. It was in a slum, but this unique structure stood proudly above one of the dingiest blocks in the once-genteel commercial district.

The edifice was the proverbial white elephant: handsome, commodious, and historic but nearly destroyed by neglect and abuse. Its underlying merits were virtually invisible when we went to take a look. We had to wade through the homeless to go in, but Wally insisted that this hulk had possibilities. I had to agree, despite my anxieties the very first time I looked around the place. I set foot inside quite timo-

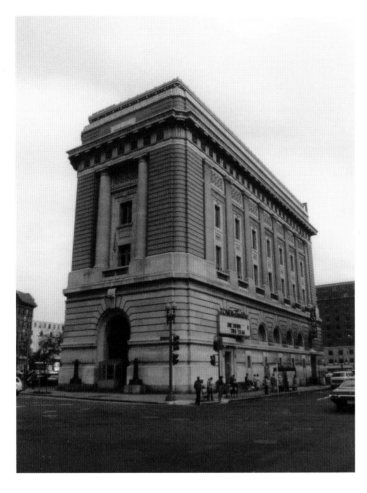

rously, startled by rats as big as cats, sickened by the smells, and discomfited by unmistakable signs of recent habitation by those seeking a place to get out of the cold. "Take me out of here," I wanted to scream as we found our way through the wreck of a building, itemizing its hidden assets.

Six stories tall with a full, high-ceilinged basement, it had almost a flatiron footprint, a truncated triangle actually. Its short side, the west front, overlooked a spacious intersection of three streets; this ceremonial entrance faced the classic Georgian facade of the New York Avenue First Presbyterian Church, two blocks away was the Department of the Treasury, and just beyond that was the White House itself. Its high ceilings and large open spaces were designed to be impressive and could become art galleries, if one could imagine them without the grime, graffiti, and garbage. With its tiny windows, the whole building had a substantial feel, almost like a fortress.

Constructed in 1907, it was built to the highest standards of solidity, with thick masonry walls that were absolutely fireproof. Its antique construction and

ABOVE: *The Museum building, when I first set eyes on it, was the proverbial white elephant. The structure, a former Masonic temple, stood proudly above one of the dingiest blocks in the once-genteel commercial district, now a slum. It had a substantial feel about it, almost like a fortress.*

RIGHT: *The building's high ceilings and large open spaces were designed to be impressive and could become art galleries, if one could imagine them without the grime, graffiti, and garbage.*

those tall walls were among the reasons that we could even hope to buy this ideally situated building, as Wally explained. It was too expensive to tear down, and it was on the verge of being declared untouchable as a historic landmark, which is why Michael knew about it. Because of its massive construction it would be impossible to renovate into a modern office building that could be operated profitably or even economically by a corporate owner. And here it was, a relic within blocks of both the most famous address in the world and Washington's then convention center, the keystone of Mayor Marion Barry's plan to revitalize the city's old downtown.

This was the National Masonic Temple, headquarters of the ceremonial fraternity to which George Washington belonged, along with most of the other Founding Fathers. It was the bastion of a male secret society—an ironic venue for an organization dedicated to becoming the champion of art by women and about women!

At the time of its opening in 1907 the builders themselves had described it as follows:

> Washington being the nation's capital, the Masonic temple located there ought to be of great dignity and simplicity and entirely in keeping with the classic public buildings for which Washington is well known. The architects have had these facts in mind and have designed a building, which, by its classic proportions, is unmistakably a temple, but so modified as to suit the changed conditions of our time and age. . . . The classic style of architecture which has been employed in this building is the most enduring of all styles and surely the one style in which the Temple of the Ancients reached its greatest beauty and highest development.

The building was the work of Waddy B. Wood, the architect of choice for both Washington's gentry and its government managers around the turn of the twentieth century. A Virginian, Wood came to Washington as a draftsman and haunted the Library of Congress, poring over architectural books and drawings to learn his craft. In time he became principal of a major firm whose oeuvre varied in style but was almost uniformly impressive. It included the residence that is now the Textile Museum, the house Woodrow Wilson would occupy after his presidency, and the enormous Interior Department headquarters on Virginia Avenue.

He designed the Masonic Temple at the height of his career. Like much of his work, it was an architectural hybrid, impressively neoclassical and endearingly classic. The building rises 110 feet from the sidewalk—about ten stories by today's standards—with an auditorium on the first floor and the upper floors outfitted with large, gallery-like rooms dedicated to the diverse needs of a traditional fraternal order. Its classic facades enclosed seventy thousand square feet of space, ample room for museum galleries, offices, and all the associated facilities.

The asking price was five million dollars. We were able to raise that amount, and in December 1985 we put together a financial plan that enabled a limited part-

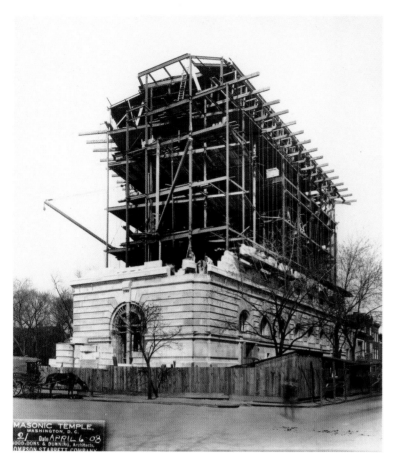

nership to purchase the property for the Museum. When news got around, all the nearby property values went up, and the building was appraised for twelve million dollars! Thus we were able to borrow eight million dollars for renovation.

Given the fact that the National Trust had its eye on the building, and a local preservation organization called "Don't Tear It Down" was raising hell over almost every building erected before I was born, we did not want to risk delaying renovation work. Wally engaged Clark Construction Group as our primary contractor, and engineers quickly applied for an exploratory construction permit. This allowed us to remove many elements of the building's interior: the ground-floor theater with its sloping floor, part of the mezzanine, which would be extended, and various other impediments.

A distinguished architectural firm, Keyes Condon Florance Architects, developed an excellent renovation plan, which we worked hard to refine. For one thing, the original plan called

ABOVE: *Designed in 1907 by Waddy B. Wood, the architect for both Washington's gentry and its government managers, the National Masonic Temple was built to the highest standards of solidity, with thick masonry walls that were absolutely fireproof.*

RIGHT: *Transformation of the Masonic temple into the National Museum of Women in the Arts began in 1985. Here is a photo documenting renovation of what would become the Great Hall.*

for the principal entrance to be the door at the short west end of the building. But given that the frontage on Thirteenth Street is barely fifty feet long, entering and leaving taxis and limousines would be difficult if not hazardous, and so the main entrance was moved to the long frontage on New York Avenue. Turning to the interior, Wally widened the architects' plan for the stairs from the ground floor to the mezzanine and made sure that all the museum-related requirements were met. He was assisted by a highly respected museum consultant, Dr. David Scott, formerly director of the National Collection of Fine Arts (now the Smithsonian Museum of American Art).

Now, let me backtrack a moment to one of my most fortuitous meetings, which occurred at the Washington Antiques Show in 1984. A friend introduced me to a very attractive young woman, an interior designer named Carol Lascaris. We had a brief conversation and went our ways, but now, all these years later, Carol still says she was captivated by the vision for the Museum, which she imagined in the course of our four-minute conversation.

What struck her was the central fact I was repeating again and again to anyone who had an interest in art, to anyone who would listen. Great women artists had been ignored, or forgotten, or somehow denied; they'd been left out of art history books. In college Carol had majored in fine arts and interior design, with a minor in art history, and so my litany struck her. Her generation of art history students never learned about women who were artists, from the Renaissance onward. Some of these belonged to the first rank, but they were nameless. Their works were either attributed to their teachers and contemporaries or else forgotten. I named names she had never heard, such as Sonia Delaunay and Elaine de Kooning, and she left the Antiques Show with a new mission in mind.

Carol and her husband, Climis, visited the house to see the collection, and we became friends through our mutual interest in art. Climis and Carol had a large interior design firm that did palaces in the Middle East. He had a special interest in stone interiors—his family owned a marble quarry in Turkey—and so we invited them along to see the Masonic Temple building, when it was still a wreck. Both Climis and Carol were intrigued and offered to help, because by then they were both excited about the idea of the Women's Museum.

The building's ground floor was absolutely essential to my plan for NMWA. As Carol remembers, my thinking ran along these lines: Washington runs on politics, of course, and it is fueled by parties, in both senses of the word—political groups

TOP: *Wallace Holladay, Museum Director Anne Radice, and contractors discuss architectural blueprints for the future home of NMWA.*

ABOVE: *Carol Lascaris designed the interior of the Museum.*

Carol Lascaris learned in her art history classes about Robert Delaunay and Willem de Kooning, but she hadn't heard about their equally talented wives, Elaine de Kooning and Sonia Delaunay.

RIGHT: ELAINE FRIED DE KOONING (1918–1989). *Bacchus #3,* 1978. Acrylic and charcoal on canvas, 78 x 50 in. (198.1 x 127 cm).

PAGE 66: SONIA TERK DELAUNAY (1885–1979). *Study for Portugal,* c. 1937. Gouache on paper, 14¼ x 37 in. (36.2 x 94 cm). Courtesy of Elaine de Kooning Studio.

and social events. Dinners, banquets, buffets, and balls are held as partisan gatherings and as benefits for nonprofits ranging from the animal welfare groups to the National Symphony Orchestra. Washington never had sufficient venues in which to hold such gatherings; gracious, elegant, or simply spacious dining accommodations for several hundred people were few. Looking around the ugly shell of the Masonic Hall, I imagined the space devoted to a well-designed, spacious ballroom, a place for the top charities in the city to entertain their friends and A-list donors. Having served on many nonprofit boards, I knew that such a space would serve several purposes. For one, I knew how much cause-related organizations would pay for the right place to throw a party; renting out NMWA's Great Hall would create a handsome revenue stream, a must for any nonprofit institution in the making. But my plan had more to it than that. I imagined building a caterer's kitchen where fresh food could be prepared. The kitchen would be commodious, well-equipped, and easy to maintain. It was realized and proved to be a major asset in our rental practices once the museum opened its doors.

I knew that our biggest challenge—next to becoming solvent—was to introduce the work of major women artists to Washington's power people, to make them aware of the great void in the history of art, to create a buzz. We hoped to educate movers and shakers, as well as people all across the country. A beautiful party room could do both! We would provide more than just a space for an event. We would open some of the art galleries to guests and offer docents to answer questions and thus expose Washington's elite to the works of great women artists.

When I discussed these interlocking ideas with Wally and the Lascarises, Climis couldn't contain himself. If we were going to have a Great Hall, it must have marble

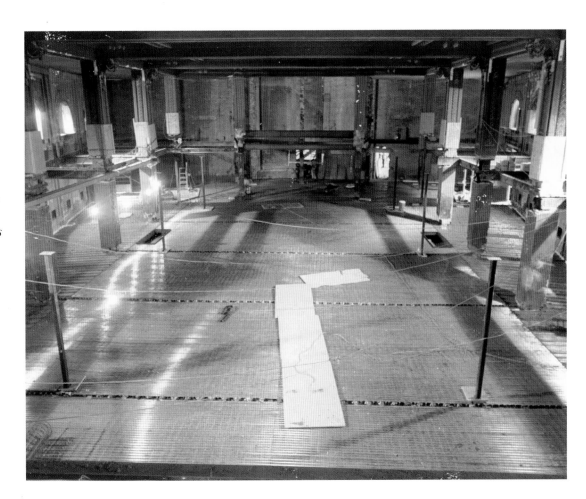

RIGHT: *The building's ground floor was for many years a movie theater. This space was essential to my plan for NMWA's Great Hall—a spacious ballroom for the top charities in the city to entertain their friends and donors, bringing the Museum a handsome revenue from rentals.*

BELOW: *Climis Lascaris donated marble from his family quarry in Turkey for the ornate floors of the Great Hall.*

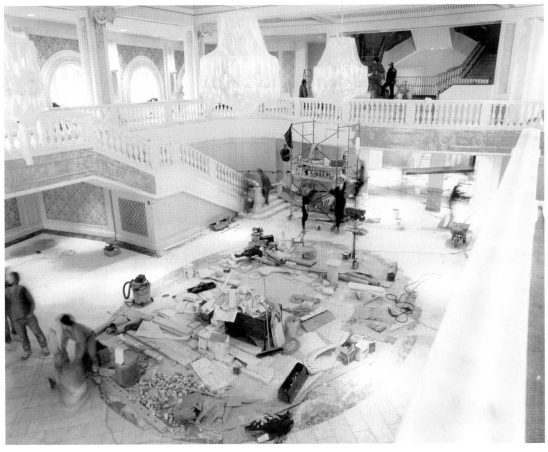

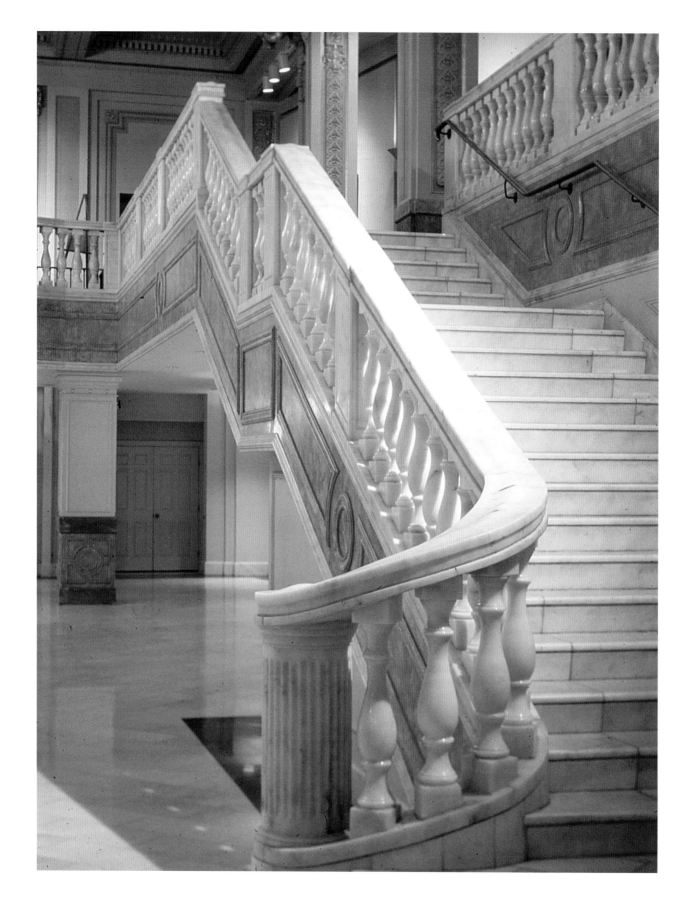

OPPOSITE: *Carol Lascaris and her team designed the marble floor, and she also conceived the broad staircases with sweeping balustrades.*

RIGHT: *This is, in my opinion, the most beautiful room in Washington, the Great Hall of NMWA. And we made it from scratch!* Photo by Robert Isacson.

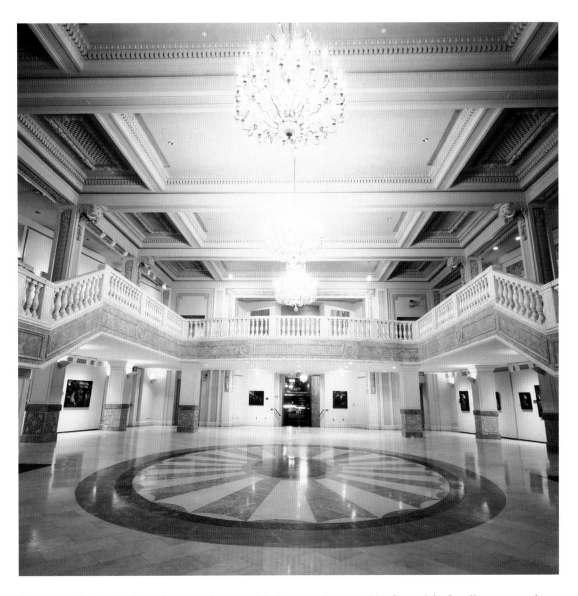

floors, and that being the case he would donate the marble from his family quarry in Turkey. When skilled marble setters couldn't be found anywhere in the neighborhood, Climis contacted his quarry managers, then applied to the State Department and got work visas for fourteen Turkish craftsmen. The decorative plaster inset panels on the columns and windows were poured from molds made from the antique originals.

But then we hit a snag. Though I had explained my idea to the architects, they couldn't seem to get their arms around it. Keyes Condon Florance seemed devoted to a modern, utilitarian atrium that might be imposing—another power room in Washington—but not an enclosure that could serve as an elegant ballroom, a spacious place for a fancy wedding, a beautiful room for a gracious luncheon, a room where Cinderella might dance until midnight.

But Carol got the idea. After Climis volunteered to provide the marble, Carol worked on an aesthetic plan for the room. When we had listed most of the

elements—which included practical considerations such as identifying the load-bearing columns—she worked up a color scheme. It began as pink and gray, then was refined to a hue called terra-cotta rose and an off-white color called "Afean sugar," plus black and gray. Then she had one of her design-team artists paint an architectural rendering that not only showed the specifics of colors, the broad stair-case, and the sweeping balustrade, but also implied the elegant feeling of the room.

This is how we went about creating the most beautiful room in Washington for special events, our Great Hall. One measure of its success is the award for historic preservation from the American Institute of Architects that Carol and Climis still display with pride in the foyer of their offices. What pleases Carol especially is that most people think the Great Hall is a relic of the original building, a space that we simply had to scrub and polish in order to restore to its early-twentieth-century grandeur and graciousness. Not at all: While we saved what we could of the original, most of the Great Hall was made from scratch!

When Carol showed me the rendering, I was amazed to see my vision actually illustrated in gentle watercolors on paper. It was then that I knew we were on our way. I can hardly give Carol and Climis enough credit for all they have done. The Lascarises have been in the first tier of friends of NMWA and have performed countless tasks. Carol was president of the museum for six years and is a very active president emerita and co-chair (with Climis) of our endowment drive, which has exceeded its goal in celebration of our twentieth anniversary.

<hr/>

I WON'T BOTHER TO DESCRIBE ALL THE MACHINATIONS we had to go through to arrange the financing and obtain the permits and approvals to secure the building for our practical use. Suffice it to say that at one point we received a bill from the city of Washington for $42,677.13 for rental fees on underground vaults that extended beneath the public sidewalk from our basement. Then we were charged $32,742.70 in taxes because our nonprofit status was not yet ratified. This was forgiven only after the City Council passed a special bill, which in turn had to be approved by Congress (because the District of Columbia lacks full self-government). Interestingly, we had no trouble at all from City Hall. I met with the popular and soon-to-be-controversial Mayor Barry, and he offered to open doors and remove obstacles. The fact is, he recognized what a museum would contribute to downtown, whose renaissance was one of his administration's promises.

As interior renovation work continued, I turned my attention to fundraising for the Museum. The merits of networking paid off as several major national corporations agreed to participate in founding and furnishing the National Museum of Women in the Arts. My experience on the boards of other nonprofits taught me

AT&T underwrote the main reading room of the Library and Research Center.

to take corporate support very seriously, to approach donors carefully, to handle them with deference, and to take advantage of every opportunity that presented itself. For example, early on I approached AT&T and asked the woman in charge of giving to the arts if the company would be a founding member for one thousand dollars a year for five years. She agreed, saying, "I don't believe AT&T has to have a board meeting for that." For two years I kept her well informed, sending semiannual letters with photographs of the improvements. When I asked what she thought of our progress, she answered, "We have never had such attention to detail for such a modest gift. I am going to introduce you to the head of our foundation." He was interested and came down for a tour. The result was that AT&T underwrote the main reading room for the Library and Research Center.

After Gerald Lowrie became the director of AT&T's Washington office, I paid him a call. We talked about how the Museum came about and the involvement of AT&T. Eventually, he toured the facility, which went so well that I invited him to join our board, and he agreed. It was wonderfully fortuitous, because his input was invaluable. He was a highly intelligent businessman and a delightful human being.

Other corporations also graciously helped us in the earliest days. American Standard contributed all our plumbing fixtures; DuPont gave us carpeting throughout; the Hearst Foundation donated library furniture; and the Mars family, of the famous Mars candy company, underwrote a rare book room. I have often said that without our country's great tradition of volunteerism and philanthropy, the Museum could not have come into being.

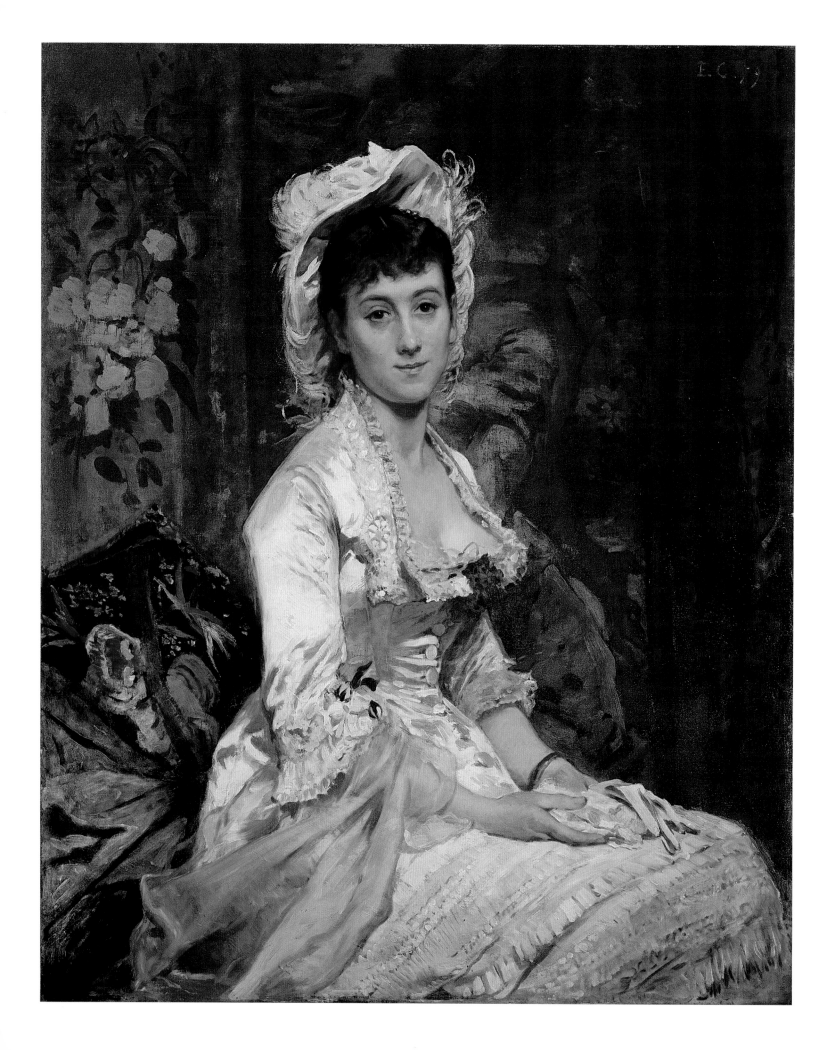

Reaching Out Across the Nation and Beyond

THE ART COLLECTION BEGAN IN OUR HOUSE on R Street in George-town, but when we started to think seriously about founding a museum, I began keeping artists' files in my interior design office, located in one of my husband's company properties. When an adjacent apartment at 4849 Connecticut Avenue became vacant, we took that over for the budding museum. Krystyna Wasserman, our librarian, first worked there, as did Jeanne Butler Hodges, our first acting director. Soon the Holladay Corporation's accountant, Helga Carter, agreed to do our bookkeeping pro bono. When we outgrew the apartment, we moved to a larger building owned by the Holladay Corporation at 4590 MacArthur Boulevard.

After Mrs. Hodges left to start a family, Charlotte Newton became administrative director, and shortly thereafter we published and distributed the first issue of a museum newsletter, *National Museum of Women's Art News,* a very modest effort. Meanwhile, we prepared to purchase our own building downtown. Before we moved again, Anne-Imelda M. Radice, who had been an adviser and member of the board, became director. Anne, who had a doctorate in art history from the University of North Carolina, had worked in the Education Department at the National Gallery of Art and was an architectural historian in the Office of the Architect of the Capitol. During President George H. W. Bush's administration she would serve as acting chairman of the National Endowment for the Arts. Anne is now the director of the federal Institute of Museum and Library Services, and so our paths have crossed again.

But back on MacArthur Boulevard, thanks to the efforts of board members Margaret (Peggy) Steuart and Betty Jane Gerber, the Junior League of Washington awarded NMWA an $89,000 grant toward the establishment of a wide-ranging and dynamic volunteer program. The grant enabled the Museum to pay for a volunteer

Two paintings I almost always include in my lectures are Eva Gonzalès's Portrait of a Woman in White *(opposite) and Helen Frankenthaler's* Spiritualist *(page 76).*

EVA GONZALÈS (1849–1883). *Portrait of a Woman in White,* 1879. Oil on canvas, 39½ x 31 in. (100 x 81.2 cm). Promised gift of Wallace and Wilhelmina Holladay.

coordinator. We were fortunate to get Patricia Kessler, who had held a comparable post at the Chrysler Museum in Norfolk, Virginia. With volunteers being organized, we launched a series of occasional lectures and opened our home on Thursdays for tours by appointment. Art lovers heard about us, largely through word of mouth. Visits would be arranged, and volunteer docents would lead them on guided tours, followed by tea. The first docents, significantly, came from the ranks of our "Founding Members," people who had pledged to give at least five thousand dollars over five years. Two of these individuals are with us still—as members of our governing board—and I am grateful to them. Evelyn Moore has guided the Women's Committee, which now numbers more than a hundred members, and Chris Leahy, a former teacher, serves as board liaison for our educational programs.

We continued holding the house tours from 1983 until the Museum opened in 1987, with groups of as many as thirty people coming through. It amazes me still that there was never a problem with security, and nothing was ever missing or broken.

I TAKE IT AS A MATTER OF PRIDE that we have never gone about our business in quite the way that other museums do. For example, the first department to function in our temporary headquarters was not the curatorial office, but the library. Our first successful grant proposal was not for mounting an exhibition; the National Home Library Foundation gave us a five thousand dollar grant to purchase reference books and exhibition catalogs. And one of our first employees was not a curator; she was a librarian.

Our longest-serving employee by far, Krystyna Wasserman, arrived in May 1982. In July 2002 she retired from her full-time position as director of our Library and Research Center and is now working as part-time curator of book arts. During NMWA's formative period I mentioned our growing collection of books and other materials about women artists in one of my many conversations with people at the National Gallery of Art. A senior librarian, Caroline Backlund, passed my comment on to a friend who was then volunteering at the Gallery. Krystyna was and is a remarkable person, but back then her credentials could hardly have been more perfect; she had master's degrees in library science and in art history, and she was one of the few docents who could give tours in several languages, including her native Polish.

Here are two marvelous artists' books Krystyna acquired.

OPPOSITE, TOP: MIRELLA BENTIVOGLIO (born 1922). *Á Malherbe (To Malherbe),* 1975. Onyx, 3¼ x 7 x 5 in. (8.3 x 17.8 x 12.7 cm). Gift of the artist.

OPPOSITE, BOTTOM: M. L. VAN NICE (born 1945). *Swiss Army Book,* 1990. Ink on paper, linen, wood, pen nib, and ribbon, 5½ x 24½ x 11½ in. (14 x 62.2 x 29.2 cm). Museum purchase: The Lois Pollard Price Acquisition Fund.

BELOW: *Librarian Krystyna Wasserman (center), Director Anne Radice (right), and I celebrating the opening of the Library and Research Center on September 22, 1987.*

Wally and I had about three hundred books in those days, but our library was unique, as it included pamphlets, vertical files, and other materials about women artists. Krystyna came to work for us, having been instantly intrigued with the idea of developing a library that provided information on women artists to scholars and students. At a 1984 conference of art librarians, she became captivated by an exhibition of artists' books at the Cleveland Institute of Art. Krystyna researched the subject and fell in love with it. That was the genesis of our own collection of artists' books, now perhaps one of the finest in the world. As our principal librarian she continued to develop the library into a priceless repository. Today it is, we believe, the most extensive collection of published and non-published material on women artists anywhere and the only institution doing archival work exclusively on women artists.

When she first joined us, Krystyna quickly became a woman of all work: librarian, editor, writer, scout, diplomat, hostess, and more. She won't let me forget that at one point I said I had to let her go; before the building opened we had a budget crunch and simply had to cut expenses. After I gave her the bad news, she took the bit between her teeth and invited me, her employer, to have lunch at the tearoom at Lord & Taylor. In that very feminine setting she explained to me that I couldn't afford to get along without her, but that she could afford to take a huge pay cut and work for a pittance until we got on our feet. Of

course, I accepted her generous offer, and I have never regretted it. The library has always been a centerpiece of the Museum, because one of our principal tasks has been to serve as the first major repository in the world for information about women artists of all periods and nationalities. After these many years Krystyna is a treasured and dear friend.

JUDGING FROM MY DIARY, by Christmas 1984 I could not tell where my private life ended and my work for NMWA began. I was working long hours and began to travel frequently, giving slide lectures almost wherever and whenever I was invited, in order to develop the Museum's national presence. I went down to Atlanta to give a talk at a function planned and hosted by Jean Astrop, a dear friend who is now on our National Advisory Board. One of the guests was Margaret Cox of Coca-Cola. She gave me the name of Joan Hayes in her New York office, whom I arranged to meet, and Mrs. Hayes in turn suggested I contact Ingrid Jones, head of the Coca-Cola Foundation, who in turn passed me on to an associate. When he asked, in effect, "What do you want?"—foundation people are accustomed to being asked for money—I answered, "No, let me ask: What do you want?" I learned early that it is the best negotiating policy to have both giver and receiver rewarded.

In the case of Coca-Cola, what they wanted had nothing to do with gender. "We want to reach young people all across the country," the Coca-Cola man told me. Miracle of miracles, that night an idea came to me. Young people, mostly college students, flock to Washington every summer, looking for work experience in their fields. Usually they are paid nothing. I suggested that Coca-Cola sponsor an

I find inspiration in Helen Frankenthaler's real and imaginary landscapes that project feelings of serenity and spirituality through her often lyrical floating forms.

HELEN FRANKENTHALER (born 1928). *Spiritualist,* 1973. Acrylic on canvas, 72 x 60 in. (182.9 x 152.4 cm).

internship at the Museum through a grant. This the company agreed to do, setting up a twenty-five-thousand-dollar endowment, the income from which would pay an intern approximately fifteen hundred dollars per summer.

I had not realized that colleges all over the country post available internships and that the Coca-Cola internship would draw competitive attention because it offered a stipend. We received the willing service of a smart young intern, the student returned to college proud to have held a museum job in Washington, and Coca-Cola made its desired connection to young people plus the advertising value of having its name posted. Win-win is always the best relationship.

One of the first Coca-Cola interns selected was Gail Ryder, a very bright young woman from the University of Maryland. She was assigned to the library, where Krystyna gave her the task of writing an essay comparing the work of black women artists before and after the civil rights movement. Gail wrote an outstanding paper, *Black Art as Social Anthropology: The Voice of African-American Artists Yesterday and Today,* in which she discussed Elizabeth Catlett's sculpture and photographs by Carrie Mae Weems. We sent a copy of it to our new benefactor. Krystyna knew how much donors value seeing the significant results of their generosity. The people at Coca-Cola were so pleased that they increased the endowment to fifty thousand dollars, and later to seventy-five thousand.

ELIZABETH CATLETT (born 1915). *Stepping Out,* 2000. Bronze, 30 x 9½ x 8½ in. (76.2 x 24.1 x 21.6 cm). Promised gift of Wallace and Wilhelmina Holladay.

WHILE OTHER MUSEUMS CALL THEMSELVES "NATIONAL," like the National Gallery of Art or the Smithsonian's museums on the Mall, from the start we were national in having a constituency of proven supporters and committed members all across the nation (and in several countries abroad). We organized many of these members into effective action groups through state and foreign committees, a supporting structure that I believe was unique, as far as museums were concerned.

I'll never forget hearing about the surprise in the Smithsonian's top echelons when they heard about our name. My friend Richard Howland, who held a high position in the Smithsonian Secretary's office, was deputized to call on me and advise that use of the word "national" in an organization's name was just not done,

as all the "national" museums then were affiliated with the Smithsonian. I looked him in the eye and said, "Tell it to National Car Rental. Tell it to the National Symphony and the National Football League and the National Organization for Women." Richard bid me good afternoon and didn't speak to me for several weeks. Now I notice that the great Institution itself has gone on a kind of "branding" craze, so that the buildings under its aegis have "Smithsonian" as their first name, as in the newly renamed Smithsonian Museum of American Art.

The National Museum of Women in the Arts was not to be simply a building in Washington with a local constituency and a few visitors from out of town. From the start, I believed we must be a national institution—even international, in time. Consequently we launched a membership campaign and discovered that women (and many men) would send in their dues from all over the country.

Membership in the Museum would give people a stake in seeing us thrive; it would strengthen our identity; it would provide another income stream; and it would validate our national status. When we opened in 1987, we had members in all fifty states and many foreign countries—something that no other museum could claim then and, I suspect, few can claim now.

The idea of membership seemed natural to people everywhere. But what made our membership into an important economic boost resulted from a direct mail campaign. Soon after we moved to MacArthur Boulevard, Roger Craver and Rodger Schlickeisen from Craver, Mathews, Smith & Company, came to me and explained their expertise in direct mail. In those days, before every mailbox was filled with junk mail, direct mail was a relatively new marketing and fundraising technique. Since we had an attractive mission—to recognize the achievements of women artists throughout history—the two men felt we were an excellent candidate for a direct mail campaign aimed at recruiting new members. They explained that there was no guarantee of a return, but they felt certain it would be worthwhile. I asked many questions to determine the costs, the possible return, and other matters. The initial cost would be forty thousand dollars. The Museum's budget couldn't manage that, so I agreed to put up the money as a loan and make it a gift if we failed.

The letter soliciting support went out nationally in 1984, and we waited on pins and needles. Imagine our joy when members from all over the country signed up. By the time we cut the ribbon in 1987 we had sixty thousand members, who had paid at least twenty dollars each. We were way ahead of most museums—and much of it was due to the direct mail campaign.

Unfortunately, we don't have that many members now. During the first five years I cut expenses to the bone so that we would always be in the black. We stopped "prospecting" to replace members who fell by the wayside, and there is always attrition if you don't continue recruiting new members. In those days we had only a black-and-white newsletter rather than the wonderful magazine we have

now for communicating with the membership. We are now prospecting again, and NMWA is still, we believe, one of the ten largest museums when measured by membership. In the meantime, the average gift has increased substantially.

The board and staff are happy that long-time colleague Dr. Susan Fisher Sterling, who has been with NMWA since May 1988 and served as chief curator and deputy director for Art and Programs, has recently been appointed director of NMWA. She explains the membership phenomenon quite simply: What other museum has a *natural* constituency? It would stretch the definition to say that the constituents of the American Museum of Natural History are taxidermists and botanists, or that modern artists make up a majority of those who flock to join the Museum of Modern Art. But, from the start, the National Museum of Women in the Arts would serve women per se, and in response to this promise women have responded.

If we were to have members throughout the country, what better way to enrich their active interest and support than through a local affiliation? We now have twenty-nine state committees in as many localities[1] plus committees in eight foreign countries[2]. The women and men in these NMWA-affiliated groups work on behalf of women artists in their home states and countries and extend our educational raison d'être.

I can hardly overstate the importance of our state and foreign committees. Indeed, they may be one of NMWA's most effective secret weapons and the reason we have grown as well as we have. Texas, among the first committees to get organized, has proved to be one of the most unusual, the most generous, and certainly one of the most active anywhere. Texans are go-go great!

The driving force behind the Texas Committee—almost a force of nature in her own right—was my dear friend Elizabeth Hutchinson. Her husband, Everett, had been active in Texas politics, was appointed chairman of the Interstate Commerce Commission by President Lyndon Johnson, and then became deputy secretary of the Department of Transportation. After they moved to Washington, Elizabeth joined the board of the American Field Service, where we met. When I told her about my idea for NMWA, she became a lifelong ally and advocate, one of the Museum's greatest champions.

Not content to support a cause passively, Elizabeth asked if I would visit Texas with her with the idea of forming a committee. Before I knew it, she had scheduled a tour fit for a rock star. Everywhere we went a hostess would hold a luncheon or a cocktail party or a dinner. On these occasions I would give a slide

NMWA's Texas Committee was the first, and has been one of the most active, of our state committees. Elizabeth Hutchinson was the heart and power behind the Texas Committee.

1 Alabama, Arizona, Arkansas, California/Bay Area, California/Southern, Colorado, Connecticut, Delaware, Florida, Georgia, Illinois, Indiana, Greater Kansas City, Massachusetts, Mississippi, Montana, New Mexico, New York, North Carolina, Ohio, Oregon, Pennsylvania, Rhode Island, Tennessee, Texas, Utah, Vermont, Washington, West Virginia.

2 Canada (Vancouver), Czech Republic (Prague), India (Delhi), Ireland (Dublin), France (Paris), Italy (Florence and Milan), Spain (Madrid), United Kingdom (London).

lecture, which I became reasonably good at because of so much practice during our little "visit"—of nearly two weeks.

Elizabeth has the most impressive capacity for friendship of anyone I've known. At great effort and inconvenience she will attend weddings, birthdays—whatever is important to those she cares about. Furthermore, she keeps in regular communication with an incredible number of acquaintances made over the years. Her list for our Texas trip read like *Who's Who*.

I met Caroline Rose Hunt, the oil heiress and sister of the wildcatter Hunt brothers, when she gave a tea in her Houston hotel, The Mansion. Caroline and I greeted the seventy-five women guests as they came through the receiving line in beautiful designer clothes, after which we were all seated for high tea. When the last guest in the line had been introduced, Caroline turned to me and said, "I like you"—my introduction to the delightful frankness of Texans. Surprised, I quickly responded, "I like you too." We have since become good friends.

Ellen King, whose family owned the King Ranch, gave a luncheon in Austin. In Vernon we visited Electra Biggs, who had sculpted Will Rogers for the Fort Worth Coliseum and whose ranch was, mind-bogglingly, many square miles in size. In Waco, Jo Stribling's husband, Tom, gave me an opportunity to appear on his television station and tell its viewers about the Museum. Among the many other hosts from around the state was Betty Bentsen Winn, the sister of the well-known Democrat Lloyd Bentsen. I gave lectures wherever I went and was warmly entertained with luncheons, ice cream socials, teas, and dinners.

On the last night of the tour, in Fort Worth, I told Elizabeth, "I'm going to get in bed and order a bowl of soup. That's it!" She said, "Oh, Billie, there is this wonderful local woman with a beautiful house, we just have to go for a brief time. We'll just have a drink and leave. Please, it is important." There was no way I could refuse Elizabeth after all her work, so I agreed. The woman was charming, and over cocktails she said, "I've arranged a very special Texan dinner for you. We are having these marvelous small rare birds, like squab, but much better. My cook is fixing them according to a very fine recipe." I looked at Elizabeth; she looked at the ceiling, not saying a word. It turned out to be a lovely evening and one that successfully involved the hostess. Only Elizabeth, with her many friends all over that big state, could have made it all happen. It was an exhausting but very successful two weeks.

The Texas Committee was formalized and came into being at a 1985 meeting at the Governor's Mansion in Austin. That event was hosted by the honorary chair, Linda Gail White, wife of the governor, Mark White. Since then, I am proud to say that every first lady of Texas has been honorary chair of our Texas Committee: Rita Clements (Mrs. William Clements), Laura Bush (Mrs. George W. Bush), and Anita Perry (Mrs. Rick Perry), the wife of the current governor. Governor Ann Richards herself was an honorary chair.

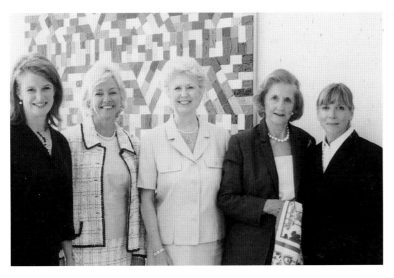

Because of the prominence of its many members the committee has been enormously productive and supportive. The Texas ladies organized themselves into a committee that was almost a social club, with annual weekend trips to exciting destinations—excursions that even the committee members' husbands looked forward to. (Uniquely, the Texas Committee has a strictly limited membership, and when a vacancy occurs the selection of a new member is a very serious undertaking that takes even geographical distribution into account.)

Over the years the Texas Committee presidents have become more involved. Several have come on our National Advisory Board. Alice West and her husband, Gordon, have participated in our trips and cruises, she has served as chairman of our National Advisory Board and is now a trustee, and Gordon is the chairman of the Museum's Endowment Foundation (for those who have given a hundred thousand dollars or more to the endowment). MaryRoss Taylor, Carol Ballard, Caroline Hunt, Dorothy and Ray LeBlanc, and Joe and Teresa Long have all given one hundred thousand dollars or more to the endowment, and Suzy Finesilver, Janie Hathoot, Sandra Childers, Betty Bentsen Winn, Linda Able-Choice, Jo Stribling, and many others have also supported the Museum.

Like the Texas Committee, the Mississippi Committee has been exceptionally active. Left to right: Betsy Bradley, director of the Mississippi Museum of Art; Caroline Boutté, a NMWA trustee; Gladys Lisanby, a longtime patron of the Museum and founder of this committee; I; and Ilene Gutman, NMWA director of National and International Programs. The painting behind us is Bay St. Louis *by Valerie Jaudon, whose work is in NMWA's collection.*

* * *

IN ADDITION TO BEING THE HEART AND SOUL OF THE TEXAS COMMITTEE, Elizabeth Hutchinson came up with the idea of having a painting from the Museum collection reproduced on a Christmas stamp. The United States Postal Service was always looking for visual images to print on its stamps, the Christmas stamps especially, and Elizabeth knew Postmaster General William J. Henderson. We nominated one of my favorite religious images, Elisabetta Sirani's *Virgin and Child*, as a 1994 Christmas stamp. Henderson admired the painting, saying, "I like it because the baby and the Madonna look like they love each other. Why are so many pictures of the holy family so stiff and stern?" His answer was a joke attributed to journalist Cokie Roberts: "Maybe they wanted a girl."

The Sirani Madonna was accepted, and we were delighted that the artist's name and dates were printed on the stamp. It would give us new exposure to tens of millions of people across the nation and help make known a prominent woman artist of the Renaissance. The stamp was designed, printed, and sold. Then came a shock. As I was out shopping one day, I was astonished to see our Madonna on Christmas cards

prominently displayed in a Hallmark store. We were upset for two reasons: First, there was no credit line announcing where the image had come from or its ownership. Second, we had not given permission nor were we receiving any share of the profits (or royalties) from this baldly commercial venture. I was not pleased.

We discovered that the Post Office sold Hallmark the rights to use the image; apparently this was routine, though of course it was also, at the very least, unethical. We went to the Post Office and raised objections to what seemed like blatant theft—selling our image to a third party without our permission and without offering a royalty, as is customary when museum images are used for profit. There were apologies and explanations. Our advisers said that we could take the matter to court, but the chances were not particularly favorable and a lawsuit would be expensive in terms of time and money. But since we were still dissatisfied, and in fact could put the Post Office to the trouble and expense of having to contest a lawsuit, they finally agreed to a compromise. Soon after, the Post Office announced that it would issue additional stamps using images from our collection; these stamps would identify the artist by name and give NMWA appropriate credit—on the face of the stamps themselves. The result was two beautiful and very popular stamps with floral images by the seventeenth-century naturalist painter Maria Sibylla Merian, who made exquisite renderings of the flora and fauna of Surinam.

This painting by Elisabetta Sirani became the United States Postal Service's Christmas stamp in 1994.

ELISABETTA SIRANI (1638–1665). *Virgin and Child,* 1663. Oil on canvas, 34 x 27½ (83.4 x 69.9 cm). Conservation funds generously provided by the Southern California State Committee of the NMWA.

AS WE WERE DEVELOPING INTO A FULL-FLEDGED ORGANIZATION, I thought of a few hospitable habits that proved to be very constructive—little traditions. Each month I give a small luncheon to introduce people who are important in various areas to the Museum. My purpose is not to ask for anything, but to enlarge NMWA's circle, to strengthen our presence in Washington, and to raise our profile. I have found it a

The Post Office used two engravings by Maria Sibylla Merian as stamp images.

MARIA SIBYLLA MERIAN (1647–1717). Plates 2 (LEFT) and 28 (RIGHT) from *Dissertation in Insect Generations and Metamorphosis in Surinam,* 1719.
PLATE 2: Hand-colored engraving, c. 12¾ x 9¾ in. (32.4 x 24.8 cm).
PLATE 28: Hand-colored engraving, c. 14⁵⁄₁₆ x 10 in. (36.3 x 25.4 cm).

useful and productive practice that helps NMWA in many ways, primarily by forging new friendships for the Museum, some of which can last for generations. For example, I first met Marcia Carlucci, the wife of President Reagan's Secretary of Defense, when she was my luncheon guest. Not only did she become a member of NMWA, as most of these ladies do, but she went on to chair a gala. She has been elected to the board and recently, her daughter was married in the Museum's Great Hall.

Of late luncheon guests have included Susan Scanlan, a museum patron and chair of the National Council of Women's Organizations; Elena Poptodorova, the Bulgarian ambassador; NMWA board member and television reporter Jan Smith, who is broadcaster Sam Donaldson's wife; Harriët van der Wal, the wife of Christiaan Mark Johan Kröner, the Netherlands ambassador; Chan Heng Chee, the ambassador from Singapore; and Marjorie Principato, whose husband is a distinguished physician and medical adviser to the royal family of Saudi Arabia. Marjorie recently heard that the furnishings of a Scottish castle, including an important paint-

ing, were being sold privately. She placed the winning bid for the painting, a self-portrait of early-nineteenth-century English painter Jane Fortescue (Seymour), Lady Coleridge, which she gave to NMWA.

My office keeps an open file of distinguished Washington women—entrepreneurs, doctors, lawyers, lobbyists, wives of members of Congress, ambassadors, Supreme Court justices, and newcomers to the capital city. Each month I select about fifteen names from the list and send out invitations on the Museum's stationery. Typically, six or eight ladies accept, a perfect number for these events. When we gather at noon, I tell them about the Museum and take them on a short tour; then we retire for a meal in the Kasser Board Room. During lunch I ask each of my guests to tell us about their lives and careers, which makes for memorable conversation, a wonderful introduction to one another, and a most welcome entrée to Washington for many of the newcomers. Also, I'm pleased to say, these monthly luncheons have earned a certain cachet over the years.

In 1990 I invited the wife of the Danish ambassador to one of the luncheons. She greatly admired the Museum and mentioned that Her Majesty Queen Margrethe II was coming to Washington for a state visit. Sometime later I received a call from the embassy's cultural attaché suggesting that he and the ambassador come to meet me. After a brief tour, the ambassador told me that the queen, an artist herself, was very interested in design. Perhaps something could be planned to make NMWA a part of her Washington schedule.

What resulted was an exhibition, *Ten Danish Women in the Arts*, which included leading women painters, silver designers, and porcelain and textile artists. The main attractions were the queen's ecclesiastical designs and her illustrations for J.R.R. Tolkien's *Lord of the Rings*. Her Majesty opened this delightful exhibition with understated elegance. When she arrived at the Museum, my six-year-old granddaughter, Jessica, gave her a bouquet of flowers and received a loving pat of thanks.

Surrounding the exhibition and Her Majesty's state visit were events that became special occasions. The Danish government sent members of the Royal Ballet, who danced for an invited audience in our performance hall. Uncertain of my role, I tried to be a quiet presence next to the Queen, but she was most grateful and drew me into everything.

There was a state dinner at the White House, to which Wally and I were invited. Her Majesty was, of course, at the President's table. Dear Barbara Bush, who had been a

Queen Margrethe II of Denmark was included in NMWA's exhibition Ten Danish Women in the Arts. *She is best known for her illustrations of Tolkien's* Lord of the Rings.

great friend of the Museum, seated me at her table with the prince consort. What might have been stiff and formal turned out to be great fun. Mrs. Bush has always been an outgoing, natural delight. Mstislav Rostropovich, the maestro of the National Symphony Orchestra, sat to my right and Mrs. Bush's left. Roving violinists came to the table and played "Tango Jalousie," a tune often heard in the United States. The prince, seated at Mrs. Bush's right, asked, "Maestro, would you help me with a musical question?"

Rostropovich, a very nice man, said, "But of course, Your Royal Highness."

The prince asked, "Who is the composer of this piece they are playing?" Rostropovich looked dismayed.

The prince laughed triumphantly and said, "It is a Danish composer, but few know. It is Jacob Gade."

A son of the President and Mrs. Bush was seated at a table nearby, next to a very glamorous movie star whose décolletage exposed most of her bosom. At one point Barbara excused herself, went over to his table, and said something to him. He gave her a look that boys give their mothers when they have been reprimanded. When she returned I couldn't resist asking what she had said to him. With a smile, she said, "I told him to keep his eyes on his plate."

Maggie Bumpers, the sister of Arkansas Senator Dale Bumpers, was another luncheon guest. She became interested in the Museum, and when she asked what she could do, I joked that I'd like to meet her fellow Arkansan, Helen Walton, the queen of retail marketing. The joke was on me, as Maggie replied, "Nothing could be easier. She is a dear friend." She simply phoned Helen, invited her for the following weekend, and made lunch reservations for us all in the lovely paneled restaurant at the Hay-Adams.

Helen, a brilliant woman and a doer all her life, had graduated at the head of her class at the University of Oklahoma. She married Sam Walton, the man who created and developed Wal-Mart with Helen at his side. She was the materfamilias of Wal-Mart, the most successful retail enterprise in history. Sam and she had a wonderful relationship. He was an outdoorsman, and she loved to go camping and roughing it with him.

Maggie, Helen, her friend Ed Dell Wortz—the women's golf champion—and I sat down to lunch. The ladies from Arkansas immediately grasped the importance of the Museum, but Helen didn't want to commit herself until Ed Dell said, "If you'll lend your name, Helen, I'll do all the work." Helen then agreed that—in name at least—she would chair the new Arkansas Committee. As the Chinese proverb states, "A journey of a thousand miles begins with a single step," and we were on the march.

Helen and I became good friends, and visiting Arkansas was a treat for me, in part because her house in Bentonville is fabulous. Built by Frank Lloyd Wright's star protégé and nestled in a wonderful site, the home is a sinuous, extended one-story dwelling surrounded by luscious landscaping that features a creek with a dam and

waterfall. The foyer has a pool, and the gardens extend into the house itself.

When the Arkansas Committee was announced, it was clear to me that Helen had not let Ed Dell do all the work, for it had a blue-ribbon—royal-blue—membership comprising the state's wealthiest and most prominent women. They got right down to business, Helen actively in the lead, and decided to launch a model project that would provide Arkansas public-school children with art materials. The effort was highly effective, raising the potential of those children by introducing many of them to their first creative activities. In recognition of this achievement, Helen won a Governor's Award. I couldn't have been happier for her nor more proud that such a project was carried out in the name of the National Museum of Women in the Arts' Arkansas Committee. The awards luncheon was perfect—except for the food, which recalled the time when America lived on brown meat, floured gravy, and soft white bread.

We could not have known it at the time, but Helen's initiative was the first step in realizing a central part of NMWA's mission: educating people in art, its history, its appreciation, even its creation. (Of course, conventional wisdom in professional circles holds that education per se is one pillar of any museum's raison d'être.) Still, it's fair to say that in addition to educating people of all ages through exhibitions, special events, and programs, NMWA has had greater direct impact on in-the-schools education than many other museums, even larger and better-established ones. (And to think that while we are introducing schoolchildren to art in general, we are also pursuing our primary mandate, which is to celebrate art created by women and to correct the historical record!) I was especially pleased to see the public recognition of the Arkansas Committee's work, because it demonstrated that the public and leaders in many fields respond to the arts with surprising verve.

One of the women who became involved with NMWA before the Museum's actual founding was Chris Leahy, who was a docent when our collection was still in my home. Chris was a founding member, then a volunteer and then a part-time employee of the education department. She had taught in elementary schools; education was her vocation and her passion.

One day I was wandering through the galleries and stopped to hear her giving a tour to a group of young children, perhaps seven or eight years old. They were seated on the floor in front of *Iris, Tulips, Jonquils and Crocuses,* a painting by Alma Woodsey Thomas. Totally absorbed, they were hanging on Chris's every word.

ABOVE: *The Arkansas Committee of NMWA.*

OPPOSITE: *Children from local schools often attend tours led by the NMWA education department and docents. I always observe with great joy their expressions of rapt attention as they look at the familiar scene portrayed in Lilly Martin Spencer's canvas on page 88, or, opposite, an abstract painting by Alma Woodsey Thomas.*

ALMA THOMAS (1891–1978). *Iris, Tulips, Jonquils, and Crocuses,* 1969. Acrylic on canvas, 60 x 50 in. (152.4 x 127 cm).

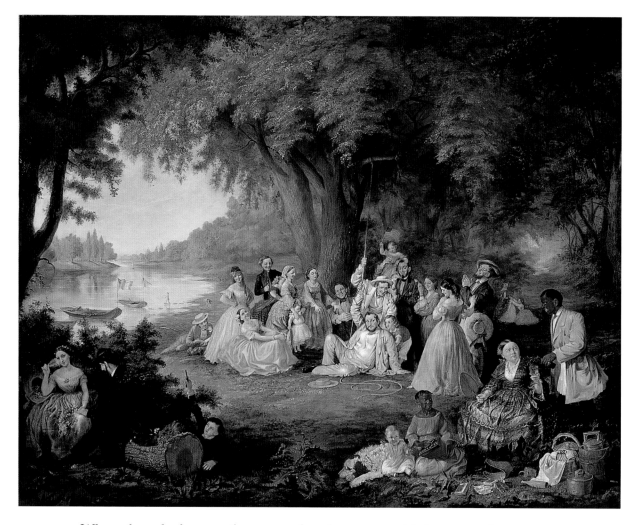

LEFT: LILLY MARTIN
SPENCER (1822–1902).
*The Artist and Her Family
at a Fourth of July Picnic,*
c. 1864. Oil on canvas,
49½ x 63 in. (125.7 x
160 cm). Conservation
funds generously
provided by the Florida
State Committee of the
NMWA.

OPPOSITE: *This portrait
was on the cover of our
booklet* Discovering Art,
*created especially for our
youngest visitors.*

Lavinia Fontana (1552–
1614). *Portrait of a
Noblewoman,* c. 1580.
Oil on canvas, 45¼ x
35¼ in. (114.9 cm x
89.5 cm)

When she asked a question, every hand went up with happy excitement.
This is how love of art is born, I thought.

I was then on the Advisory Board of the Girl Scouts and a good friend of both
the chairman of the board and the staff director. They had asked me about art
materials for young people, and it occurred to me that Chris must be the expert.
Were materials available that would suit a Girl Scout troop? If not, Chris was the
perfect person to compile or create something appropriate and the perfect person to
write a book for this particular venue. She set to work, and the result of her efforts
was a winner that has now been in print and widely distributed for almost a decade.

It was a richly illustrated, but really quite simple, twenty-four-page booklet
called *Discovering Art.* The photograph on the front cover pictured a diverse group
of Girl Scouts and Brownies in NMWA, gathered around one of our most appeal-
ing pictures, *Portrait of a Noblewoman* by Lavinia Fontana. The first few pages told the
reader how to prepare for a visit to a museum. In easy language, it described what
to look for and what kinds of pictures one would see: portraits ("pictures of people"),
still lifes, narrative pictures, landscapes, and abstracts. The book was designed to

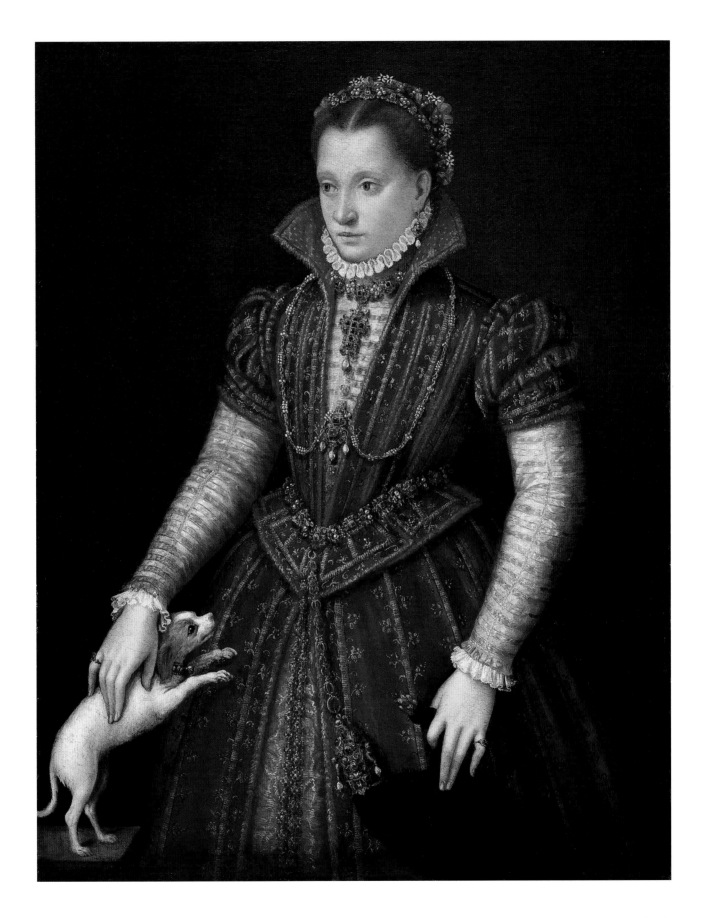

enable a Scout leader to take her girls to any art museum. The leader could point out that the book showed a portrait and then say, "Now you look for a portrait in the museum." This was important because it truly involved the young person. Then followed landscapes and the other kinds of works. There were exercises in making pictures. The last exercise instructed: "Now you try to paint one of these and put yours in the pocket in the back of the book."

Groups of children were given assignments from the book, and the results were truly gratifying. It would be the first museum visit for some, but having read the book and done the exercises made it less intimidating. The book encouraged them to try their hands at creating art, taught art terminology, and explained how to look at art with a questioning mind.

The Girl Scouts loved the book and used it widely. I showed it to some of my friends and the Museum's founding members; the next thing we knew, our state committees were ordering copies in bulk for Girl Scouts in their areas. With the kind introduction of Ingrid Jones, the director of the Coca-Cola Foundation, I managed an appointment with the UPS Foundation in Atlanta. I explained that we wanted to redesign the book to broaden its use and audience. The result was titled *Exploring Art*, the cover of which showed boys as well as girls gathered around Fontana's *Noblewoman*. UPS generously gave $125,000, enough to reprint the book and introduce it to different audiences. Toyota underwrote it for Girls, Inc., in New York, a member of the Georgia Committee underwrote it for the schools in a poor section of Georgia, and the Mississippi Committee distributed it throughout that state.

The books *Discovering Art* and *Exploring Art* were accompanied by a teacher's guide. The popularity of this little volume swelled; it won awards, and I can't tell you how many tens of thousands of copies we have printed. This was a real feather in our cap. Several other educational resources for young people developed as a result—both directly and indirectly. One resource, called "Art, Books, and Creativity (ABC)," is a year-long model curriculum that we developed through a three-year, multimillion-dollar project funded by the U.S. Department of Education. This teaching/learning plan integrates the arts into the core curriculum of elementary schools. (Just a reminder: Within the elementary examination of culture and history, there is a specific focus on the contributions of women.) The curriculum, now available online, was developed and tested under our supervision in two school districts, one in Arlington, Virginia, and the other in Albuquerque, New Mexico. These schools were chosen because they serve economically disadvantaged students under the federal government's Title I criteria (based in part on the number of students applying for free lunches).

A successor program to ABC called "Teachers Connect: Distance Learning in the Arts" has also been funded by the Department of Education. This project is being tested in Albuquerque's public schools and in Pascagoula, Mississippi, where schools are still recovering from Hurricane Katrina.

Back within our walls, NMWA conducts a wide range of education programs for school children, older students, adults, and entire families. On the first Sunday of every month, we hold Family Programs, which feature hands-on art activities, workshops, music and dance performances, storytelling, and tours of the exhibits for children six through twelve (with an accompanying adult). We also offer an annual Family Festival. One of my favorite programs is our Role Model Workshops. During the school year, students ranging in age from middle schoolers to college undergraduates enroll for monthly workshops with successful women in the visual, literary, and performing arts. Then they meet for a weeklong session in the summer. This program is always oversubscribed, which is very gratifying.

Needless to say, all these programs require the work, time, and energy of dedicated people. Our education department has grown considerably since Chris Leahy's day. We are fortunate to have an outstanding staff in that department, now led by Deborah Gaston. After all, education is a keystone in all we do as a museum.

As YOU CAN SEE, the state committees were often the source of innovative ideas and initiatives. Formal rules now govern the way state committees are organized. We have a vested interest in their success, after all, and in the way they conduct themselves. The first requirement for a state committee is that a core group of women have proven leadership abilities and demonstrated interests in the arts, especially arts created by women. Once such a core group is identified, Ilene Gutman, our very able director of national and international affairs, gets in touch with them and starts the ball rolling. The next step is formal incorporation as a nonprofit organization. It is of utmost importance that the members of a state committee be committed to their state, to the arts, and to artists who are women.

Creating a lasting committee system was never a sure thing, which is one reason we developed the set of rules and standards that we eventually adopted and continue to adjust. There were false starts, and there were resurrections as well. Take the Paris Committee, for example.

Early in our history, Aude de Kerros and Count Pierre d'Oillison invited me to France to meet and speak to many important people in the art world. NMWA had no staff person to handle this aspect of development in those days, and the initial enthusiasm was not properly followed up. In retrospect, my trip was premature.

A decade later Ondine Langford, an American who had lived in France for eighteen years, became interested in the Museum and wanted to create a Paris Committee. I suggested that she contact Aude, who rejoined immediately, and Pierre, who agreed to help. Another Frenchwoman, Nicole Tordjman, whose husband had served as commercial consul at the French embassy in Washington, took

a great interest in the Museum, became actively involved, and even conducted tours for visitors in French. Now back in Paris, she was excited about the committee and became a member. Tara Whitbeck, the Paris-based daughter of one of our very first board members, Roma Crocker, also joined. In short order, Ondine put together an excellent group of women, about half of them French and half expatriate Americans. Aude had important connections who were able to arrange for me to present a slide lecture at the Senate in Paris.

ABOVE: *Ondine Langford, the attractive and energetic chair of the Paris Committee, with me.*

OPPOSITE: *Berthe Morisot's* The Cage *was included in the exhibition of this great Impressionist painter at the Museum in 2005.*

BERTHE MORISOT (1841–1895). *The Cage,* 1885. Oil on canvas, 19⅞ x 15 in. (50.5 x 38.1 cm).

The auditorium was filled with distinguished people, including Pierre Rosenberg, the former director of the Musée du Louvre, and his wife, Béatrice, the daughter of my friend Liliane de Rothschild. The reception afterward was funded by Paula Wallace, president of the Savannah College of Art and Design, who joined our National Advisory Board and was to become a friend. The event won many French friends for the Museum—this in a nation famously known for coolness to strangers.

Gretchen Leach, wife of then ambassador Howard Leach, hosted a tea and invited Arnaud d'Hauterives, secretary of the Académie des Beaux-Arts and the former director of the Musée Marmottan Monet, who has been very helpful to the Paris Committee since. It has been wonderful that people of stature have been kind and generous, and it has always surprised and delighted me to have the unanticipated pleasure of their involvement.

Having taken root, the committee began a series of exciting activities. Ondine introduced me to Jean-Marie Granier, then the director of the Musée Marmottan, the home of many of Berthe Morisot's works; that meeting led to our exhibition of that important Impressionist, one of NMWA's most successful shows.

Later in 2007, Ondine helped set up a meeting with Henri Loyrette, the director of the Louvre. When I went to Paris for the meeting, the wife of the American ambassador, Debbie Stapleton, gave a luncheon in my honor and seated me beside Domitille Loyrette, a wonderfully attractive woman who speaks perfect English. She told me all about her husband and his outstanding career. (He was formerly director of the Musée d'Orsay, where he was responsible for the Gare d'Orsay's rehabilitation and development as a museum, a monumental undertaking.) The next day, when I met with him in his impressive office at the Louvre, I began the conversation by saying, "Your wife speaks well of you." He returned: "She speaks well of you, too." It was an auspicious beginning. His head curator also attended the meeting, at the end of which it was

agreed that NMWA would exhibit some of the Louvre's paintings by women artists in 2010. In parting, Mr. Loyrette said, "It is going to be exciting."

The exhibition will be the second in what we hope will be a series showing artworks created by women from the premier museums in the world. The first was our landmark exhibition from Saint Petersburg's Hermitage, which was a great success. After the Louvre, we hope for the Prado and the Tate. Through our scholarly catalogues of these shows, we shall create a library of paintings by women from the great museums of the world.

Ondine, who seems to know everybody in the Continental art world, also introduced me to Vittorio Mosca, who became the prime mover of our committee in Milan. In 2004 he invited me to give a slide lecture as I had done in Paris, and I addressed an audience of five hundred distinguished guests at the Società del Giardino—the most beautiful building I have ever been in—a grand palazzo that had once been Napoleon's residence. My visit to Milan turned out to be fruitful, because in addition to being able to address the cream of the northern Italy's arts community, I was able to strengthen the Milan Committee and meet many of its members personally. Vittorio gave a buffet dinner in my honor, and Deborah Graze, the American consul, gave me a luncheon, both of which allowed me to get to know quite a number of the region's cultural leaders. This, in turn, with Vittorio's help, gave NMWA the entrée in arranging to borrow many of the pictures that were featured in our twentieth-anniversary exhibition, *Italian Women Artists from Renaissance to Baroque* in 2007.

In November 2007, I visited Milan again, this time to attend the opening of a major exhibition, *Women Artists from the Renaissance to Surrealism*, organized by Artematica and headed by Andrea Brunello. An impressive exhibition of two hundred works by women was presented at the Palazzo Reale Museum. Twenty excellent pieces were borrowed from the National Museum of Women in the Arts and were highlighted. First Lady Laura Bush wrote the following letter for me, which was prominently mounted at the entrance.

> Greetings to everyone gathered for the opening of *Women Artists, from the Renaissance to Surrealism!* Through art women have been inspiring and enriching the lives of others for centuries. I am delighted the Palazzo Reale Museum in Milan is celebrating these wonderful contributions women have made to art.
>
> My admiration goes to Mayor Letizia Moratti and everyone else who is helping to make this exhibit a success. A special thanks goes to my friend Wilhelmina Holladay for providing works from the National Museum of Women in the Arts.
>
> May the unifying bond that art provides further strengthen the friendship between Italy and the United States.
>
> With best wishes for a great exhibit,
> Laura Bush

Twenty paintings from NMWA's collection, among them Lotte Laserstein's Morning Toilette *were included in a major exhibition in Milan in 2007,* Women Artists from the Renaissance to Surrealism.

LOTTE LASERSTEIN (1898–1990). *Morning Toilette,* c.1930. Oil on panel, 39¼ x 25⅝ in. (99.7 x 65.1 cm). Gift of the Board of Directors.

The exhibition was widely covered by the media, and seven thousand people came on opening day!

In June 2007 Ilene Gutman and I went to Madrid for a week to be with the Spanish Committee, organized by Elisa Mancini. The impressive schedule they had prepared made for a fascinating stay. Pilar de Aristegui, an artist and an old friend from the days when her husband was with the Spanish embassy in Washington, gave a beautiful garden party at her spacious country estate that boasted thirty varieties of roses. It was a great pleasure to see her and Carlos looking handsome and full of life.

Another member of the committee, Mayte Spinola, gave a dinner for more than a hundred guests at her handsome estate, which is filled with treasures, from Roman antiquity to contemporary art. Women wore traditional embroidered and fringed scarves, and a prize was given for the most beautiful. The hostess draped one on my shoulders, so that I could enjoy the exquisite needlework.

On another evening, a dinner for four hundred was held in a magnificent historic building, the Casino, which dates to the 1700s. Caroline Gruosi-Scheufele, a jewelry designer and president of Chopard, was hostess. Caroline's original diamond jewelry was paraded by models in gorgeous black designer dresses. It was a privilege for me to be asked to speak to the guests about the Museum and its collection.

A meeting at the Royal Palace with the Director General and the Director of Exhibitions Martin Laborda was held in the private quarters where the king receives foreign diplomats when they present their credentials, and where only a few privileged visitors are allowed. The director here and others I visited in Madrid generously indicated the possibility of creating future exhibitions with NMWA.

In early November 2007 Ilene and I visited London to better know our U.K. Committee. Lady Barbara Thomas Judge, a patron of the Museum in the early years, gave a large party in my honor in her spacious contemporary penthouse overlooking the Thames. The nighttime view of London, seen through the glass walls of the apartment, was spectacular. As she moved from New York to Hong Kong, I had lost track of Barbara, so it was a great surprise when I heard that she had offered to give a party. I gave a brief speech to the guests—numbering about a hundred, although the room could easily have taken a hundred more—who included directors of museums, gallery heads, and prominent members of London's art world. The Museum's presence in England was certainly enhanced by the event.

Philippa Glanville, former curator of metalwork at the Victoria and Albert Museum and the author of NMWA's *Women Silversmiths* catalogue, is a great scholar and an adviser to the committee. She arranged a symposium on women collectors at the Royal Society for the Encouragement of the Arts. I gave the keynote address, "The Joy of Changing History," and three others gave scholarly speeches on collect-

ing. Foremost Portuguese artist Paula Rego, who recently exhibited at NMWA, was among the hundred-plus guests.

When Bob Bennett, famous trial lawyer and brother of former secretary of education and political pundit William Bennett, learned we were going to London, he introduced me to Baroness Mary Goudie, a member of the House of Lords. The Baroness, a friend of his who had spent time in Washington, was interested in the committee in England and offered to help. When she returned to Europe she invited me to have tea with her during my stay in London, and I accepted her invitation. Because of her prestige, her input could be very helpful.

Member Dasha Shenkman, a major collector of contemporary art by women and a member of the U.K. committee, gave a luncheon at her house. Chief Curator Sheena Wagstaff of the Tate Modern, ceramicist Jeff Lee, and designer Zandra Rhodes were among the guests. Dasha's large home was filled with wonderful works, which she generously showed us. Dr. Wagstaff kindly offered to arrange for the committee to tour the Tate's Louise Bourgeois exhibition before the museum opened to the public the next day. We took advantage of her offer, and it was indeed a special treat to spend some quiet time with Bourgeois's art. That evening Ilene and I were the dinner guests of committee chairman Sarah Treco and her husband, Jamie, who is an American with great charm and who supports Sarah in every way.

The time in London was memorable with the pièce de résistance being a farewell reception at Clarence House, the official London residence of the Prince of Wales. In the dining room they were preparing a family celebration for Her Majesty Queen Elizabeth's wedding anniversary. It was like being able to touch a piece of history. This was made possible by Janice Sacher, chief curator of the Royal Collection and a member of our U.K. Committee.

The committees abroad and the prominent individuals that comprise them are a great step forward. I dream of a truly international awareness of the Museum, and the outreach of these committees may make it possible. Thanks to them, our presence abroad has been more firmly established. We are deeply indebted for their efforts on behalf of NMWA.

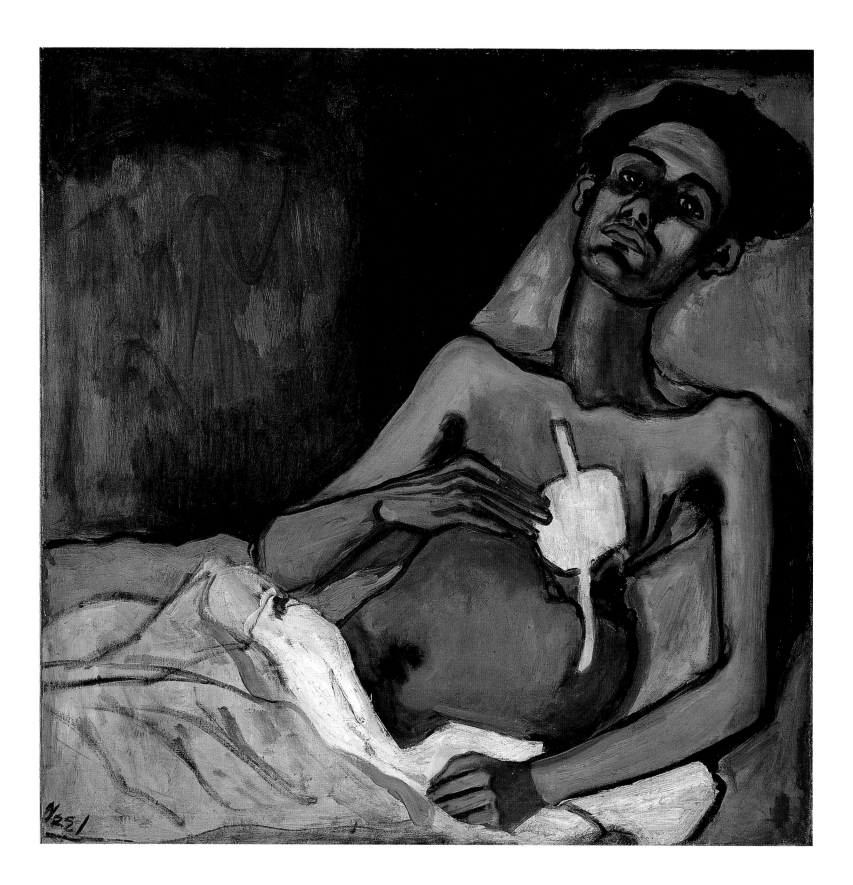

The Grand Acquisitions

T HE FIRST PIECE OF ART WALLY AND I PURCHASED TOGETHER was acquired at an art exhibition of student work held at a large public high school in Arlington, Virginia. It was a delightful picture full of humor and cost a hundred dollars. We hung it in the kitchen, where it gave much pleasure. To own a work of art is a special experience, because one knows that "ownership" is really quite nebulous and paradoxical. Every work of art has inspired or thrilled other viewers, because art by its nature is owned in part by anyone who sees it and is moved by it and remembers it afterward. Yet owning a picture—taking it home and deciding how to frame it and where to hang it—brings a sense of joy at being able to look at it whenever you want, of guardianship, and of having to care for it responsibly, which is a kind of nurturing. Such is one of the enticing facets of collecting art.

Another wonderful facet is what you learn about the art you encounter and the people you meet, the artists in particular. Artists are exceptional people, often quirky, sometimes even mad. One thing they are not is boring. As a result, building a collection is an enriching experience in and of itself, with people as eccentric (or downright mind-blowing) as Alice Neel, as worldly as Clare Boothe Luce, and as enduring as Angelica Kauffman (who, of course, I could know only through her art).

Wally and I purchased this great portrait of poverty and despair, T. B. Harlem, *directly from Alice Neel during a visit to her studio.*

ALICE NEEL (1900– 1984). *T.B. Harlem,* 1940. Oil on canvas, 30 x 30 in. (76.2 x 76.2 cm).

THE NOTABLE TWENTIETH-CENTURY ARTIST ALICE NEEL was unconventional as a painter and as a person. Her uncompromising honesty was the heart of her art, as proved in her nude self-portrait, now in the National Portrait Gallery, which she painted when she was eighty-one years old, fat, and wrinkled. In the flesh (so to speak)

her unbridled pronouncements used unleavened honesty to manipulate and embarrass, and she had virtually no inhibitions. In spite of that I was truly fond of her and a great admirer of her work.

In 1979, the National Women's Council for Art, with the help of Joan Mondale, whose husband was vice president, arranged for President Carter to present outstanding achievement awards to three women artists over the age of seventy at the White House. Alice and her daughter-in-law, Nancy Neel, who took care of her in her declining years, were our overnight guests in Washington. We were happy to offer our hospitality and gave a small dinner party that included Isabel Bishop, who would also be honored. Alice took delight in teasing the ever-polite, maidenly Isabel all through dinner with remarks like, "Have you ever painted a nude man?" and "Wouldn't you enjoy having one pose?"

Truth to tell, Alice had psychological problems. She had been suicidal at one point in her life and spent several months in a mental hospital. While truly gifted, she could be very emotional. When the White House ceremony opened, Alice began weeping, while Isabel kept her quiet composure; Louise Nevelson, who was also being honored, accepted her award stony-faced behind a mask of heavy makeup. When Alice's turn came to step forward, she could barely speak as tears poured down her cheeks, but she managed to say loudly enough for all to hear, "Oh, Mister President, isn't it lucky I don't wear false eyelashes." Louise didn't bat a heavy lid.

Wally and I had recognized Alice's artistic gifts long before she became celebrated, and we very much wanted a picture by her. I went to New York to scout out her art. At her studio she showed me many paintings, and I admired an early work, done in 1930. On the same trip Richard Brown Baker took me to a seminar sponsored by the New York School of Design, where Alice was to be interviewed by the art critic and modern art historian Barbara Rose. The program was in progress when Alice spotted me seated in the center of the auditorium. She called out in her loud voice, "There's Billie Holladay—she's a collector, a big fan, and she admires my work. Billie Holladay! Stand up and let them see you . . ." Then: "Who's that with you? That's not your husband!" She found great pleasure in teasing and embarrassing; to her, it was an interesting game. The audience was amused, but poor Dick wanted to crawl under the parquet.

Soon after, in the spring of 1978, Wally and I decided to buy one of her paintings. I asked her if we might come to the studio and requested that she again arrange some works for us to see. When we arrived she had a dozen pictures leaning against the wall, including *T. B. Harlem* as well as the painting from 1930 that I had previously admired, which Alice assumed we would buy. I had told Wally that

Al Hirschfeld, the renowned cartoonist, drew this amusing picture of me in front of sketches of works from NMWA's collection.

This is the only photograph I have of Louise Nevelson. Her famous eyelashes are barely visible. At left is the sculptor Elizabeth de Cuevas.

I thought *T. B. Harlem* was truly her best painting. It is an oil painting of her lover's brother lingering in agony after surgery that would not save him from tuberculosis, a great portrait of poverty and despair. I was delighted that it was included in the lineup.

Wally looked around, and finally he said, "We'll take that one," pointing to *T. B. Harlem*.

"You want *T. B. Harlem?*" she gasped, indicating she didn't want to sell it.

"You put these out, and all were for sale," Wally remarked. "I believe you said the price was fifteen thousand dollars." He was the model of the incredulous businessman whose word was his bond and who assumed the same went for her. She couldn't tack against that breeze. We not only had a deal, we had a bargain.

Later, she offered us her great double portrait of the feminist scholar Linda Nochlin with her daughter Daisy. She told me that I could have it for eighteen thousand dollars. I assured her we would think about it. Either she was getting anxious or she needed cash fast, because she called in the middle of the night and declared, "I want you to have the Nochlin painting, Billie. You have to take it. It's only twenty-one thousand dollars." I was angry at being awakened at three o'clock in the morning, but I was not so fogged by sleep that I missed the fact she had just tacked an extra three thousand onto the price. I cut her short, saying as firmly as I could while not awakening Wally, "Alice, I've decided I just don't want it. Good night."

As it turned out, I was the loser that night—and purely out of pique. Less than fifteen years later, Alice was dead, and her paintings were given a major exhibition in a prominent museum. The splendid Nochlin picture now hangs in the Boston Museum of Fine Arts. In 2006, our Museum presented Neel's portraits of women in an outstanding show. No one who saw it could doubt her enormous creative ability. Having her work displayed at NMWA had special meaning for me, as we had become good friends before her death.

THE GREAT EIGHTEENTH-CENTURY ARTIST ANGELICA KAUFFMAN was born in Switzerland and was taught painting by her father, who was ultimately of less renown than his gifted daughter. She painted in Italy and then in London, where she introduced the genre of history painting and was a founder of the Royal Academy. She worked with architect Robert Adam, painting murals in many of his

I bought The Family of the Earl of Gower *by Angelica Kauffman at Sotheby's auction house for a very reasonable price. A terrible snowstorm that paralyzed New York City prevented potential bidders from attending the sale.*

ANGELICA KAUFFMAN (1741–1807). *The Family of the Earl of Gower,* 1772. Oil on canvas, 59¼ x 82 in. (150.5 x 208.3 cm).

famous buildings. Benjamin West, the American portrait painter who lived most of his life in England, was also a colleague. Kauffman was one of the most successful women artists of her time and the only one who declined an invitation from Catherine the Great to come to Saint Petersburg when the empress was developing the Hermitage collection—because at the time Kauffman was too busy with her commissions in Italy and earning a handsome living.

Some of her works are monumental and rarely come up for sale, so I was excited when her very large group portrait, *The Family of the Earl of Gower,* depicting this noble English family in flowing classical garb, was featured in a Sotheby's catalogue one winter. I planned to spend several days in New York to attend the auction. Since I hadn't been in the city when the auction works were on display, I called Sotheby's and asked if I might come early to examine the painting. This is usually forbidden since the items for sale are already arranged in order but they made an exception because they knew me. I was asked to arrive at least two hours early so that there would be plenty of time to pull the painting out and later replace it.

I arrived at Sotheby's before a blizzard began. It grew increasingly hazardous and was to become the worst storm New York had experienced in many years. Most potential bidders were caught in the swirling snow and the snarled traffic, and when

BARBARA HEPWORTH
(1903–1975). *Merryn*,
1962. Alabaster,
13 x 11½ x 8¼ in.
(33 x 29.2 cm).
Courtesy of the Bowness,
Hepworth Estate.

the auction started few seats were filled. The Kauffman was number eight in the catalogue, and I was the only one to bid on this masterpiece. I bought it for eight thousand dollars! After the sale several late arrivals came up to me, distressed at having missed out, and offered to buy the painting for considerably more than I had paid for it. I could have made a substantial profit in mere hours, but, obviously, I declined. The picture has become a favorite in the Museum's collection, and I enjoy remembering the experience whenever I see it.

Having purchased it for a song, I found that shipping it home was another matter. Then there was also the question of where to put such a large painting. For a while it camped in our garden room, leaning against the wall. Our friend Jacob Kainen was the most all-around knowledgeable art professional I ever knew and certainly the most knowledgeable artist of his time. The Kauffman provided him the opportunity to prove his expertise. When he and his wife, Ruth, came for drinks one evening, he glanced at this enormous picture and said, "Where did you get the Kauffman?" Both supporters of the Museum in many ways, they once brought a beautiful original print by seventeenth-century artist Maria Sibylla Merian to our beach house in Rehoboth as a house gift.

Well, we couldn't just keep the Kauffman leaning against the wall, but we couldn't hang it anywhere in the house; it would overwhelm any room it hung in. So until the Museum building was renovated, we loaned it to the Holton Arms School in Bethesda, Maryland, from which my daughter-in-law, Winton, had graduated and where my two granddaughters were enrolled.

―◇―

EVEN A MUSEUM'S CHAIRMAN OF THE BOARD is not above the scrutiny of alert docents and staff. One day I was giving a tour to a group of VIPs. Barbara Hepworth's fabulous white alabaster *Merryn* was on display. This piece has always held indescribable mystery for me, because it combines such contrasting shapes and ideas: It is so smooth and sensuously feminine with a seductive opening among its

curves, yet its substance is cold stone. It is a vision of purity, yet its body is visibly flawed by fractures in the rock. Its very name reminds me of King Arthur's wizard, Merlin, but it may as well refer to St. Merryn, a small village about eighty miles east of Hepworth's home in St. Ives.

Wally and I had bought *Merryn* at auction some years earlier. I remember feeling particularly victorious, because we won the bidding against a Japanese party—at a time when Japan's economy was booming and it seemed that Japanese collectors were acquiring the best of everything, since price was no object to them. At that sale, however, the stars must have been in happy alignment, or someone missed a step, because Wally and I won the bidding. Soon we had the piece proudly displayed on the coffee table in our family room, where we spend much of our leisure time.

We had given the sculpture to the Museum, and we were delighted to see it on display. I was discussing it with my distinguished guests, talking about its tactile shape. I even stroked the familiar curve. Suddenly, seemingly from out of nowhere, the Museum's registrar, Randi Greenberg, appeared and said with cold authority—absolutely correctly, under the circumstances—"Mrs. Holladay, please don't touch the art objects." I pulled back, as if the cool alabaster was on fire, properly admonished.

I never told the registrar where the piece had been located before we gave it to the Museum. Nor did I relate how one Sunday afternoon my little grandson Addison put his hand through the hole in the middle of the sculpture. He got stuck, and we had to grease his arm with soap to free him!

DURING A 2007 VISIT TO MADRID, my friend Pilar de Aristegui arranged a meeting with Gabriele Finaldi, the deputy director of the Prado. A handsome, extremely knowledgeable man in his thirties, he took us on a tour of the museum's dramatic new addition, whose magnificent brass doors were created by sculptor Cristina Iglesias. Back in his office, I began telling him about the Museum. Trying to be succinct, I began, "Well, my husband and I collected works by women artists." He said, "Whom did you collect?" Starting with the earliest artists, I mentioned Lavinia Fontana. Immediately, he said, "Oh, yes, she was 1500s in Bologna. Did you know she was once asked to be a Vatican painter?" Next, I mentioned Sofonisba Anguissola, and he said, "Of course, she came to Spain as a court painter. We have paintings by her here in the Prado." It was exciting to have him know so much about women artists, and we got along famously.

As our conversation progressed, he said, "Do you know the artist Josefa de Óbidos?" When he learned that the Museum had mounted an exhibition of her work, *The Sacred and the Profane: Josefa de Óbidos of Portugal,* in 1997, he wanted to know how it had been arranged. I explained that the Portuguese ambassador and

It was quite a coup to find this painting of the Archangel Gabriel.

JOSEFA DE ÓBIDOS (1630–1684). *Archangel Gabriel*, 1675. Oil on canvas, 65⅜ x 41⅛ in. (166.1 x 184.9 cm).

his wife were friends and helped arrange for this seventeenth-century artist's work to be exhibited at NMWA. He then told the following story: About a year and a half ago he had attended an art fair. From across the room he noticed a large work that he recognized as a Josefa de Óbidos. Examining it more closely he saw that it was signed "Josefa de Ayalla" with the date. Being very familiar with her paintings, Gabriele knew that this was the way the artist had signed her name.

The art dealer approached him and said, "I see you are interested in this picture. We don't recognize the signature but believe it is from the Escuela Cuzco." Gabriele did not enlighten him about his error but merely noted that the painting was interesting and went on his way. About a week before our visit he was passing by the dealer's gallery in Madrid and out of curiosity went in to see if he still had the Josefa. It was there, with a price tag of seventy-five thousand euros. The dealer said, "Ah yes, you are interested in the Cuzco painting," and Gabriele simply nodded and left. Now he suggested we might want to pursue this rare treasure.

When the gallery opened the next day, I was already outside waiting, along with Ilene Gutman. I spotted the Josefa, a wonderful work by that famous Portuguese artist. After a few minutes the dealer came over and said something in Spanish about the Escuela Cuzco. He spoke no English, and my Spanish is very poor, but we communicated. The asking price was indeed seventy-five thousand euros. After a while I took a piece of paper and wrote fifty thousand and handed it to him. He took it and wrote sixty thousand, firm. I asked him how much it would cost to deliver it to Washington. He followed through later, calling us with the delivery price, which came to about ten thousand dollars.

After consulting with Wally by phone, we decided to buy the painting. Next, I called Pilar and told her that the picture was important, and asked for her help explaining that there needed to be a clear understanding with the dealer. She translated for me, telling him in Spanish that I would make the purchase with money wired to him if he would split the cost of the shipping. He agreed, and this rare painting is now in the Museum's collection, where it is cared for and admired by many.

It was a coup, and we owed it all to Gabriele Finaldi of the Prado. In many years of collecting, we have never seen another Josefa for sale and wonder about its actual worth. Being able to acquire such a historic painting for an affordable price was great good fortune.

Not all acquisitions were such a success. I must also remember the one that got away. I kept a bronze bust called *Peggy* by Evelyn Beatrice Longman in the foyer of our home for many years; it depicted such a happy girl I felt she would put anyone coming into the house in a better mood. It was the likeness of the seven-year-old daughter of Daniel Chester French, the creator of grand sculpture, including the brooding president seated in the Lincoln Memorial. Longman was the only woman French ever hired as an assistant and perhaps the most accomplished American

Peggy by Evelyn Beatrice Longman was made in the likeness of the daughter of Daniel Chester French, the sculptor of the statue in the Lincoln Memorial.

EVELYN BEATRICE LONGMAN (1874–1954). *Peggy (Portrait of Margaret French),* 1912. Bronze, 27½ x 12 x 10½ in. (70 x 30.5 x 26.7 cm).

woman ever to create monumental sculptures herself.

One of her most memorable works was *The Spirit of Communication*, a handsome, gilded bronze youth with lightning bolts coming from his raised hand. Inevitably called "Golden Boy," this forty-ton, twenty-four-foot-tall figure stood atop New York's newest skyscraper, the AT&T Tower, on Broadway in 1916. It was no small thing that Longman got this commission, which was awarded after a blind international competition.

AT&T decided in the late 1970s to build its new headquarters on Madison Avenue. The building was constructed to showcase Golden Boy in the lobby, but the company CEO, surprised that Golden Boy was completely nude, requested that the statue's manhood be removed for modesty considerations.

In 1992 AT&T moved its headquarters to Basking Ridge, New Jersey, and placed Golden Boy at the entrance. The new CEO, whose public relations campaign had everything pegged to the future, felt that the statue was old-fashioned and spoke to the past. He decided to give it away.

When I heard that, I became very excited and dreamed of how triumphant Golden Boy would look atop the west end of our "flatiron" building, facing across Thirteenth Street toward the Treasury Building and the White House. As I've mentioned, the AT&T Foundation had become a founding corporate member of the Museum and underwrote our Library and Research Center. I went back to the foundation's director to see if we might have a chance of receiving Golden Boy.

Because of the statue's weight, AT&T sent structural engineers to do a study. The building was very strong, having been built to the standards of 1907. So the engineers approved, and the city approved, and even Longman's son happily supported the move of his mother's work to Washington. Carter Brown, head of the Fine Arts Commission at the time, was pleased with the idea. He noted how many buildings in Paris had statues on the roof and felt it would be wonderful looking down New York Avenue. All the pieces were falling in place.

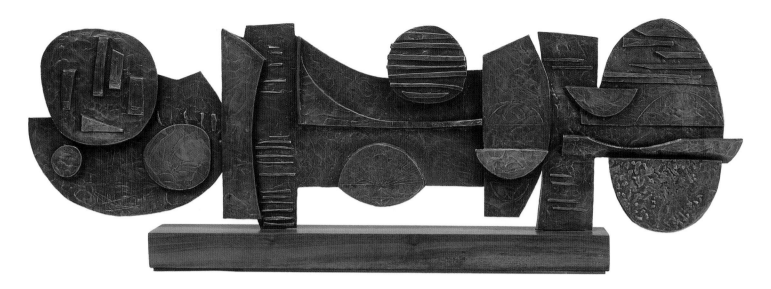

But when the CEO announced his decision to the AT&T staff and workers, a row ensued. Golden Boy might be retro, but he was their beloved icon. They insisted the statue be kept, and the CEO backed down. I was dismayed, and the foundation's director was distressed at reneging on a promise. He assured me that AT&T would make it up in some way; they did, by becoming a Corporate Member (1988–93 at $5,000 per year) and by providing generous support for the exhibitions *Lilla Cabot Perry: An American Impressionist* and *Enterprising Women*. Golden Boy, restored and regilded, now adorns the AT&T headquarters in Bedminster, New Jersey.

<center>⊶⊷</center>

GETTING TO KNOW ARTISTS PERSONALLY makes the collector an especially privileged person, because one learns things that strangers never know and that scholars can puzzle out only after exhaustive study. Take the matter of artistic influences, for example, which has always interested me. Look at Dorothy Dehner and her husband, David Smith. Or Lee Krasner and her husband, Jackson Pollock.

Dorothy was an extremely stylish lady, with echoes of her once-great beauty when I knew her. As a young woman she set out to be an actress and appeared at the stellar Pasadena Playhouse in California. Then she settled in New York, where she found plenty of drama, especially after she gave up the theater, turned to the visual arts, and met David Smith at the Art Students League. They married in 1927 and pursued their artistic careers in tandem. Dorothy invited me to visit her apartment in New York, where I tape-recorded a long interview with her in 1990. One of the things I found most curious was that while she was married she did only line drawings and collages. She explained that David would not allow her to make sculpture, as that was his province and he guarded it jealously.

It was a stormy marriage, she said. They lived on a farm, at Bolton Landing,

This abstract cityscape was inspired by the view from Dorothy Dehner's Manhattan studio.

DOROTHY DEHNER (1901–1994). *Looking North F,* 1964. Bronze, 17⅞ x 62 x 2 in. (45.4 x 162.6 x 5.1 cm). Gift of the artist.

Lee Krasner once came to our apartment in New York for dinner and conversation. She could drink more vodka than anybody I had ever met. After several rounds we bought this work.

Lee Krasner (1908–1984). *The Springs,* 1964. Oil on canvas, 43 x 66 in. (109.2 x 167.6 cm).

in the Adirondacks, where he famously made many of his pieces in steel, and where privately he abused her terribly. It could only have been an extreme love-hate relationship from the start, and it became stormier and stormier. Finally, one night he became so violent that she had to flee—in the nude. She ran to the nearest house, which was some distance away in that rural setting, where the neighbors, a psychiatrist and his wife, gave her shelter. The psychiatrist told her she had to leave David or he would probably kill her. For her own protection, and perhaps her artistic salvation, she ended the marriage. That is when she began to sculpt on her own, she told me.

In 1993 she came to Washington for a greatly deserved show at the Corcoran, *Dorothy Dehner: 60 Years of Art,* arranged by the director, David Levy, her godson. She visited NMWA and was impressed with the work on display. She was intrigued and very sympathetic to the idea of a museum for art by women, and she wished to be included. She told me to pick anything I wanted from the exhibition for our permanent collection.

I chose *Looking North F,* a beautiful configuration of wooden elements that were then cast in bronze. While it appears abstract at first glance, it is a cityscape inspired by the view from her studio in lower Manhattan, an interpretation of a geographic, physical reality. While it has a balance that might be seen as resonating with David Smith's work, in its representation of a geographic reality it is utterly original. Could

it have been inspired by Smith? Or could it be that she inspired his later work?

That question led me to wonder what Smith's work would have been like without her—without either her inspiration or the distraction of that violent love-hate match. I also wonder what kind of artist she would have become had she married another man. These are questions for the critics and historians of art to ponder.

<center>⊹</center>

ANOTHER WOMAN WHO LIVED IN HER HUSBAND'S SHADOW was Lee Krasner. In about 1991 she came to our apartment in New York for dinner and conversation. (Not even on my trips to Russia have I ever seen anyone drink vodka like she did.) The upshot was that we bought one of her great works, *The Springs*.

In this and other canvases in the same genre, Lee told me, she was drawing shapes she saw in nature—inspiration derived from the rural surroundings of the home she shared with Pollock on eastern Long Island. For reasons that remained unexplained, she did not exhibit this body of work publicly until years after creating it; yet she began making these pictures at least two years before Pollock rose to fame for his drip-painting abstractions, the action compositions that have a striking resemblance to hers.

Pollock, of course, became known as a pioneer abstractionist, the baddest boy of his era, whose rowdy behavior and drinking cost him his life at the wheel of a careening car. Lee lived in the background as an artist while he was alive; she gained public stature only after his death. And when her star rose, it was with pictures that included what appear to have been springboards—in terms of composition if not technique—for the kinetic, action-created canvases that brought her husband extraordinary fame.

So I ask the question: Could Jackson Pollock's signature works have been influenced by the earlier drafts of his wife, Lee Krasner?

<center>⊹</center>

THE AUTHOR, PLAYWRIGHT, AND DIPLOMAT CLARE BOOTHE LUCE had been our distinguished ambassador to Rome for several years, and after her retirement she was a regular guest at the Italian embassy in Washington. I met her at a small dinner there a few years after the Museum opened, and she said, "I have something for you, a Frida Kahlo." This was before that great Mexican original had become such an extremely popular painter, but of course I knew her work and admired her as one of the most gifted women painters of Latin America.

Mrs. Luce had two apartments at the Watergate, one her residence and the other a storage facility for her art, furniture, papers, books, and vast numbers of

Self-Portrait Dedicated to Leon Trotsky by Frida Kahlo was a gift of Clare Boothe Luce. It is the only Kahlo on view in Washington, D.C.

FRIDA KAHLO (1907–1954). *Self-portrait Dedicated to Leon Trotsky*, 1937. Oil on Masonite, 30 x 24 in. (76.2 x 61 cm). Gift of the Honorable Clare Boothe Luce.

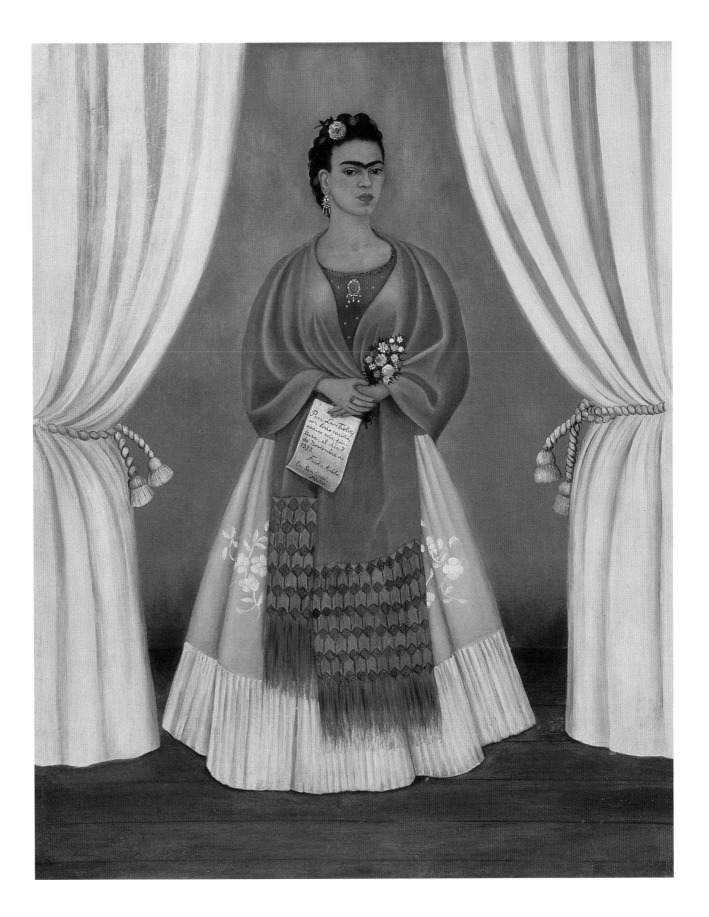

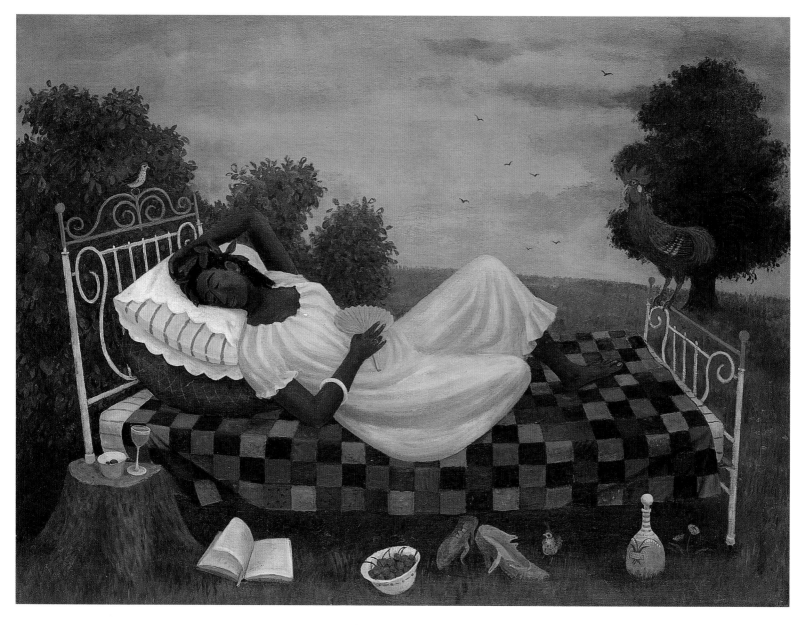

mementos of her fascinating life. Mrs. Luce greeted me cordially, wearing a blue peignoir, her hair beautifully styled. Without any further preamble, she declared, "I'm going to die in two months. There are a few things of interest that I want you to have for your museum." Clearly, she did not intend to waste any time.

One of her gifts was Kahlo's remarkable *Self-Portrait Dedicated to Leon Trotsky,* and she told me an incredible story about it. While conventional scholarly wisdom holds that Kahlo presented the picture to Trotsky, who was briefly one of her lovers, Mrs. Luce had another account. She said she was visiting in Mexico when Kahlo had just finished painting it; indeed she was in the artist's studio when the phone rang and the caller told Kahlo that Trotsky had just been assassinated. A tormented soul at the best of times, the artist was devastated by the news and went momentarily

DORIS LEE (1905–1983). *Cherries in the Sun (Siesta),* c. 1941. Oil on canvas, 27 x 36 in. (68.6 x 91.4 cm). Gift of the Honorable Clare Boothe Luce. Courtesy of the Estate of Doris E. Lee, William P. Emrick.

Wally and I have a family tradition. He gives me a work of art every Christmas. Years ago it was Harriet Whitney Frishmuth's sculpture, Playdays, *for our fountain in the garden.*

HARRIET WHITNEY FRISHMUTH (1880–1979). *Playdays*, 1923. Bronze, height: 50½ in. (127.3 cm). Promised gift of Wallace and Wilhelmina Holladay.

insane, picking up a knife, saying, "I'm going to kill myself," and then running at the canvas to slice it to bits. Luce intervened, she told me, and said, "No, no, don't destroy it. Please, sell it to me, and I will preserve it as a tribute to Trotsky." That is how the picture survived.

Mrs. Luce was a practical, real-life feminist, though she never claimed to be. She was a do-as-I-do-and-not-as-I-say feminist, and she believed firmly in our Museum's cause. Along with the Kahlo self-portrait, she also gave us a picture by Doris Lee, *Cherries in the Sun,* and part of her personal library. She was a woman for all seasons.

More recently Wally gave me a beautiful portrait by Cecilia Beaux, Ethel Page (Mrs. James Large). *This work is now in NMWA's collection.*

Cecilia Beaux (1855–1942). *Ethel Page (Mrs. James Large),* 1884. Oil on canvas, 30 x 25⅛ in. (76.2 x 63.8 cm).

THIS ACQUISITION IS NOT YET PART OF THE MUSEUM COLLECTION, but it will be one day, and I thought I would tell the story because it is a very special memory to me. We have a tradition. The family, including our four grandchildren, gathers on Christmas Eve, and we get all dressed up. Wally knows what I want for Christmas, as we talk a great deal about art. Several times, he has bought me a work of art as a surprise and has hidden it in an open place, where everybody can see it but me. Being very busy, I don't notice.

One Christmas it was a Harriet Whitney Frishmuth's sculpture, *Playdays,* for our fountain out in the garden. Frishmuth created many sculptures of beautiful young girls blossoming into womanhood. This one is up on her toes, as if dancing, and the frogs around her are spitting water. Wally installed *Playdays* in our garden without my knowledge. He wrapped a big red ribbon around the waist of the lovely nude cast in bronze, tied a bow, and put on the garden lights. But I was very, very busy and didn't look out of the window of the garden room library where the family was gathered. Of course, my grandchildren were tee-heeing and talking and trying to make me aware of it in a funny way, and I—busy making sure everybody was being properly taken care of—wasn't paying any attention whatsoever.

Finally, the littlest one, Addison, said, "I want you to look out the window."

And I said, "Well, fine, why? What's out there because it's evening, it's nighttime."

And he said, "I want you to look out the window," and he took my hand and dragged me over to the window, and there was this beautiful statue, Wally's present to me. And, of course, the children just loved this. The next year, as I was sitting at the table with my back to the fireplace, the picture over the mantel had been removed (unbeknownst to me), and Wally's Christmas present was hanging in its place. This time it was Cecilia Beaux's *Ethel Page (Mrs. James Large),* which is now in NMWA's permanent collection. The children loved the excitement, and Wally did too.

The Shows That Went On— The First Ten Years

L OOKING BACK OVER TWENTY YEARS OF EXHIBITIONS, I continue to be encouraged and heartened by several pleasant facts. For one, while all art does not appeal to all people, art by its very nature stirs human emotions and provokes reaction. I think it is fair to say that every one of our exhibitions warmed someone's heart. Furthermore, the more important shows pleased and excited thousands of our members and visitors. I have never ceased to be amazed by the range of great art we have been able to exhibit—and surprised by the variety of opinions expressed by individuals, and even by the critics: encouraging or disparaging, a rave review or none at all. I believe that this feast over the course of twenty years is impressive.

Ellen Day Hale's June *was included in NMWA's first exhibition,* Highlights from Washington's Newest and Oldest Museums, *organized in 1984 in collaboration with the U.S. Capitol. At the time we were still looking for a building to house the Museum, and the show was held at the USA Today headquarters in Rosslyn, Virginia.*

ELLEN DAY HALE (1855–1940). *June,* c. 1893. Oil on canvas, 24 x 18⅛ in. (61 x 46 cm).

NMWA's FIRST EXHIBITION, June 21 to November 14, 1984, went largely unnoticed but deserves to be reported for the record. Anne Radice, curator in the Office of the Architect of the U.S. Capitol, became interested in the Museum. It turned out that the Capitol's art collection included works by women. Anne identified those and obtained permission from Congress to borrow some of them. About the same time Vince Spezzano, Sr., vice president of the Gannett Company, suggested through a friend, Grace Nelson, that NMWA might want to hold an exhibition in his handsome USA Today headquarters in Rosslyn, Virginia. We called the exhibition *Highlights from Washington's Newest and Oldest Museums: The National Museum of Women in the Arts and the U.S. Capitol Collection,* and I felt the name was right for a number of reasons. In spite of the fact that the show was modest, it was prestigious to be associated with the Capitol. The modest catalogue in beige and black was prepared

by Anne and Mary Lou Hansen, and the checklist of the exhibition was written by Pamela Violante, all of them associates of Anne Radice. Many of our members came to see the forerunner of what was to be.

In the catalogue, the Architect of the Capitol, Mr. George M. White, wrote:

> I am delighted to have this privilege and opportunity to participate in this premier exhibition sponsored by the National Museum of Women in the Arts and to express my sincere and warm welcome to this praiseworthy addition to the museum community.
>
> The exhibition, a joint effort between the U.S. Capitol and the National Museum of Women in the Arts, presents a selection of masterworks of special historic and aesthetic significance. This small sampling of works suggests the depth of both collections through the inclusion of many media. The U.S. Capitol is fortunate to have in its collection numerous magnificent works of art by women artists. I am pleased and honored to be able to share this selection of their artistry in this exciting celebration.

Our real inaugural exhibition at the Museum, *American Women Artists: 1830–1930*, broke new ground in several ways when it opened in 1987. Of course, it was our debut, a landmark in itself, and it was reported in national magazines and newspapers everywhere. For the most part, the critics and cultural reporters welcomed us warmly. John Russell in the *New York Times* wrote: "Women artists have suffered, and still do, from the indifference of curators, dealers, and critics. Not least they have suffered from the indifference, if not the downright hostility, of male artists, many of whom are obsessed with 'turf' in their attitude toward woman artists. To have a museum of their own to go to is very tempting to women artists who know that if it comes to a choice between showing a male artist and a woman artist of comparable stature, most museums will go for the men, as will many dealers also."

I felt vindicated by his coverage, and the wide attention we received. There was only one notable exception that still pains me to remember. Robert Hughes wrote an article in *Time* magazine that slapped both NMWA and the Terra Museum in Chicago. He targeted us for special attention, noting: "Until ten years ago, with a few resolute exceptions like Georgia O'Keeffe, Mary Cassatt, and Louise Nevelson, women artists were shabbily treated by American museums and either omitted from their collections or treated as token presences. The idea that art by women was necessarily second rate lingered discreetly in some quarters through the '70s. Today it is gone, at least in America." He noted that living artists like Nancy Graves, Louise Bourgeois, Susan Rothenberg, and Cindy Sherman are collectable and pronounced: "No talented woman has real difficulty getting her work into a serious gallery." The fact that even today the above artists are hardly household names belies his premise.

The inaugural exhibition in the Museum's current location, American Women Artists: 1830–1930, *included a painting by Elizabeth Jane Gardner Bouguereau. The lion in the picture was sketched at the zoo in Paris. When the lion died, Bouguereau bought the body and kept it with the live lamb in her studio until she finished the canvas.*

ELIZABETH JANE GARDNER BOUGUEREAU (1837–1922). *The Shepherd David,* c.1895. Oil on canvas, 61½ x 41⅜ in. (153.7 x 105.1 cm).

Hughes then argued: "What is true, however, is that most female artists, like most male ones, are not very talented and live ill-known in a catastrophically overcrowded art world. Thus it is easy for Ms. Anybody, M.F.A., to blame the obscurity of her work on sexist machinations against her as a member of a class and plangently call for redress in quotas and affirmative action. Hence the National Museum of Women in the Arts . . . an idea whose time has gone." While he said some other hurtful things, and seemed to have a personal vendetta against us, what angered me especially was the fact that, so far as I knew, Robert Hughes had never been to the Museum or talked with anyone connected with its formation. He certainly never interviewed me.

The debut exhibition was a success. We had engaged Dr. Eleanor Tufts, an eminent feminist art historian at Southern Methodist University in Dallas to organize and curate it. Dr. Tufts did a great job of identifying and gathering outstanding works by American women artists. Rather than chronologically, the exhibition was organized in five categories: portraiture, genre and history, landscape, still life, and sculpture—the areas in which women made many outstanding contributions. The exhibition carried our banner when it went on tour to the San Diego Museum of Art; the Minneapolis Institute of Arts; the Wadsworth Atheneum in Hartford, Connecticut; and the Meadows Museum at SMU. Ninety-nine paintings and twenty-five sculptures by American women artists—as early as Charles Willson Peale's nieces, Anna Claypoole Peale (1791–1878), Margaretta Angelica Peale (1795–1882) and Sarah Miriam Peale (1800–1885)—were being seen seriously, some of them for the first time. NMWA's presence was getting noticed—in *Antiques Magazine*, *The New York Times*, and elsewhere; NMWA was being recognized for achieving an essential museum function, namely organizing and mounting a significant exhibition.

When *American Women Artists* opened at the San Diego Museum of Art, Steve Brezzo, my friend and the director, organized a masked ball to celebrate the opening.

He articulated the important message that—regardless of whatever had been happening on the "women's lib" front—this was not a sexist show. Rather, he called it "a first step towards rewriting art history." Writing in the *San Diego Union,* art critic Robert L. Pincus celebrated the fact that feminist historians and curators had "already set in motion the needed pressure on mainstream museums to incorporate art by women into collections, shows, and books."

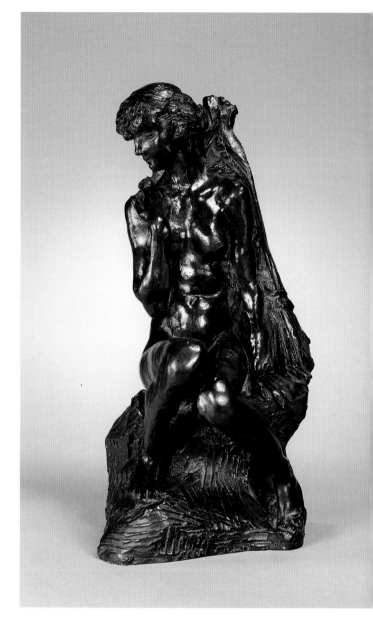

⊶———⊷

IN 1988 WE ORGANIZED THE FIRST RETROSPECTIVE IN AMERICA of work by the extraordinary French sculptor Camille Claudel, a beautiful woman better known as Auguste Rodin's celebrated model, assistant, and mistress. Claudel's love affair with the famous sculptor, who was twenty-four years older, ended tragically with her nervous breakdown. The artist's family put her in a mental hospital, where she spent thirty miserable years prior to her death in 1943.

"Her systematic brutalization is one of the most loathsome episodes in the long and often somber history of French family life," John Russell wrote in *The New York Times.* But what he had to say about her work and our exhibition was far more important to me: The exhibition proved Claudel to be a "gifted, intelligent, hardworking, and innately heroic artist whose surviving work deserves close professional attention at a high level. Nor should we ever forget that she lived in a time when the notion of a woman as an artist of genius was thought to be contrary to nature." Further, he noted that "the National Museum of Women in the Arts in Washington has done us all a service by presenting the retrospective." Russell, the leading critic of the time, came to few exhibitions in Washington, so for him to give us a positive review was high praise. Wally and I were active socially then, and I sensed from our peers that the Museum's worth in art and other circles had enjoyed a significant lift.

Camille Claudel: 1864–1943 was co-curated by the artist's grandniece and biographer, Reine Marie Paris, and an American scholar residing in France, Meredith Martindale Frapier. Many French museums and private collections, including Musée Rodin, loaned sixty-three of Claudel's best works for the exhibition. The show traveled to Japan, where it was sponsored by Asahi Shimbun (thanks to the Japanese connections of NMWA trustee Lily Tanaka and her husband, William).

NMWA held the first exhibition of Camille Claudel's work in the United States. I bought this sculpture for the Museum from the artist's family after the exhibition closed.

CAMILLE CLAUDEL (1864–1943). *Young Girl with a Sheaf,* c. 1890. Bronze, 14⅛ x 7 x 7½ in. (17.8 x 19.1 cm).

TOP: *Greek Ambassador George Papoulias and his wife, Emily (here with Wally and me in 1989), helped bring to NMWA* Three Generations of Greek Women Artists.

ABOVE: *Agnese Udinotti's* Monument to My Father #40 *was included in this exhibition and is in the collection of Alexandra Udinotti of Athens, Greece.*

In addition to Claudel's fabulous drawings, and plaster and bronze pieces, the exhibition included some Rodin works that were inspired by their relationship, such as *La France, Mademoiselle Camille Claudel,* and *Galatea.*

Claudel's earlier works, *Young Girl with a Sheaf* (which I purchased for NMWA's permanent collection), *The Flute Player,* and *The Waltz,* reflect her happiness in the mutually enriching relationship with Rodin. Her later works are expressions of agony, passion, and rebellion directed against the great sculptor, who abandoned her for a longtime mistress, Rose Beuret, whom he married on her deathbed.

Since NMWA's exhibition, Claudel has been recognized internationally as one of the most interesting women sculptors. A film starring Isabelle Adjani made Claudel, like Frida Kahlo, a popular heroine of our times.

NMWA's Washington location has always been a great advantage as we seek to organize stellar international art exhibitions. Since our earliest days, my connections, and others', to the ambassorial community have enabled us to bring to fruition important international shows that have surprised and delighted the critics and public alike. We proudly debuted our first co-sponsored project of this kind thanks to Greek Ambassador George Papoulias and his wife, Emily, who had become friends. Melina Mercouri, the famous actress remembered for her role in *Never on Sunday,* was the cultural minister of Greece. When her brother came to the embassy for a visit, we attended a party in his honor, and I invited him to the Museum. A 1989 exhibition, *Three Generations of Greek Women Artists: Forms, Figures, and Personal Myths,* resulted from this brief encounter. *The Washington Post* expected quiescent and demure art, but this exhibition turned out not to be "pretty." Instead, the critic Michael Welzenbach wrote in *The Washington Post* that the exhibition demonstrated that "contemporary Greek art is beginning to make itself felt abroad, and that Greek women artists rank with the men. In fact . . . women would appear to be ahead of them." I was also pleased by the comment that "the museum has graduated to an impressive level of curatorial acumen."

A year later we offered our first exhibition of long-overlooked American Impressionist Lilla Cabot Perry, a Boston Brahmin by birth and a disciple and friend of the French master Claude Monet. Meredith Martindale Frapier curated the exhibition. Pamela Moffat, whose husband was related to the artist, helped with loans, memorabilia, and artifacts from the family. *Post* reviewer Hank Burchard exclaimed: "NMWA has mounted a magnificent Perry retrospective that promises to restore her to the front rank of American artists. She'll be awfully hard to overlook after this formidable display of seventy-five paintings which reveal Perry to be an impressive stylist who reveled in her artistic freedom yet never relaxed her self-discipline." Perry famously summered in France at Giverny with her Impressionist friends; she also studied art and worked in Japan, perhaps the first American woman to do so; after all, Commodore Matthew Perry, the naval hero who "opened" Japan to the West, was her husband's uncle.

The exhibition Lilla Cabot Perry: An American Impressionist *introduced this neglected Boston artist to the public.* Lady with a Bowl of Violets *became a popular icon at NMWA. She was on the cover of our early membership brochure as well as the poster advertising the exhibition.*

LILLA CABOT PERRY (1848–1933). *Lady with a Bowl of Violets,* c. 1910. Oil on canvas, 40¼ x 30 in. (102.2 x 76.2 cm).

A GALA MARKED THE OPENING OF *Stitches in Air: Antique Belgian Lace and Contemporary Interpretations* in April 1992. Ambassador Juan Cassiers attended with his wife, Marguerite. "It's been known for a long time how talented women artists have been throughout the ages, but it needs to be said again. Men tend to forget sometimes," observed Mrs. Cassiers, emphasizing the fact that lacework requires care, fine labor, discipline, and dedication, qualities that are universally feminine.

How the show came to be is another one of those links-in-a-chain stories. Several years ago I was putting in a routine day in my office at the Museum—another one that proves that no day is routine—when the receptionist put her head in the door and said, "The Countess du Monceau de Bergendal would like to see you." She was wide-eyed, as visits by countesses are not routine occurrences here. Beautifully dressed and speaking elegant English, the countess said in essence, "I am very interested in what you are doing. We have a wonderful women's club interested in art in Brussels, and I am its president. Perhaps there is some way we could work together." I told Nadine—we were soon on a first-name basis—that Wallace and I would be in London in a few months, and perhaps we could fly to Brussels so that I might give a slide lecture about the Museum to the members of her committee. She was pleased, and Wallace and I made the trip.

Nadine gave a dinner party for us in her magnificent house facing the main square of Brussels. We were served wild game and other delicacies by liveried footmen. It was an unusual experience, and I admit being very impressed. Her club was made up of a group of knowledgeable, responsive women. We also visited Nadine's village, an hour outside of Brussels—yes, she seemed to own the whole village. She was treated like royalty, as were we.

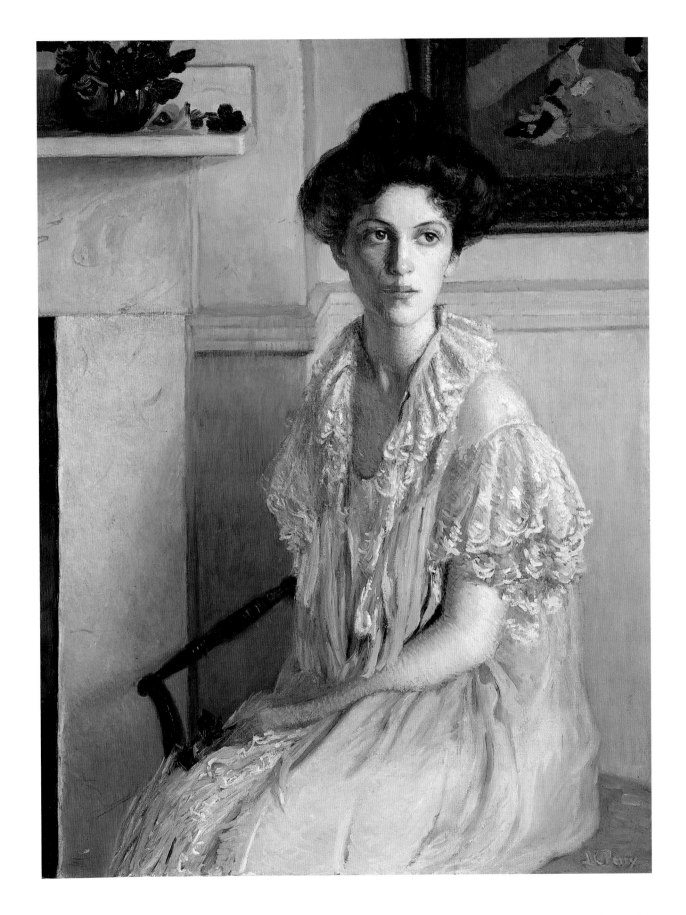

When the countess found out that we took groups from the Museum on interesting trips abroad, she offered to arrange one for the group in the Lowlands. It turned out to be one of our most memorable trips. Touring the countryside, we were made welcome in private châteaus, even a palace, most of which were owned by relatives of Nadine.

Thanks to her efforts we were privileged to meet the remaining royalty of Belgium, who still maintain a rare stratum of privilege. When we visited the beautiful palace of her cousin, a prince, he said, "My family has lived here for seven hundred years." I could think only that this was long before the history of our country even began. I found it awesome that this branch of Nadine's family had steadily used and kept in wonderful condition a building that was seven hundred years old. It was filled with priceless art and antiques.

Visiting her nephew's huge estate, we were entertained with champagne in the large library. As he prepared to uncork the bottle, his dog immediately positioned himself some feet away. When the cork blew out, the dog expertly caught it in his mouth. We clapped our praise, and our host said, "Oh, he does it every day, as we always have champagne at this hour."

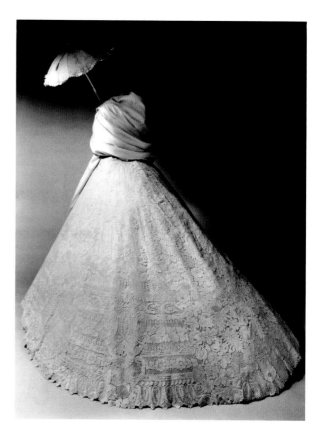

Every two years Brussels hosts its International Lace Biennial competition, sponsored by Queen Fabiola. Artists using both ancient skills and technology create contemporary works in linen fibers, including multidimensional wall hangings and lace sculptures so beautiful they take your breath away.

Jean Astrop of our Georgia Committee had a Belgian friend who worked closely with Her Majesty to arrange the biannual exhibitions. Jean had visited the shows in Brussels for some years and had been kind enough to share the catalogues with me. When I mentioned this to Nadine she offered to arrange for NMWA to bring the next display to Washington. We came up with an idea that made the exhibition truly special. Nadine's husband had been secretary to the king, a position of great prestige, and she was able to persuade the government to loan us the elegant antique lace veils and garments worn by the country's queens for their weddings and coronations. These were national treasures never before shown outside Belgium. The NMWA show was two-faceted. In one

OPPOSITE, TOP: *The* 1992 Stitches in Air *exhibition included this beautiful* Jupe de Gala, *c.*1867.

OPPOSITE, BOTTOM: *This modern interpretation of lacework by Louise Termolle was also included in* Stitches in Air.

BELOW: *Photographer Carrie Mae Weems brought new audiences to NMWA.*

CARRIE MAE WEEMS (born 1953). *Untitled (Man Smoking),* n.d. Silver print, 27 x 27 in. (10½ x 10½ cm). Courtesy of the artist and Jack Shainman Gallery, New York.

large gallery were the grand old treasures once worn by royalty, and in another were the wonderfully creative contemporary lace masterpieces.

FROM THE BEGINNING, NMWA's board and staff understood that contemporary women artists were really making great strides in the 1980s and 1990s, exploring ideas that were significant and, at times, challenging to audiences both here and abroad. Providing emerging and midcareer artists with their first museum exhibition was and is an important part of our mission. We also knew it was beneficial for the Museum to introduce these new artists to the public, artists whose works might not be seen anywhere else.

One example was Carrie Mae Weems, an African-American photographer, whose work we were privileged to exhibit in 1993 in her first retrospective anywhere. Here was an artist with a political mission: to reveal "the status and place of Afro-Americans in our country." And yet, as *Washington Post* journalist Jo Ann Lewis pointed out, the exhibition "is anything but the customary in-your-face political tract about race, class, and gender. A photographer and storyteller of broad range and sensitivity,

Weems at her best manages to advance the discourse in word-image combinations that are deeply moving and sensuously beautiful." Michael Kilian wrote, in the *Chicago Tribune*, "If ever there were pictures each worth the proverbial thousand words, they are those of the black photographer Carrie Mae Weems." Again, the show, co-curated by Susan Fisher Sterling, carried our name far and wide. It traveled and was seen by appreciative audiences in Saint Louis; San Francisco; Miami; Cincinnati; Los Angeles; Portland, Oregon; Minneapolis; and Philadelphia.

Recognizing the global nature of contemporary art, we again moved beyond the U.S. in 1993 and 1994 to present *UltraModern: The Art of Contemporary Brazil* and *Forces of Change: Women Artists of the Arab World.* Both shows were cutting-edge, but they were

Frida Baranek's iron sculpture, shown here, has the lightness of a drawing in space. The artist was included in the exhibition UltraModern: The Art of Contemporary Brazil.

FRIDA BARANEK (born 1961). *Untitled,* 1991. Iron, 43 x 39 x 75 in. (109.2 x 99.1 x 190.5 cm). The Lois Pollard Price Acquisition Fund. Courtesy of the artist.

very different in intention and scope. For *UltraModern,* Marisa Ricupero, wife of the ambassador of Brazil, and cultural counselor Fausto Godoy arranged for NMWA chief curator Susan Fisher Sterling to visit Brazil with them to select the best of contemporary Brazilian art by women. The result was a landmark show of abstract and conceptual art created from the mid-1950s to the present by eighteen artists, including Lygia Clark, Mira Schendel, Beatriz Milhazes, and Regina Silveira, whose work was then virtually unknown in North America. The show's sophisticated styles also debunked the strongly held belief here that Brazilian culture is all about sensual and exotic hedonism. Ultramodern it was, with constructions using high-tech materials including acrylics, aluminum, weathered iron, and matte and reflective plastic, representing a contemporary urban culture that is integral to the life of Brazil. For the Spring Gala, Brazilian Nelson Buoro flew in from the Amazon, as one reporter Patricia Dane Rogers wrote in *The Washington Post,* "with a planeload of ginger blossoms, orchids, and exotic palms to transform" the Great Hall.

In 1994 we organized and debuted *Forces of Change,* a show of works by Arab women, the first to tour the United States under our aegis. A juried show curated by Salwa Mikdadi Nashashibi, it was the most comprehensive exhibition of contemporary Arab women artists ever assembled in the United States—160 works by 70 artists from 15 countries—sculptors, painters, photographers, ceramists, and

The groundbreaking exhibition, Forces of Change: Women Artists of the Arab World, *featured work by contemporary Arab women. It underscored the unifying power of art in spite of raging conflicts in the Middle East.*

computer, video, and installation artists. It broke new ground by providing an extraordinary overview of the work Arab women are producing both in their own countries and abroad. Nashashibi, president of the International Council for Women in the Arts, built the show around four themes: Problems of Daily Life; the Influence of Contemporary Art Movements on Arab Artists; Explorations of Traditional Artistic Expressions; and Image and the Word—namely modern interpretations of Arabic calligraphy and the use of the written word as a mode of visual expression.

I was so eager to present this show, in part, because it proved the great unifying powers of art. There was "a wholly unexpected feeling of creativity and freedom" in these works, "not the widespread popular image of a veiled, silenced, and put-upon female population stuck somewhere between the belly dancer, the harem, and modern religious arguments about veiling," noted Amy E. Schwartz in *The Washington Post.* Her review emphasized that the exhibit "does more than any news footage to evoke the chaotic, jumbled textures of the modern Middle East."

Schwartz observed: "Though the National Museum of Women in the Arts isn't known for flaming polemics, you'd expect its new show on women in the Arab world to be, if not too hot to handle, at least politically volatile. The people who put the show together, female Arab artists and sculptors from fifteen countries, would answer that that's just one more media misconception about their lives."

NMWA organized a symposium during the exhibition's duration. One speaker, the first woman to qualify as a surgeon in Sudan, Nahid Toubia, suggested that fundamentalist movements in many cases have arisen in response to the substantial progress being made by women as they demand and enjoy greater freedom and equality in the Arab world.

Forces of Change gave wide coverage of the diversity of the arts in the Arab world, with particular emphasis on the experimental and contemporary forms of expression.

———⊶———

FOR ANOTHER EXHIBITION, one of our more unexpected partners was the car manufacturer BMW, which had already demonstrated interest in art when it invited celebrated male artists, including Robert Rauschenberg, Andy Warhol, and Alexander Calder, each to adorn one of its cars. The only woman invited to do so was the South African artist Esther Mahlangu, a member of the Ndebele tribe, a native community of South Africa that for generations had been decorating house exteriors with hard-edged freeform designs as a kind of public message—to announce births

Esther Mahlangu, a member of Ndebele tribe of South Africa, arrived at NMWA to celebrate a display of the BMW she was commissioned to paint with her tribal designs. Taking advantage of Mahlangu's visit, we asked her to create a mural on the façade of the newly acquired building next door, which was to become the site of the new Museum annex. The exotic artist on the scaffolding stopped traffic on New York Avenue for hours.

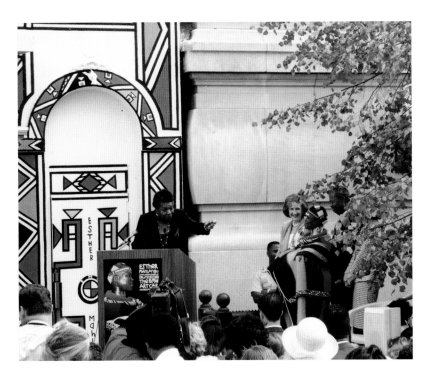

ABOVE LEFT: *Maya Angelou spoke at the inauguration of Mahlangu's mural.*

ABOVE RIGHT: *At the time when Mahlangu painted the mural, South African President Nelson Mandela visited NMWA. I was thrilled to give a tour to this great man.*

and marriages, for example. Esther was one of the most exotic women to appear in Washington ever. As one newspaper account by Lynne Duke in *The Washington Post* described the sexagenarian: "Her neck is stretched long and regal by the rows of copper and brass chokers she has worn like a neck brace since [puberty] as the tribal custom for married women. Metal rings also encase her lower arms and legs, and thick beaded bracelets and anklets added color. A beaded goatskin skirt hangs to her knees, topped by a woolen blanket wrapped shawl-like around her bare chest." She would never get through airport security today; even in 1994 she stopped traffic.

Esther Mahlangu attracted extraordinary attention and generated articles not only in the art press, but also the African-American press and the automotive press. It was certainly a first for NMWA to be featured in *AutoWeek* magazine as we unveiled in the Great Hall one of BMW's thirteen art cars, the model 525i as decorated by a South African woman in a sub-Saharan style.

Mahlangu's project even brought Maya Angelou to speak at the exhibition's opening. But Esther did more than attend the unveiling of the car that she had painted in South Africa. The old building next door—which we had purchased to tear down and make way for an addition to the Museum—was still standing. A scaffold was built so that Esther could paint striking traditional murals in acrylics on the facade. Cars stopped in the middle of the street, and people watched from the sidewalk as this exotic creature painted away without a nod to them.

Nelson Mandela, South Africa's newly elected president and a member of the Tembu tribe, made a state visit to Washington at the time of this exhibition. The National Museum of Women in the Arts was the only museum he visited in

Washington. I was preparing to take him on a tour of the exhibition when a member of his entourage pulled me aside and said, "Under no circumstances are you to take him up and down steps, on doctor's orders. You must arrange the tour so that there are no steps for him to climb."

The show included some wonderful tapestries, handmade by the women of the Ndebele tribe, which had been hung at a lower level. As I was leading President Mandela through the exhibition he looked over the railing of our spiral stairway and spotted the tapestries. He became excited and said, "Come, Mrs. Holladay. I want to tell you about those tapestries." He proceeded to march down the steps while telling me about the folktales that the tapestries depicted. One showed a woman with a large basin on her head; a serpent in a tree descended toward the basin. Mandela explained that the serpent was very dangerous and had been frightening the people in the village. This brave woman had boiling water in the basin on her head; the serpent dropped into it and was killed. I enjoyed hearing the story, but I was horrified when he turned and began to climb back up the rather long stairway to continue the tour. There were gasps and looks at me, but we carried on. Fortunately, he seemed fine.

I had been instructed that under no circumstances should anyone impede his departure. A teacher from a nearby public school had brought her all-black second-grade class to see Mandela. While he was leaving, he saw them and left his entourage to talk to the teacher and shake hands with the children. There was nothing I could do to interrupt the happy delay.

It was a real privilege to have had this brief time with this great and wonderful man. In spite of his historic importance, our meeting made evident his very human and kindly approach to life.

As for Mahlangu's murals, they remained on display for some time. When the wreck next door was razed, her work was broken up, but not before we photographed it and kept a few examples for a permanent record.

⊷

In 1995 we made headlines with the exhibition of *Sofonisba Anguissola: A Renaissance Woman*, which originated in Cremona, Italy, went to the Kunsthistorisches Museum in Vienna, and then came to NMWA, its only stop in the New World. The show was covered by the *International Herald Tribune*, among many other papers. Its critic, Roderick Conway Morris, called her "one of the most gifted and original artists of the sixteenth-century, [who] achieved during her lifetime international celebrity and the admiration of fellow artists from Michelangelo to Van Dyck, only to sink subsequently into almost total obscurity." Another case of a brilliant woman artist being forgotten. And what a life she had!

When the exhibition Sofonisba Anguissola: A Renaissance Woman *opened in 1995 we did not have a painting by this artist in NMWA's collection. Six years later I was overjoyed to acquire this portrait.*

Sofonisba Anguissola (c. 1532–1625). *Double Portrait of a Lady and Her Daughter*, n.d. Oil on canvas, 52 x 39½ in. (132 x 100.3 cm).

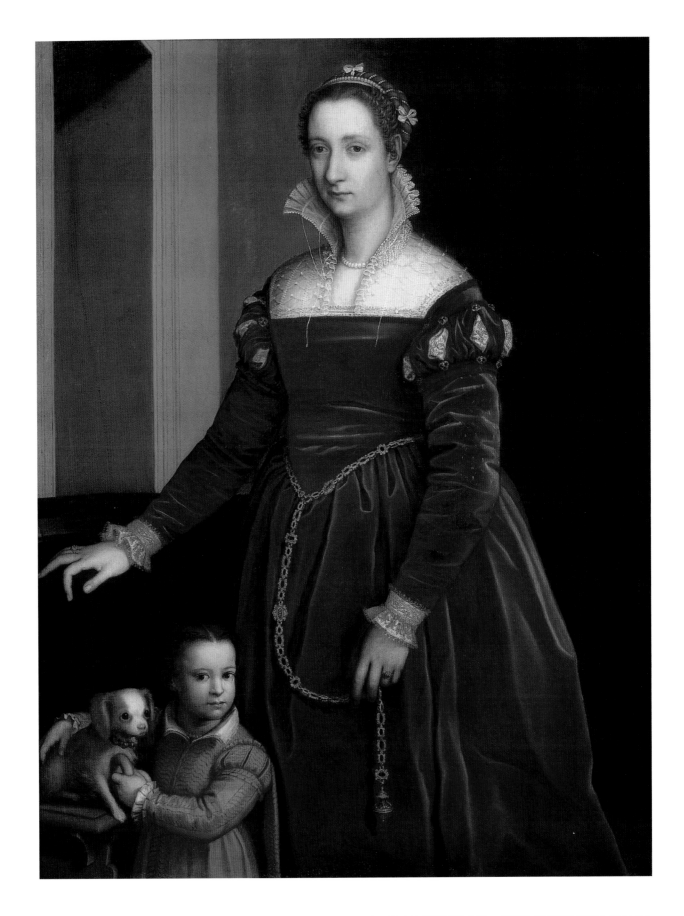

Nobly born in Cremona, Sofonisba studied painting and won such acclaim that she was invited to Spain and the court of Philip II, where she spent fourteen years teaching drawing to Queen Isabel de Valois and painting portraits of the nobility. But she did not sign her work, nor did she accept commissions in the usual manner, with contracts and invoices and receipts, in other words the kind of paper trail that enables scholars to make firm attributions. Given the mores of the day, she was paid for her portraits in gifts of gems, extravagant clothing, and favors from the court. Marrying reluctantly, she was widowed by Barbary pirates and then married a younger man, a sea captain himself.

With this show, *The Washington Post*'s Paul Richard asserted, "the National Museum of Women in the Arts, doing just what it's supposed to do, has retrieved from obscurity Sofonisba Anguissola, a painter of the Renaissance ignored far too long by most masculinist historians and nearly everybody else." Deserving to be known, "her painting is too competent, her story too adventurous . . . her accomplishment too rare." *Smithsonian* magazine devoted four pages to her pictures. It was a glorious exhibition.

Queen Sonja and King Harald of Norway flew to Washington for the opening of the exhibition At Century's End: Norwegian Artists and the Figurative Tradition, 1880–1990.

<div align="center">⟷</div>

A GROUP SHOW OF MODERN PAINTERS brought Queen Sonja of Norway to open the 1995 exhibition *At Century's End: Norwegian Artists and the Figurative Tradition, 1880–1990*. With her husband, King Harald, she was making an informal visit to the United States (not a state visit) in order to advance economic and, particularly, cultural relations. The featured artists were Marianne Heske, Ida Lorentzen, Kristin Ytreberg, Hanneline Rogeberg, Hege Nyborg, Line Waelgaard, and Kitty Kielland. The Norwegian Chamber Orchestra, which was led by a woman, played for an invited audience that included Second Lady Tipper Gore, with a picturesque Norse honor guard in attendance in the Great Hall.

I became very good friends with the Norwegian ambassador and his wife as a result of planning this exhibit. I was deeply moved when he announced that the king and queen wanted to knight me. The first part of the ceremony would be at the embassy, and then the king would bestow the honor in Oslo. Ten of us went to Norway, where we enjoyed visiting the studios of some of the country's top artists as well as the magnificent scenery.

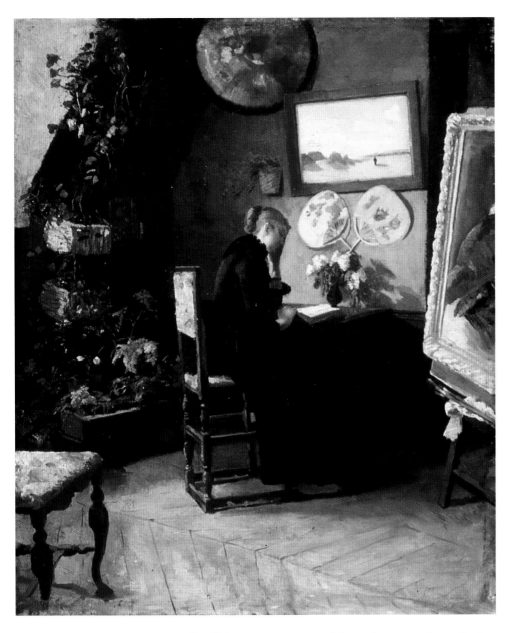

This painting by Kitty Kielland was selected by curator Susan Fisher Sterling for At Century's End.

KITTY KIELLAND (1844–1914). *Studio Interior,* 1883. Oil on canvas, 16¾ x 14½ in. (42.5 x 36.8 cm).

From time to time, we were delighted to take traveling exhibitions from other museums. It was still difficult, even in the 1990s, to find institutions willing to take up the challenge of looking at women in the arts in a serious way. One exception was *A History of Women Photographers,* co-curated by art historian Naomi Rosenblum and Barbara Tannenbaum, chief curator of the Akron Art Museum in Ohio. Based on a 1994 book of the same name, the exhibition made the important point that women have been central to photography since the medium's invention in the mid-nineteenth century. Arranged according to subject matter, *Women Photographers* showed us that in every aspect of the medium—portraiture, social and scientific documentation, advertising, photojournalism, personal expression—women were integral and innovative practitioners.

Who had known that an Englishwoman was making photographs called cyanotypes (blueprints, basically) in the 1840s? Anna Atkins used this process to depict specimens of plants and animals in one of the first long-term modern scientific studies of the natural world. A woman of the peerage, Clementina Lady Hawarden, might have been the first art photographer; she found photography a "life enhancing experience as well as a medium of artistic expression," as Susan Fisher Sterling wrote in NMWA's *Women in the Arts* magazine. Gertrude Käsebier came in her wake, as did Frances Benjamin Johnston, an early photojournalist, who recorded life at Virginia's Hampton Institute in 1899. Later, during the Great Depression, came Dorothea Lange, and Margaret Bourke-White, the first famous female photojournalist, and a giant beyond gender. Even Cindy Sherman was included, representing a new generation that had successfully

merged the categories of photogra-
phy and fine art in the 1980s.

All of these women and some
two hundred more were represented
in this major survey, which broke
new ground and opened many
people's eyes to the ubiquity of
women in photography's history. As
Rosenblum said to Constance Bond
of *Smithsonian* magazine: "People
have asked me, why a show on
women photographers? . . . It's not
that I want to separate out women
and say they're better or worse. It's
because the history was getting lost,
that's why." She kept running across
fine women photographers who,
although often well known in their
own time, seemed to be slipping into
oblivion. My point—and NMWA's
reason for being—was proved and
endorsed again!

⬥

In 1997 NMWA celebrated
timeless arts with *The Legacy of
Generations: Pottery by American Indian
Women,* which *The Washington Post's* Jo
Ann Lewis called "one of the most
illuminating exhibits to turn up at
this museum in its ten-year history."
The great authority on Indian pottery was an old friend, Susan Peterson, who was
raised by her archeologist father in an Indian Pueblo and is the only white woman to
be invited to the innermost ceremonies of the Indians. When she learned that we were
collecting art by women she said some of the finest was the pottery of the southwest
Indian women. I did a bit of research and, like many others, found the mysticism of
the Indian women and their pottery captivating. Susan introduced us to the work of
the famous potter Maria Montoya Martinez, of the San Ildefonso Pueblo. We were
surprised by the very high price but purchased a handsome black pot by Maria while

One treasured photograph in our collection is by Gertrude Käsebier, which was included in the exhibit A History of Women Photographers.

GERTRUDE KÄSEBIER (1852–1934).
The Manger, c. 1899.
Platinum print, 7⅜ x 5½ in. (19.4 x 14 cm).

she was still alive. Next Susan said that the matriarch of the Acoma pueblo tribe, Lucy Lewis, had recently completed her greatest pot. She and her daughters wanted me to buy it for the collection but, oddly, wouldn't state a price.

Susan invited me to an Iowa pottery symposium to speak about women artists and the contribution Indian women had made to the art of ceramics. Lucy and her daughters were there. We were all invited to a spaghetti dinner at the house of the symposium's chairman. While there Susan said that Lucy Lewis had brought the prize pot (carried over her shoulder in a large cloth folded into a sack). They again urged that it be bought for the Museum's collection but failed to state a price. Lucy spoke no English, but a daughter twice mentioned a pickup truck. It finally dawned on me that they were bartering; they wanted a truck as payment for the pot. It turned out that the truck was actually worth less than this very special pot. So we bought the truck for them, and the magnificent pot came into the collection.

The idea of a show of the Indian pots was intriguing. Funding for shows is always difficult, and I had no idea who would underwrite a ceramics exhibition. Then, like so many things connected with the development of the Museum, an unusual thing happened.

Climis and Carol Lascaris had a dinner party at their beautiful house in Virginia, and I was happy to see the wife of the Egyptian ambassador there. We had been working together on the Arab women artists exhibition, *Forces of Change*, but I had never met her husband. She explained that he had been delayed but would be arriving soon.

Later I was standing in the foyer when a statuesque man with a darker complexion arrived. Thinking it was the ambassador, I said: "Good evening Mr. Ambassador, I'm happy to meet you. Your wife and I are friends." He said, "Well, if you are going to goof on my name, an ambassador isn't bad." I hate making explanations for a faux pas, and this one was a little complicated, so I quickly said, "Sorry," and went in another direction.

As fate would have it, at dinner I was seated beside the same gentleman. He ignored me and began talking with the woman on his right and the host, who was seated next to her. His remarks were all about Sicily. He said, "I am Sicilian. Sicily is the best of Italy. We have the best food, the best scenery, our history is more glorious . . ." and on and on.

I said, just loudly enough for him to hear me, "And modest too."

He sputtered, turned to me, and said, "I can't believe you said that."

"I couldn't resist," I murmured.

"First, you call me by the wrong name, and then you insult me," he replied. I better pay attention to you." We both laughed and began to enjoy ourselves. He turned out to be Lou Noto, the CEO of Mobil, and he asked me if his company had ever helped the Museum. I told him that the wife of the former CEO was a member

and had given a small sum, whereupon he took a pin from his lapel, gave it to me, and said, "The head of our foundation is Ellen McCloy. Get an appointment with her, and wear this pin." I put the pin on and said, "I can't wait."

As we were saying our goodnights to the host, he came up with his wife, whom I had not met. She saw the pin and asked, "Where did you get that?" I pointed to Lou. She said, "I can't believe you gave her that pin!" Because of her startled reaction, I tried to take it off and return it, but he said, "No, you keep it," and they departed.

A few days later, when I arrived at Ellen McCloy's office, the first thing she said was, "Where did you get that pin?" I told her. She laughed and said, "What do you want? It's yours." It was then that I learned the pin was worn by the leaders of Mobil during international conferences. It gave the wearer entrance to the inner sanctum. I told Ms. McCloy about the coming exhibition that was foremost in my mind, and she exclaimed "Mr. Noto will love it. He has a house in Santa Fe." Indeed, Mobil generously underwrote the exhibition, and the show was a rousing success.

The Legacy of Generations: Pottery by American Indian Women featured six remarkable artists who had rediscovered—reinvented, really—traditional pottery forms of their ancestors, the lost Anasazi, Hohokam, and Mimbres peoples. Curiously, perhaps uniquely in a sense, this pottery was not raised for practical or ceremonial use, but to be sold—as art pottery. The movement began in the early decades of the last century, when the Southwest was becoming a mecca for vacationers among a scattered Native American population that had nearly been exterminated. Struggling for their living through subsistence farming on reservations, the six matriarchs seized the opportunity to provide what some thought amounted to souvenirs, but what the world soon recognized as fine art. Like their ancestors, these potters had no wheels, but built up seemingly perfect round bowls using coils and slabs of clay. They learned how and where to mine the clay itself and how to create the magnificent bowls.

Mobil was very generous and added so much to the exhibition by sponsoring great educational programs. Lou's staff conducted a contest for Washington schoolchildren. Since a central theme of the show was about legacies, an essay contest challenged girls and boys from the D.C. schools to write essays on the theme, "How My Grandmother Influenced Me." The twenty winners were invited to the Museum with their grandmothers. All were given lunch in deluxe lunchboxes that were theirs to keep. After lunch they received framed plaques to take home. The presenter at the award ceremony was First Lady Hillary Rodham Clinton. She gave a little talk in which she told the children, "You are the smart ones. You have won the prize. You are the future leaders of the city. Continue with high standards, and we shall watch your progress." The children were touchingly puffed up and proud.

Lucy Lewis's Jar, *which I bartered for a truck, was displayed in one of our most successful exhibitions,* The Legacy of Generations: Pottery by American Indian Women.

LUCY MARTIN LEWIS (1902–1992). *Jar,* 1983. Earthenware with slip, 9½ x 12 in. diameter (24.1 x 30.5 cm diameter). Courtesy of the Lucy M. Lewis Family.

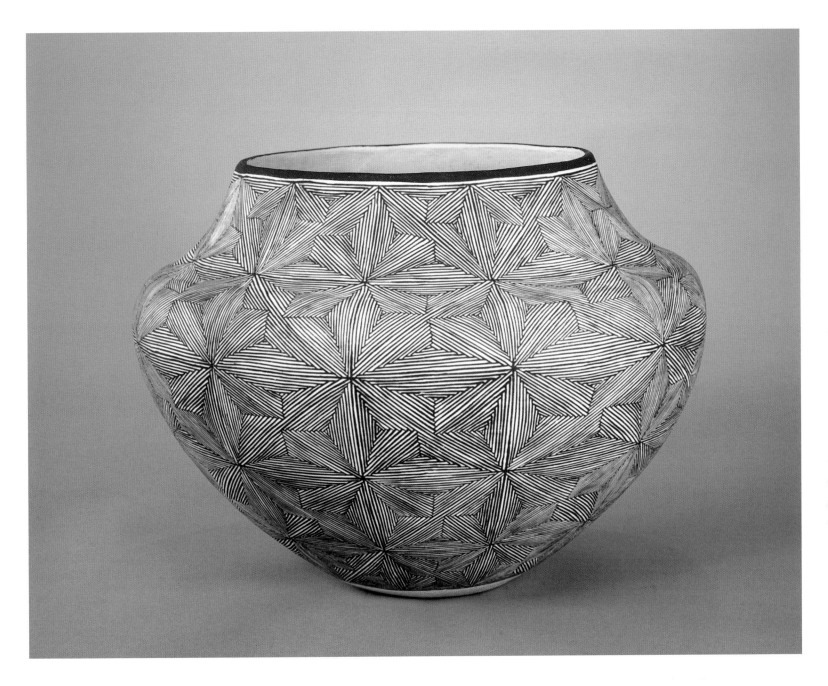

Thinking how precious the legacy of the exhibition would be—several of the potters were quite old—I contacted my friend Sharon Rockefeller, president of Washington's public television station and the wife of the senator from West Virginia. Sharon agreed to the possibility of a documentary. Susan Peterson, who was so well known and trusted by the Indians, was able to arrange for the filmmakers to interview the matriarchs and film them at work. Like the show's catalogue, the documentary turned out to be a classic, which is still shown from time to time on PBS and is sold in our gift shop. One might say it is just another legacy of the Women's Museum.

More Room of Our Own

This sculpture is part of Louise Nevelson's installation presented in 1959 at the Museum of Modern Art in New York. In spite of Nevelson's wishes no museum bought the entire installation and its parts were dispersed among different public and private collections. In 2007 the Jewish Museum in New York reassembled the work, and NMWA was one of the venues for Dawn's Wedding Feast. *The White Column in the Museum's collection represents one of the attendants in the wedding chapel.*

LOUISE NEVELSON (1899–1988). *White Column from Dawn's Wedding Feast*, 1959. Painted wood, 110 x 15½ x 12½ in. (279.4 x 39.4 x 31.8 cm).

IN THE FIRST FIVE YEARS we had a challenging list of goals. It would be necessary to get the library in operation, develop a plan for renting the facility after hours, work to organize the staff and volunteers, and more. These challenges required constant diligence, watching every penny and frequently making tough decisions. The hard work paid off because at the end of five years we could very proudly say that all priorities had been accomplished and that we were in the black. For the next five years we defined two enormous goals. First, we would develop our newsletter into a magazine, because with a large, far-flung membership it was essential to communicate if we were to keep our constituency informed and interested. The second goal was to find some elbow room—to enlarge our building—and there was only one way to do that.

It remains a high irony in my mind that the once-state-of-the-art edifice erected as the headquarters of the Masonic brotherhood had become ours to restore and occupy as a Museum founded to celebrate and champion art by women. (The sale agreement had a curious stipulation: If our workers disturbed the ceremonial cornerstone, its contents would be surrendered to the Masons.) Meanwhile, we learned that however beautiful the building appeared, it was not perfect. For starters, we needed the essentials for the successful operations of a modern museum. These were gotten by trading something that didn't exist!

Our original architectural firm, Keyes Condon Florance, was commissioned to design an office building on the parcel of land to our east, owned by Mohammad Haddid. Coke Florance of the architectural firm conceived of an arrangement whereby we could jointly plan our buildings to best use both sites. Washington restricts the height of buildings to eight floors, and we had room for another floor that we could not use. But the rights to build that extra floor could be transferred

to another building within the block. So we assigned a portion of our excess footage to Haddid in exchange for space owned by him on which we could build a large elevator shaft, catering kitchen, and loading dock. The loading dock would serve the two buildings, with long-term cross easements protecting the rights of both of us.

In the space between our two buildings stood a smaller structure, owned by an individual named Sonny Buttinelli. Haddid wanted to buy his property, which had originally been listed at $3.5 million, but the two men feuded, and their dislike became so severe that Buttinelli said he wouldn't sell it to him at any price. We regarded it covetously, because it was the only possible expansion space for us. It housed a pornography parlor, not our first choice for a neighbor. (Wally opined, "It's just another form of art.") However, a local law said that no such establishment could operate within a certain distance of a church. There stood the famous New York Avenue First Presbyterian across from our Museum. I spoke with the church elders, and they kindly agreed to exercise their right to object to the porn establishment and get it closed down, and that was done. It was very thoughtful of them, because in no way did I want to antagonize Mr. Buttinelli so long as he owned that property.

I called Mr. Buttinelli and explained that I would like the right of first refusal on the sale of the property if he ever decided to sell. I told him that I had no money at present, but if we were certain the property would be available, I might be able to raise it. He agreed to meet with me at an address on Connecticut Avenue. When I arrived, I found that there was no such address. As I looked up and down, a woman came up to me and said, "Are you looking for Sonny?" She directed me around the corner to a pizza parlor, where I found him. I never learned the reason for his subterfuge.

The only way for the Museum to expand was to acquire this small structure adjacent to NMWA's building.

We sat in a booth, and he asked if he could get me anything. I was intrigued by his offer of hospitality and his peculiar way of approaching business. Over a cup of tea, I proceeded to tell him about the Museum. His only comment was: "I like women. I like my mother." Gradually he relaxed and became friendly. When we finished he walked me to my car.

Since he seemed somewhat receptive, I began to talk with friends of the Museum about the possibility of acquiring the building. Evelyn Metzger, a New York artist and a longtime friend of the Museum, said she would give us half a million dollars. I told her to hold on to the money until we were assured of the building's availability. It was reassuring to know that there was possible interest and a donation.

The Honorable Mary Mochary, the current president of NMWA's board of trustees, has been one of the Museum's most generous supporters.

Some time later I got a call from Mary Mochary, the former mayor of Montclair, New Jersey, and a member of our Professional and Business Women's Council, whom I had not met. She had heard about the addition and asked to meet with me. When we met soon after, Mary told me the reason she had called in the first place. "My mother has given to the arts all her life. She has worked hard to encourage artists and has been a true patron [and a collector], but she has never received any recognition in any way. If you would name the addition after her, my brother and I will give you one million dollars." It was the beginning of a beautiful, and long-lasting, friendship.

Mary introduced me to her mother and father, Alexander and Elisabeth Kasser. They were charming, cultivated people whom I liked instantly. World citizens, her parents owned houses in Paris, Monaco, Vienna, and elsewhere. A meeting was arranged, and Mary, her parents, Sonny Buttinelli, and I went next door and inspected the creepy building, which was in such total disarray that it would have to be torn down. I was relieved that the Kassers weren't appalled by its condition. Sonny was pleasant, and he had dressed up for the occasion—in a cowboy hat and boots.

We were closer to acquiring the space, but the asking price was still $3.5 million. Sonny would call me from time to time and I would repeat my plea that I wanted first refusal on the sale of the building—if he ever got another potential buyer. I did not tell him that some of the money had been promised.

Janice Adams was the president of the board at that time, and her husband, Harold, was the Senior Partner of RTKL, a very successful international architectural firm. As the building would have to be torn down and completely replaced, they agreed to do all of the architectural and engineering work pro bono. This was a wonderful gift. Then, Carol Lascaris, who was vice president of the board, stepped up; she and Climis, who had done such important work on the Great Hall, agreed to do the interior design work pro bono as well.

Soon after, I went to a meeting of the Texas Committee and brought them up to date on our expansion efforts. A member, Sarah Pavey, stood up spontaneously and said, "Let's all pledge five thousand dollars each, one thousand now and a thousand a year for four years, to help make this possible." Seventeen members raised their hands and agreed to do it. I announced they would be founding members of the wing and their names would be engraved in glass at the entrance of the new building. The possibility of doing this was offered to others, and finally we had 171 new founding members and $855,000.

Whenever Sonny Buttinelli's lawyer called me, I just kept saying I didn't have enough money yet to purchase the building. One day, when the three of us were

on the phone, the lawyer talked roughly. When Sonny said, "Don't be mean to her," I realized I really had a friend. Months later he asked me to come to a meeting to discuss the deal, and we gathered in his office—several attorneys, accountants, Sonny, and me. They told me that I needed to make up my mind, to buy the building, and that the price was $3.5 million. When I said, "I don't have $3.5 million," they said, "You'll have to work it out with loans." When I said that was impossible, one of them finally said, "How much can you pay?" I screwed up all my courage, put on what I thought was my poker face, and said, "I will pay $800,000, and I will put Sonny's mother's name, Gerda Sophia Buttinelli, up on the wall as a main contributor." Sonny turned to me and said, "It's yours."

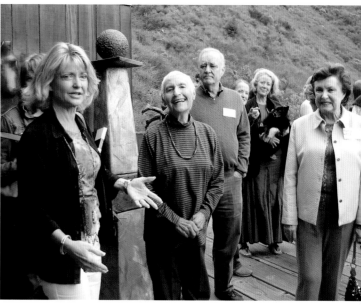

The lawyers and accountants were appalled, but not speechless. They yelled at him: "You can't do this." "Don't be ridiculous." "This is impossible." He answered, "I can do it. It's mine." Now we could proceed—to tear down the building and build the addition as a goal for our tenth anniversary celebration in 1997.

Incidentally, not only did Mary Mochary make good on her promise of a generous million-dollar gift, she later joined our board and became very active. Now, as I write, in addition to being president of her own company, she's the

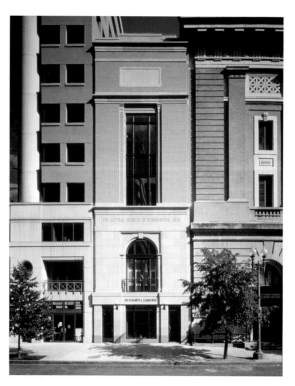

ABOVE: *Seventeen members of the Texas Committee helped create the annex by contributing five thousand dollars each. Pictured here are several members of the Texas Committee on an art tour led by former committee president Dorothy LeBlanc (at right).*

LEFT: *Mary Mochary wanted to recognize her mother's many contributions to the arts. She and her brother, I. Michael Kasser, donated funds that made possible the purchase of the dilapidated building next door to NMWA. These two photographs document the construction of the Elisabeth A. Kasser Wing.*

TOP: *Hillary Rodham Clinton attended the opening of the Elisabeth A. Kasser Wing in 1997. With me, and next to the First Lady, is beaming Mrs. Elisabeth Kasser, and Janice Adams, president of NMWA's board at the time.*

ABOVE: *Elisabeth A. Kasser cutting the ceremonial ribbon of the Museum annex named in her honor.*

president of NMWA board of trustees, a board member of the Kennedy Center and the Washington Opera, and a supporter of other arts institutions. No one who knows her background would be surprised by her outstanding generosity.

Mary was born in Hungary, and her parents emigrated to America when she was a child. She traveled extensively with them and grew up mainly in Montclair, New Jersey, where she still keeps a house and an office. Speaking many languages, she became a lawyer and a successful businesswoman. Mary entered local politics in 1980 when she was elected mayor of Montclair. In 1984, she won the New Jersey Republican primary and ran against incumbent Bill Bradley for the United States Senate. When she lost that bid, she was appointed by President Ronald Reagan as deputy legal adviser at the State Department. After the breakup of the Soviet Union she was assigned to establish embassies in the former Soviet republics and subsequently held other important posts. She remained at the State Department until 1993 as a foreign policy expert and negotiator on property issues. She has also been an advocate for refugees in the world's trouble spots.

The Elisabeth A. Kasser Wing was completed in the fall of 1997, and when it came time to invite distinguished guests to do the honors, the White House could not have been more accommodating: First Lady Hillary Rodham Clinton joined us and cut the ribbon, with a beaming Elisabeth Kasser wielding a second pair of ceremonial scissors. (Mary's daughter, Alexandra, was married in the Great Hall. She is now on our National Advisory Board, and so the participation of the family continues to be an important part of NMWA.)

The Kasser family and friends came from many countries, Spain's Princess Beatriz de Orleans-Borbon among them. As a result, when NMWA sponsored a cruise around the coast of Spain the princess received the voyagers in her beautiful castle and became a friend. She has been supportive in many other ways, especially with our European outreach, joining me and helping with the committees in Spain and Italy when I traveled there.

In spite of her many family and business obligations, Mary participates on almost a daily basis in the Museum's activities. She has given a major endowment gift and with a challenge grant has encouraged others to give. There are few who have been as valuable in the development of the National Museum of Women in the Arts as Mary Mochary.

The Kasser wing was a great addition. We were able to move the gift store, which now has a window to the street and considerably more room. On the mezzanine level it provided a beautiful room that became the Kasser Board Room and could be rented for receptions and dinners that would be too small for the Great Hall. Galleries were built on the second floor for smaller exhibitions, and on the third floor large works of sculpture could be displayed. It was a splendid enhancement to the Museum.

The Kasser Wing accommodates two large art galleries. One of them has a very high ceiling, which makes it ideally suited for displaying such large works of sculpture as Acid Rain.

CHAKAIA BOOKER (born 1953). *Acid Rain,* 2001. Rubber tires and wood, 120 x 240 x 36 in. (304.8 x 609.6 x 91.4 cm). Museum purchase: Members' Acquisition Fund.

MEANWHILE, LET'S NOT FORGET HELEN WALTON. Once she became committed to NMWA's mission, she became deeply involved. Helen joined our National Advisory Board, and when the time came to build the new wing, she stepped for-

ward in a manner that was as surprising as it was sub rosa. I reported at a meeting of the NAB on the progress we had made and the major gifts we had received: Mary Mochary's initial donation in honor of her mother; Evelyn Metzger's major contribution; Harold and Janice Adams's gift-in-kind of the architectural and engineering work; Carol and Climis Lascaris's contribution of the interior design; two chandeliers given by Yardley Manfuso and Rose Bente Lee respectively; and that nice kitty anted-up by seventeen members of the Texas Committee. When someone at the meeting asked if everything was paid for, I said, "All except about $250,000, but I'm not worried. We'll make it." My lack of worry was justified, because as soon as Helen got home she wrote a check for the outstanding balance and simply slipped it into the mail—without a word to anybody.

Having taken care of the new wing, Helen soon declared that the Museum should have a financial cushion to thrive and to weather whatever storms lay ahead. "You need an endowment," she said, and she persuaded us to organize a campaign to raise one. At that time the Ford Foundation was promoting financial security among nonprofit organizations—not by contributing to endowments but by funding feasibility studies as a mandatory first step. (Nothing can be as demoralizing or dangerous for an institution than to launch a campaign and fall short or fail.) With seventy thousand dollars from Ford, we hired consultants who gathered data, analyzed the numbers, and reported two major conclusions: First, an endowment campaign was indeed feasible because NMWA had gained both the necessary competence and the member support to conduct one successfully. Second, our goal should be twenty-five million dollars in cash and pledges, plus ten million in planned giving.

Building an endowment requires not only expertise but dedicated energy, and I could not have been happier than when Carol and Climis Lascaris agreed to chair the effort, with the assistance of the consultants, experts in the science of development.

Our consultants insisted that Helen be asked for a contribution, but I hesitated to ask for money from my friend since I have made it a practice not to do so. I

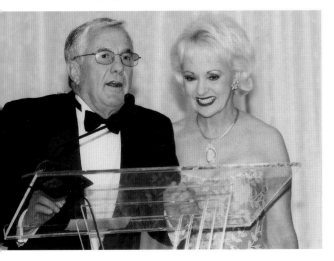

Climis and Carol Lascaris reporting on the great success of our endowment campaign.

have asked corporations and foundations, but not individuals. It fell to Climis and Carol to fly down to Arkansas to meet with Helen. Clearly her feelings were hurt that I hadn't come, but she pledged to give five million dollars anyway, one million a year for five years.

Our friendship was interrupted by an unexpected tragedy. Helen had always been a terrible driver. Between the time of the Lascarises' trip and my next visit to see her—scheduled in part for me to make amends—she had a serious accident. Her car collided with a truck, and she was severely injured. The last time I visited Bentonville, she did not know me, and she died early in 2007. The Museum and I both lost a dear and faithful friend.

Special Gifts, Special Friends

A s I HAVE ALREADY MADE CLEAR, the Museum could not have thrived as it has without the generosity and support of many devoted friends. It could not have come into being in the first place without loving people who were inspired and excited by the idea and vision of NMWA—too many, unfortunately, for all to be mentioned here.

One of them was Elizabeth Campbell. She had started WETA-TV Washington and had formerly been the dean of Mary Baldwin College. Elizabeth and I were on a couple of boards together, and I admired her greatly. She was deeply religious without being a fanatic, a pillar without being stuffy, just a very special, brilliant woman.

One day I told her about my idea for the Museum over lunch. She said: "You can do this. I am sure you can do this, Billie, you do not have to worry. But you are going to need a good tool to promote the Museum, and we will get Julie Harris to do a video for you." I had no idea that Elizabeth knew Julie Harris, whom I considered the best actress alive. The next thing I knew, Julie Harris came for a tour, and she and I talked about the idea. When she mentioned that she was headed to the West Coast, I asked her to meet with a filmmaker I knew there, Mary Carol Rudin. They apparently hit it off, and a magnificent nine-minute video starring Harris was the result. It helped me enormously as I went about promoting the Museum.

Elizabeth never stopped being interested. She continued her involvement in the Museum until her death at the age of 100. She told me, "You know, my father said: 'You must never ever give up. If you are doing something that is important, just keep at it, keep at it, keep at it. Don't let the problems interfere. If there is a big problem, solve it, but never forget that there is a superior being that helps you.'" I also remember Elizabeth telling me: "When I find things are going wrong, I realize I am trying to do it all on my own, and so immediately I seek a superior help, and it straightens

I am mesmerized by the paintings by Australian Aboriginal women artists. One of them, Yam Story, *is now in NMWA's collection.*

EMILY KAME KNGWARREYE (1916– 1996). *Yam Story '96,* 1996. Acrylic on canvas, 47⅞ x 36 in. (121.5 x 91.4 cm). Gift of the Collection of Margaret Levi and Robert Kaplan.

things out." That is the pattern I have followed when things are not going quite right.

The most colorful person on our early staff was Prince Rodion Cantacuzene, who served as pro-bono deputy director, original member of the board of trustees, and a member of our National Advisory Board. One of his great contributions was to administer the transition from our temporary headquarters on MacArthur Boulevard to the newly renovated building on New York Avenue. He also was responsible for hiring retired police officers as Museum guards (a tradition we maintain to this day), which always made our staff feel safe.

I HAVE ALREADY MENTIONED THE HELP OF ROMA CROCKER. She was kind enough to invite me to California, where she introduced me to many important people, the remarkable Shenson brothers of San Francisco, for example. Ben and Jess were both physicians, extraordinary philanthropists, and devoted patrons of the arts. They had been famous supporters of the San Francisco opera and symphony. They were among the first of NMWA's founding members and subsequently members of the National Advisory Board. They lived with their beloved mother in a wonderful house on the top of Nob Hill. I still remember how she invited me for a delicious dinner, capped off with her homemade cookies. Unfortunately, Ben and Jess are no longer with us, but they were generous to the endowment, and their will has helped make possible the Shenson Chamber Music Concert Series held annually at the Museum.

Some of NMWA's founding members shown here are (left) Dr. A. Jess Shenson, and (right) Dr. Ben Shenson, both of San Francisco.

RUTHANNA WEBER, ANOTHER PATRON OF NUMEROUS CAUSES, has been especially supportive of NMWA. A respected figure in not-for-profit Washington circles, and a leader of various charities, she was with me on the board of the YWCA, where I saw her wonderful contributions. She has been active with the Smithsonian Women's Committee, the National Cathedral, Meridian House International, and Wolf Trap Farm Park, to name just a few. She came on our board and, as I mentioned earlier, was the chairman of the Museum's opening celebrations. During the last twenty years Ruthanna organized many events that came off without a hitch. At great

Ruthanna Weber chaired NMWA's opening celebrations in 1987.

sacrifice of time and effort, she created the Museum's cookbook, managing to get the favorite recipes of women, ranging from First Lady Laura Bush on down to me. The novel feature of a binding that folds out to hold the book open on a kitchen counter makes this cookbook a desirable addition to anybody's kitchen. Ruthanna plays the piano at Christmas programs and, in her nineties, still attends every Museum event.

When I decided we should have a women's committee, I asked Ruthanna to organize it. We both wanted our recruiting campaign to reflect a tasteful approach, so we had engraved stationery made at Copenhaver. My only request was that half the women be over forty and half under forty. Ruthanna sent out a hundred invitations on our elegant stationery and received ninety-nine acceptances. Each participant would pay a hundred dollars a year, money the committee would use to cover its expenses; any surplus would go to any Museum cause they wished to support.

It takes a long time to create and formalize an organization. I learned that by watching the committee slowly grow until it was both self-sustaining and self-perpetuating. Ruthanna started by creating programs shared with the Smithsonian Women's Committee, using our performance hall for lectures on flower arranging, art, and other topics of interest. Gradually, members began to feel a part of something significant.

Several founding members of the Museum had joined the Women's Committee. After careful consideration Ruthanna approached Evelyn Moore, who had gone on to work with The Hospitality and Information Service (THIS) group at Meridian House, which helps embassy staff from abroad feel more at home in Washington. I was delighted to bring her back into the fold because Evelyn was not only a founding member, but she had also been a docent for the house tours we had held. Evelyn agreed to chair the Women's Committee and gradually brought along members who would consider taking specific roles. Once it was formalized, with officers in place—the committee's president was elected for two years and came on the Museum board ex officio—the group agreed to handle the silent auction, which is a profitable part of our annual gala. The Women's Committee has become a truly active and important part of NMWA.

In 2005 we drank a toast to Ruthanna and trustee Bonnie McElveen-Hunter's mother, Madeline McElveen, at the gala to honor their ninetieth birthdays. It brought back to me how many times Ruthanna had allowed the Museum to use her lovely house and garden in Kenwood for get-togethers, meetings, and parties.

My dear friend Nancy Stevenson has been associated with the Museum for twenty years. Soon after the Museum opened, it seemed a good idea to offer a class in art history in order to educate interested people about the contribution of women to the history of art. I talked with a volunteer coordinator at the Junior League, who suggested Nancy; she agreed to chair the program and recruit participants. It would be taught by the head of our Education Department, Harriet McNamee. Harriet, an excellent teacher who had taught at the college level, designed a curriculum, with Nancy's help,

of ten weekly lessons given at ten o'clock in the morning in our performance hall. Nancy decided the students would be served coffee and pastries when they arrived, would take the two-hour class, and, if they wished, could go to the Museum café for lunch on their own. The tuition was two hundred dollars, and the course would be offered in the spring and fall.

Nancy sold the idea to many of her friends, and the program became popular. I doubt if Nancy ever missed a class. Always beautifully groomed and dressed, she warmly greeted the participants on behalf of NMWA. The wives of many ambassadors signed up, connections that proved invaluable. The program continues, still making new friends for NMWA. Needless to say, those who took the course became members and shared their interest in the Museum with others. When the most loyal graduates wanted to continue, Nancy planned something of interest for them each month such as visiting a private collection, an exhibition, or another art event. That, too, continues.

I invited Nancy to become a board member, and she gave of her very best self endlessly. She was elected treasurer, and then, during her two-year term as president, she worked almost full time, truly concerned about every aspect of NMWA. She and her husband, Roger Stevenson, a cardiologist, have participated in all the Museum's trips and activities and, though taking no credit, helped every effort succeed. When their daughter's wedding reception was held in the Great Hall, the Museum family grew.

While I haven't told many purely personal stories, this one is important. Wally and I were at our beach house in Rehoboth for the Fourth of July in 2004, and since Nancy and Roger have a house nearby, I had invited them to join us and our houseguests for dinner. As I was upstairs dressing for dinner, I suddenly became ill. I said to Wally, "I'm very sick," and lay down on the bed. Wally called Roger upstairs; the good doctor asked two questions, picked up the phone by the bed, and called 911. I was soon in an ambulance, racing to the local hospital, where the physician later told

ABOVE: *Nancy Stevenson served as NMWA president and now chairs the Works of Art Committee. Nancy's husband, Roger, a well-known cardiologist, saved my life.*

OPPOSITE, TOP: *Nancy Valentine's excellent collection of works by Irish and English women silversmiths was bought and donated to the Museum by Lorraine and Oliver R. Grace. One of the objects in the collection is a* Glass-lined Mustard Pot with Spoon. *The glass liner prevented the mustard from staining the silver interior of the pot.*

HESTER BATEMAN (1709–1794). *George III Glass-lined Mustard Pot with Spoon,* 1778. Silver and glass, 3¼ x 4 x 2¼ in. (8.3 x 10.2 x 5.7 cm). Silver collection assembled by Nancy Valentine

ABOVE: *This antique silver rattle would please babies of any era.*

MARY ANN CROSWELL (C. 1775–??). *George III Child's Rattle*, 1808. Silver with coral, length: 5⅜ in. (13.7 cm).

me, "Your friend saved your life from this heart attack." We have, of course, been close friends ever since. I love them both dearly. Thanks be to Roger!

⊸——⊶

ANOTHER IMPORTANT PERSON IN THE MUSEUM'S HISTORY was Nancy Valentine. One day when I was working at my desk, I received a call. A woman's voice said, "This is Nancy Valentine. I have read about what you are doing, and it just so happens I have a large collection of eighteenth-century silver done by Irish and English women." I said, "Well, that is of tremendous interest. That is something I hadn't even really thought about."

She suggested we meet in New York, where we became quite well acquainted while she showed me the beautiful pieces she had collected and about which she was knowledgeable. She called me on another day and said, "When this collection is all together it would make a wonderful, wonderful gift to the Museum," and I agreed, of course. Then she said, "I know the woman who might be willing to help us do it."

It turned out that Richard Valentine, her husband, was among New York City's leading tax attorneys, and one of his clients and friends was Oliver R. Grace. Through the Valentines I met Oliver and his delightful wife, Lorraine. I suggested we go to The Pierre for lunch because that hotel is right across from our apartment. During the lunch the Graces offered to buy the silver collection for the Museum. I said to Mrs. Grace, "Since you are going to have this big investment in the Museum perhaps you would like to serve on the board or, if you prefer, the National Advisory Board." Her husband immediately said she would come on the regular board, and so she did. Lorraine greatly admired Krystyna, and the Library and Research Center became her chief interest. Over the years she contributed to

many library projects, from acquiring books for the collection to supporting numerous exhibitions of artists' books. Later on she explained that it was just too much to come down every month for a meeting and that she would really prefer to serve on the National Advisory Board, which meets twice a year. She is still an active NAB member and has very generously contributed to the endowment.

Lorraine provided funds to purchase two beautiful modern cases to display the silver in the Gallery. Later on she suggested publishing a book about the silver in NMWA's collection. Thanks to her generosity *Women Silversmiths 1685–1845* was published by Thames and Hudson. Philippa Glanville of the Victoria and Albert Museum in London (and who, years later, serves on our London Committee) wrote an essay for the book, and we hired a top-notch photographer. The volume had wide distribution and was selected as one of the outstanding antiques books by *Antiques Magazine*.

＊＊＊

ANOTHER ANGEL CAME RIGHT OUT OF THE BLUE. In 1993 I received an unsolicited check for ten thousand dollars enclosed in a letter from an utter stranger. Ms. Patti Birch wrote that she thought what I was doing was of interest, that she wanted to lend a hand, and that she might be willing to give me more money. Since I was planning to be in New York, where she lived, I phoned, and she invited me to come for a drink. When I arrived she was engaging two gentlemen in conversation about two different projects they were all working on, one in Morocco and one in partnership with the Metropolitan Museum. This was a busy woman. After they left we began a conversation that continued past the cocktail hour. She suggested dinner in a nearby restaurant.

Patti Birch was the most unusual person I've met in connection with the Museum. She was tough, but she also combined qualities of generosity, sensitivity, ambition, idealism, and surprises. Navigating through a conversation with her always kept me on my toes. It was fascinating to talk with a woman whose godmother was the painter Marie Laurencin and who had homes in the Virgin Islands, Paris, Morocco, Venice, and New York—almost a global village of elegant residences. And wherever she lived she was involved in varied programs, most of which had to do with the arts.

TOP: *Lorraine Grace served on the Museum board of trustees and later on the National Advisory Board. Over the years she joined the Library Fellows group and supported a number of library exhibitions of book arts.*

ABOVE: *Patti Birch is very animated when she discusses art; I, on the other hand, am a rather good listener (as this photo reveals).*

Sue Coe created a series of brilliant charcoal drawings of her dying mother, which Patti Birch bought and donated to NMWA.

ABOVE LEFT: SUE COE (born 1951). *The Last 11 Days: July 20th,* 1995. Charcoal on paper, 13 x 11 in. (33 x 27.9 cm). Gift of Patti Cadby Birch.

ABOVE RIGHT: SUE COE (born 1951). *The Last 11 Days: July 31,* 1995. Charcoal on paper, 13 x 13 in. (33 x 33 cm). Gift of Patti Cadby Birch.

Our conversation that evening was one of those "one thing leads to another" talks, and I didn't get back to our apartment until midnight. Patti was not secretive, but she was somewhat vague about herself. Nothing was told in detail. When we said goodnight she said, "Sometimes the chemistry is right. I know that we shall be good and longtime friends." She was right. She liked Wally as well, and we were her houseguests in Morocco, where life was nothing if not exotic. (On one occasion when we visited a friend of Patti's in his mountaintop castle, the foyer, complete with a bubbling fountain, was covered with flower petals in our honor.)

Patti used her money to get what she wanted and was so open and matter-of-fact about it that it was not in the least bit offensive to me. Once she said, "My husband was in the oil business, and we spent much time in the Near East, where I became interested in Islamic art. I want to be a part of the Metropolitan Museum of Art community, so I'll underwrite the Islamic Department, and that will be of interest to me and to them." She was also supporting the Museum of Modern Art and served on the board of that prestigious institution.

The talented contemporary artist Sue Coe had a show at the Hirshhorn Museum and Sculpture Garden in Washington. I admired her work and asked her for lunch. Soon after that her mother contracted a lingering illness and died. Sue

spent days at her bedside doing brilliant charcoal drawings of her mother's last days. Sue's gallery called me and said, "Sue so much wants someone to buy the drawings, and to have the check made out to hospice. It will be her thank-you for their kindness. Neither Sue nor the gallery want anything. Do you know someone who would do this?" It was exactly the sort of thing Patti would want to do, and I called her. She wrote a large check, bought the drawings, and gave the money to hospice and the drawings to the Museum.

This was only one of the generous, kind gestures that belied her toughness. Apart from this one request, I personally never asked her for support for the Museum. Nevertheless, she gave time, money, and advice. Eventually, I invited her to become a member of our National Advisory Board. During one meeting when a staff person mentioned that we needed a clipping service, Patti spoke up. "I'll take care of that," she said, and she did.

During one of our frequent phone conversations I was applauding the work of my favorite sculptor, the Polish artist Magdalena Abakanowicz, whose work I had long admired and had just seen exhibited at the Savannah College of Art

OPPOSITE: *Patti Birch also made possible the acquisition of Magdalena Abakanowicz's sculpture.*

MAGDALENA ABAKANOWICZ (born 1930). *Four Seated Figures,* 2002. Burlap, resin, and iron rods, 53½ x 24¼ x 99¼ in. (135.89 x 61.6 x 252.1 cm). Gift of Patti Cadby Birch and partial museum purchase: Members' Acquisition Fund.

RIGHT: *I bought this sculpture by Magdalena Abakanowicz for myself. The bronze mask reminds me of Magdalena's head, even though the title of the work is* Kayser Infant II.

MAGDALENA ABAKANOWICZ. *Kayser Infant II,* 2001. Bronze, 63½ x 12½ x 8½ in. (161.29 x 31.75 x 21.59 cm). Collection of Wallace and Wilhelmina Holladay.

and Design in Georgia. Patti exclaimed that Magdalena was a dear friend of hers and that if I was so enamored of her work she would help make it possible for the Museum to acquire a piece. I was amazed. It hadn't occurred to me that she might know Magdalena. In Patti fashion, she said, "I'll give the first hundred thousand dollars. You know her work sells for a million. You raise the rest."

A few months later the president of Poland came to Washington on a state visit, and Magdalena, the nation's foremost artist, was in his entourage. Wonder of wonders, he decided to give a dinner at NMWA. Magdalena called me, introduced herself, and made a date to meet at the Museum. I asked Krystyna, our librarian, to be with us since she was Polish and spoke the language, but as it turned out Magdalena was fluent in English.

Patti's name came up immediately. I explained that while Patti's offer was kind, in view of our budget we couldn't undertake to raise hundreds of thousands of dollars for a single work. Magdalena said, "What do you want of mine? Don't you have pictures of my work?" Krystyna had bought every book ever written about this great woman for the library, and she spread them out.

Magdalena urged me to show her which of her works I admired most. I pointed to her seated figures, my favorites. She promptly said she thought there were some in Poland and that she would let us know. The end result was a magnificent work of four seated figures, and the selling price was a hundred thousand dollars—paid by Patti. This great artist is represented in every major museum, and for NMWA to acquire a spectacular example of her work was truly exciting. A bonus from all this: Magdalena and I have been friends ever since.

STRANGE AS IT MAY SEEM, another major donation was equally serendipitous. During a particularly busy time, when I was frequently out of the office, my assistant twice told me, "A Mr. Price from Kyle, Texas, called but says he will call back." I instructed her to take his number, so I could return his call, but when I did his wife answered. She told me that she wanted to give me a gift of about a million dollars and asked that I get the details from her husband. When we finally connected on the phone, Mr. H. Y. Price explained that the family was selling a telephone company and that Mrs. Price wanted her share to go to the National Museum of Women in the Arts.

I was scheduled to go to Houston the following week for a meeting of the Texas Committee. Forgetting the huge distances in Texas, I told Mr. Price, "If it would please you perhaps I could come to call next week, since I'll be in Texas." He said that would

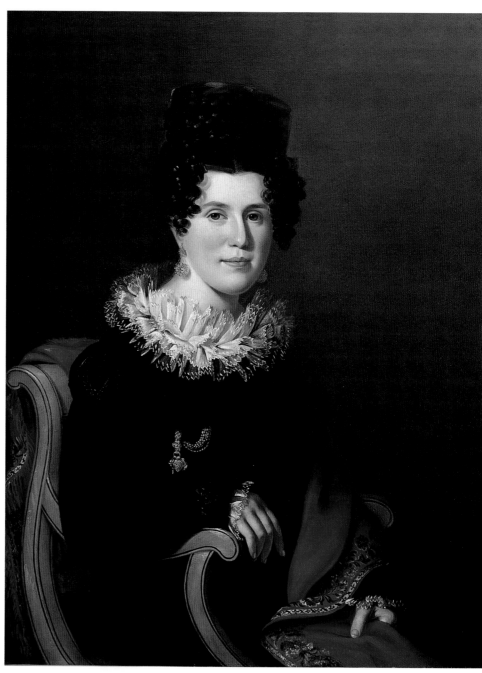

SARAH MIRIAM PEALE (1800–1885). *Susan Avery*, 1821. Oil on canvas, 35¼ x 27½ in. (89.5 x 69.9 cm). Museum purchase: The Lois Pollard Price Acquisition Fund.

mean so much to Mrs. Price, explaining that her car had been hit by a train some years before and that she was an invalid. At the meeting I asked where Kyle was, and Jo Stribling, the president of our Texas Committee, said, "I'll take you there. We'll go to my ranch outside San Antonio, and the next day we can go to Kyle." The day after the meeting in Houston we drove and drove all day long. We had dinner in a great Mexican restaurant somewhere, and we kept going, until we finally reached her ranch about 11 P.M. Texas is big!

The next morning we went to Kyle and found the Prices' house, an old,

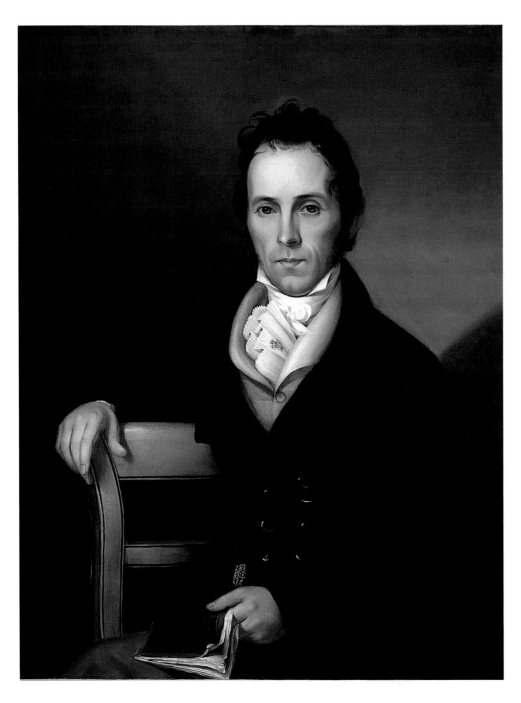

SARAH MIRIAM PEALE
(1800–1885). *Isaac
Avery,* 1821. Oil on
canvas, 35¼ x 27½
in. (89.5 x 69.9 cm).
Museum purchase:
The Lois Pollard Price
Acquisition Fund.

white mansion in an unmani-
cured, parklike setting. The
interior was furnished with big,
comfortable furniture, and the
homey atmosphere featured
paintings of children on the
walls. Jo took off with Mr.
Price to discuss horses, and
I sat down to talk with Lois
Price. She told me that she
was an artist, that her father
had been a classical musician
with a symphony, and that,
while she adored her children
and husband, the only thing
that saved her in this remote
area devoid of the arts was her
painting. Now she wanted to
give back in some way.

When I asked her how
she wanted the money to be
designated, she said, "I trust
you. Whatever you feel is
important." I insisted she think
about it. Some time later, after
long phone conversations, she
decided that half a million
dollars would be an endow-
ment in perpetuity from which
books could be purchased for
the library. This proved to be
a wonderful choice, because
it enabled Krystyna to make our library collection superior to that of any private
museum I know. You can buy a lot of books from the returns on a half-a-million-
dollar investment. Each year, the interest on the balance of Mrs. Price's gift went
to the acquisition of works of art. Of course, we wrote and called her frequently
and kept her informed.

Some years later her son Tim called me to say that his mother's last big wish
was to visit NMWA. We were able to get a hospital bed brought into the Willard
Hotel and made all the arrangements necessary for her wheelchair. We entertained

her at the Museum and for lunch at my house. She loved being in Washington, and we treated her like the queen she was. From the time of her accident she had always been in some pain, but after returning to Texas she called me and said, "Isn't it strange that I had no pain in Washington?"

<center>�003⟩</center>

SOME SPECIAL GIFTS ARE INTANGIBLE. Klaus Jacobi was the Swiss ambassador from 1984 to 1989, and his wife, Titi, became very interested in the Museum. She gave several dinners on our behalf at the embassy residence, conducted some of our tours in French, had the embassy's cultural minister collect extensive material from Switzerland for our library, and became a dear personal friend. Klaus had been called back to Switzerland to become the secretary of state, and some months later Titi phoned me and said, "Oh, I miss Washington so very much. Won't you please gather some friends and come over? I'll arrange a tour of the great private collections here." I carefully selected a group of Museum supporters, and nine of us went to Switzerland. Titi arranged for us to stay at the elegant Hotel Schweizerhof in Bern. Switzerland is not a large country, and we followed her itinerary of day trips to visit various cities in a comfortable hired bus. The Kunstmuseum in Bern houses an important collection of works by Paul Klee as well as the works of surrealist Meret Oppenheim. In the Kunstmuseum in Basel I found a beautiful still life by Rachel Ruysch in addition to outstanding works of fifteenth- and sixteenth-century Swiss and German artists. The private collections in Switzerland are never open to the public, but they are truly of museum quality. Among the most memorable were Dr. and Mrs. Paul Hahnloser's fabulous collection of French Impressionists in Fribourg; the Buhrle Collection, where we saw Degas, Matisse, van Gogh, and other great masters; and Oskar Reinhart's collection of German and Dutch masters and French paintings from Poussin to Cézanne. Titi, who is from an old, respected family, is one of the few people who could have made this privileged opportunity possible.

Klaus has died, and Titi lives alone in their lovely apartment in Bern. We still correspond, and once in a while she comes to the States. There are many great advantages to having outstanding diplomats here, but the sad part is that they leave, often ending any real friendship. Our lasting relationship is special.

<center>⟨003⟩</center>

IN 2006 the Museum presented an exhibition of aboriginal art from Australia, *Dreaming Their Way: Australian Aboriginal Women Painters*. I remember going down through the galleries by myself one evening before the show had been hung. The

paintings were leaning against the walls where they would be hung on the morrow. They exuded energy and a wonderful feeling—I was mesmerized.

To celebrate the opening of the exhibition, the Australian ambassador gave a dinner in his magnificent embassy residence; I was seated with him and Brian Kennedy, who had been the director of the National Gallery of Art in Australia. Brian was introduced to our Museum for the first time because of the exhibition, and he was quite complimentary. He said, "You know what you really should do? You should give fifty thousand dollars a year to a top scholar to do a biography, a book, about a given woman artist who has been lost in history. The scholars will compete for the opportunity, and it will not only fulfill your raison d'être, but it will also establish you as a museum concerned with the scholarly approach." I thought it was a wonderful idea, but we didn't have an extra fifty thousand dollars a year.

Soon after that, I was on a Museum-sponsored cruise that sailed from Copenhagen through the Baltic to Saint Petersburg, then back via Helsinki and Oslo. Jim and Suzanne Mellor were among the participants; he had been the CEO of General Dynamics, and Suzanne was on our National Advisory Board. One evening Carol Lascaris (who, with her husband, Climis, had organized the cruise) asked me if I would say a few words about some of the things the Museum was doing or wanted to do in the future. I got up, gave a report, and added the story of Brian Kennedy's suggestion. I probably sounded enthusiastic because I really felt it was a great idea. On my way back to my seat Jim Mellor came up to me and said, "Billie, I will take care of that for you for ten years," and offered a gift of five hundred thousand dollars.

Trying to determine a wise way to proceed with this generous gift was extremely difficult, but finally we put together a tentative committee: Joseph Baillio, of Wildenstein & Company of New York, who is the world's foremost authority, I believe, on eighteenth-century art, and who has been working on the catalogue raisonné of Elisabeth-Louise Vigée-Lebrun for many years; Eleonora Luciano, who is assistant curator of sculpture at the National Gallery of Art; and our own Jordana Pomeroy, a fine scholar with a Columbia doctorate, who is our chief curator of paintings and sculpture before 1900. Before we advertise and involve other scholars we have to be sure that every detail is in place. But we would like the series to be known as NMWA's Contributions to Art History. Recently, Abbeville Press has indicated an interest in publishing the scholarly books, so we shall begin to promote the competition.

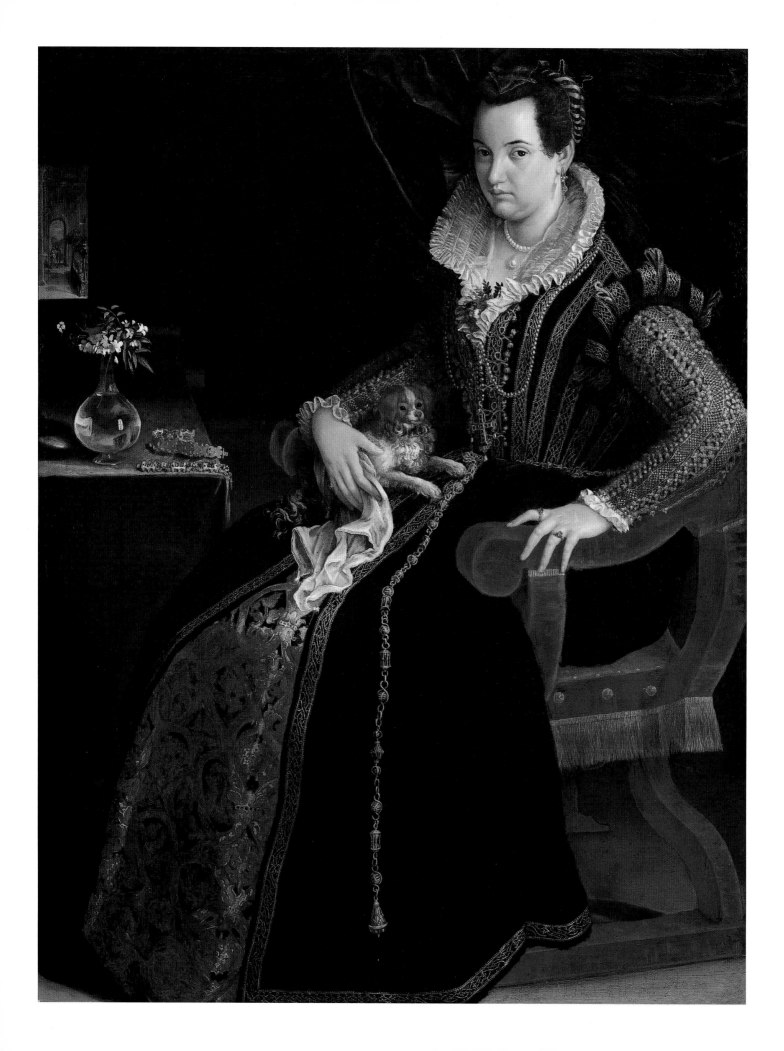

Pursuing Our Mission— The Major Exhibitions of the Second Decade

W ITH THE OPENING OF THE ELISABETH A. KASSER WING, we had the luxury of more space—including a gracious new boardroom, an expanded shop, and two large galleries with northern light. More so, we got a nice jolt in the morale—the feeling of having set some long-term goals and having met them. But as soon as the applause died away, it was back to the work of raising funds for operations, seeking underwriters, launching education projects, and planning new exhibitions. In other words, it was back to the businesses of being a museum, being the National Museum of Women in the Arts.

One of my favorite shows opened in 1998, *Lavinia Fontana of Bologna (1552–1614)*, a favorite perhaps because I remember purchasing our work of hers. Wally and I were in Paris and were packing to come home, when I said, "I'm just going to run out and get a gift for the grandchildren." He cautioned me to hurry because we had a plane to catch. As I left the hotel, I passed a gallery and noticed Fontana's *Portrait of a Noblewoman* in the window. I went in and said to the owner of the gallery, "I'm very interested in that painting in your window. I'm truly interested. Unfortunately I have no time now. We must catch a plane to the States. Here is my card, and I will be back in touch as soon as I can." He said, "If you are that interested, we have a gallery in New York, and I'll send the painting over," which he did. We then had time to examine it carefully and proceeded to purchase it. It is the oldest painting we have in the collection and a beautiful work.

We very much wanted to mount a show of Fontana's works, and I was able to enlist the help of the Italian ambassador, Ferdinando Salleo. He, in turn, persuaded the Italian government to underwrite the exhibition, which featured thirty works of the ninety paintings and thirty drawings created by, or attributed to, this Old Mistress of the Italian Renaissance. The body of Fontana's work reputedly

Recently I was able to acquire another painting by Lavinia Fontana, and I was very pleased, as her works are seldom available.

LAVINIA FONTANA (1552–1614). *Portrait of Costanza Alidosi,* c. 1595. Oil on canvas, 62 x 47⅜ in. (157.5 x 120.4 cm).

constitutes the largest oeuvre of any woman artist before the eighteenth century.

To celebrate the exhibition's opening, Dorothy McSweeny, who chaired our spring gala that year, created a Tuscan Renaissance evening. Ambassador Salleo and Anna Maria, his wife, were guests of honor, and the menu was as Tuscan as our caterers could make it. Singers from the Choral Arts Society serenaded us with Renaissance song, and a couple of duels were staged—two swordswomen bested their male opponents, no doubt over matters involving honor. The next day the duelists returned to their usual work as actors at the Shakespeare Theater.

NMWA's exhibitions are diverse in order to appeal to our membership of varying ages and interests. The following year we revived the reputation of an artist who had been forgotten—not for centuries, but for a generation—with an exhibition called *Grace Albee: An American Printmaker, 1890–1985*. Mrs. Albee was a rarity indeed, the gifted inventor of a new method of creating wood prints. She was exhibited at the Venice Biennale and elected to the American Academy of Design, one of its very few female members.

We had substantial help in rediscovering Grace Albee (an aunt of playwright Edward Albee) from her son, Fred, a Rhode Islander who inherited a treasure trove of her beautiful work. He contacted Catherine Bert, a wonderfully knowledgeable member of our National Advisory Board and owner of a gallery in Providence, Rhode Island. When she saw the stunning collection of original prints, an exhibition at the National Museum of Women in the Arts was suggested. The show was truly impressive, and the Albees, who came to the opening reception, were delighted. Fred Albee and his wife, Barbara, drew me aside and said they were giving the prints from the exhibition to NMWA. Needless to say, I was moved and very grateful to have this superb collection added to the holdings of the Museum. Then, becoming very serious, they said they had also decided to bequeath their estate to one beneficiary —the National Museum of Women in the Arts.

The 1998 NMWA gala celebrated Lavinia Fontana's exhibition. Although Fontana lived and worked in Bologna, the menu was Tuscan. Pictured here (left to right) are Gala Chair Dorothy McSweeny and Vice Chair Nancy Stevenson

AND THEN IN 2000 CAME OUR GREATEST SUCCESS. Without a doubt, the millennium year's exhibition was a blockbuster and a milestone. *Julie Taymor: Playing with Fire* opened before Thanksgiving 2000 and enjoyed the same excitement and success as her play *The Lion King*. It drew more visitors than we had ever seen before in any of our exhibitions.

In my opinion, Julie is the most creative woman in the United States, a fact I attribute to her upbringing and fabulous parents, especially her mother (who was a member of NMWA from the beginning). Her mother told me she was impressed

The exhibition Grace
Albee: An American
Printmaker, 1890–1985
*revived the reputation
of another artist. This
beautiful woodcut was
donated to the Museum by
the artist's son, Fred Albee.*

GRACE ARNOLD
ALBEE (1890–1985).
Manhattan Backwash,
1938. Wood engraving
on Japanese paper, 6½
x 8½ in. (16.51 x 21.59
cm). Gift of P. Frederick
Albee.

with Julie's talent and decided to let her do whatever she wanted to develop it. Julie and her sister were encouraged to put on puppet shows in their suburban Boston backyard when she was eight. Fresh out of high school, at the age of sixteen, she went to Paris to study mime. A Phi Beta Kappa graduate of Oberlin College, she majored in folk art and mythology, and even studied shaman rituals, coming to believe "the shaman is the first director and theater-maker. He creates spirit journeys to cure people, to help the tribes with the harvest, or get people through a death or a marriage." Then, having gone to Indonesia to study that nation's exotic theatrical traditions—and to become a director herself—she had an epiphany that could hardly be more remote from shamanism. She told an interviewer about sitting by herself in a big public square in Bali in the middle of the night, when a platoon of soldiers marched in, marched around in cadence, and marched out again. There was no one in attendance. It was not done for money. It seemed a spiritual move on their part. "That's when I knew that theater was something unto itself. . . . [it] gave me a new sense of theater."

I was delighted that we secured *Playing with Fire.* Despite her horrendous schedule as a theater and film designer, director, and producer, Taymor came to Washington

OPPOSITE, TOP: *Our exhibition of Julie Taymor's stage design,* Julie Taymor: Playing with Fire, *was a blockbuster. Here is a photograph of the installation of costumes, masks, and puppetry from* King Stag.

OPPOSITE, BOTTOM: *Taymor also wrote, directed, and designed costumes for* Fool's Fire, *based on a short story by Edgar Allan Poe.*

ABOVE: *In my opinion, Julie Taymor is one of the most creative women in the United States*

and spoke at the opening. The exhibition won stellar press notices everywhere. It was selected by *The Washington Post* as one of the ten best shows of 2000. My only regret was that it was so expensive to ship and set up that we had to charge admission; for the first time we set a ticket fee for visitors who wanted to see the exhibition. (Since the government-funded Smithsonian museums in Washington are free, we had previously assumed that ours must be as well. There seemed to be no resistance, and so the practice continues and helps to cover exhibition-related expenses.) If ever there was a multimedia artist, it was Julie, and if ever there was a multimedia exhibition, this was it. Costumes from her opera flew from the ceilings and sets were suspended from the walls; film clips were projected on screens and video displays. Our long-time exhibitions designer, Edwin Penick III, and a talented crew of theater professionals did a remarkable job of hanging Julie's puppets and costumes in dynamic poses, then lighting them so dramatically that they seemed as alive as in her stage plays.

One critic wrote, "It's the scope of her work and the sheer size of this exhibition that will dazzle your eyes." Another from *The Washington Post,* enthused: "The exhibit, the largest the museum has ever held, . . . occupies two specially refurbished floors. . . . At the entrance [of the rooms devoted to her Tony-winning Broadway musical *The Lion King*] you're loomed over by two giraffe heads on nine-foot necks. Evil Scar's costume, with its lion mask designed to float in front of and a little above the actor's face, is here. Next to it crouches the costume of his slinking jackal sidekick. 'Costume' is actually a limited word for these objects, which are also puppets that the actors can wear and become part of, as well as sculptures in their own right. . . . Small set models illustrate a variety of scenes, such as the wildebeest stampede. All this gives you some idea of the visual marvels of the show. . ."

The experience of planning and fundraising for that exhibition taught me several lessons, one of which was a reminder that leisurely travel is a wonderful way to make lasting friends. During NMWA's first cruise, to the Greek Islands, I announced that we hoped to mount the Taymor exhibition. Afterward, Eleanor Chabraja came up to me and said she and her husband, Nick, the CEO of General Dynamics, might be interested in funding it.

Sometimes my staff thinks I act unprofessionally, when I go prospecting for support without a fancy proposal all done up in presentation books. Over dinner Nick asked what the price tag might be; I said, "Four hundred thousand," a nice round figure, and he agreed to move ahead with the idea. When it became certain that we would have to pay for the shipping of several hundred fragile objects from Ohio (adding a few hundred thousand dollars to the bottom line); I had to make another appointment with Nick to explain the budget problem, but he generously agreed to split that extra expense with us.

OUR NEXT BIG SHOW, close on Taymor's heels, presented the work of another American icon, a woman who could hardly have contrasted more with the 1990s toast of Hollywood and Broadway, namely Anna Mary Robertson Moses. The show, *Grandma Moses in the 21st Century*, displayed the work of an American genius who didn't lift a paintbrush until she was well into her seventies; she'd been too busy.

Born in 1860, Grandma Moses had gone to work at twelve as a domestic. She married, bore ten children, and worked as a farm wife nearly all her life. As she grew older she found that embroidery was becoming too hard on her eyes, so she switched to painting. A traveling collector saw a picture of hers in a drugstore window in upstate New York in 1938 and alerted a gallery owner, Otto Kallir, an Austrian who had fled the Nazis and recognized this unknown "as a quintessentially American artist who reflected the freedoms he found in his new home," as one journalist wrote. Kallir gave her a solo show in 1940, and "she became famous overnight for her pictures of an idealized America that were rendered in a remarkably vibrant palette and complex compositions", according to a Reuters News Report. While Moses's popular celebrity continued to grow for the remainder of her life, within the art world she was eclipsed by newer trends such as the abstract expressionism that arose after World War II and later by pop art. Grandma Moses died in 1961 at the age of 101 after a career of more than twenty years in which she produced some 1,600 paintings.

Many people acknowledged that our exhibition, which was sponsored by AARP "rediscovered" Grandma Moses. Indeed, it put her back on the map, and it marked a new phase for the Museum as well. It was now that we learned some hard marketplace rules. Neiman Marcus proposed using one of the show's pictures as the cover of its Christmas catalogue. Since we strive to make better known the work of women artists, we were thrilled. However, we had to decline that opportunity because the Moses estate would require a royalty that made my head spin.

THEN IN 2003 CAME WHAT I WILL ALWAYS CONSIDER ONE OF OUR TRIUMPHS, artistically and diplomatically, *An Imperial Collection: Women Artists from the State Hermitage Museum*. A few years earlier—with the help of board member Kathy Springhorn, who was active in the American Friends of the Hermitage Museum—we had arranged for Dr. Mikhail Borisovich Piotrovsky, director of the Hermitage, to present a lecture at the Museum about the queen of art patrons, Catherine the Great. The demand for tickets was such that we had to hold the lecture in the Great Hall. It was standing room only to hear this uniquely distinguished speaker discuss a fascinating female. His father had been director of the Hermitage before him—a rare dynasty, so to speak, in a nation whose revolution was determined to end

Hermitage Director Mikhail Borisovich Piotrovsky presents a lecture about the queen of art patrons, Catherine the Great.

privileges like hereditary rule. But make no mistake about it, the succession of Dr. Piotrovsky is based on extraordinary merit!

At the dinner party after the lecture, the guest of honor turned to me and said, "I love your museum. I have spoken in many auditoriums in the United States, but this is like a little Russian palace." Having visited Saint Petersburg a number of times, I knew what he meant, for the city that Peter the Great built as his gateway to Europe is a wonderland of eighteenth-century palaces built by the old Russian nobility and a community of foreign diplomats and businessmen. Dr. Piotrovsky's remark provided the perfect opening for my response: "I'm so happy you feel that way. We would be honored to plan an exhibition here of works by women from the Hermitage if you would be willing to loan them." He readily agreed.

As soon as practical, Wally and I returned to Saint Petersburg, this time with NMWA's chief curator, Dr. Susan Fisher Sterling, in order to explore the idea of an exhibition. We hosted another dinner party for Dr. Piotrovsky, this time at a splendid restaurant, and he obviously enjoyed himself. The next day he called us into his office with several of his staff and told them: "Please assist our guests. I wish to loan them any paintings by women from the collection that they wish to borrow for an exhibition."

Susan and I explored the storage areas, and we were amazed—but hardly surprised—by the array of great works by women pulled out for our inspection, paintings by Angelica Kauffman, Elisabeth-Louise Vigée-Lebrun, Marie-Anne Collot, and more. The storage facilities themselves were appalling, as was the condition of many paintings, which were barely protected from the elements. For one thing, climate control was nonexistent; for another, I've been told that a proper inventory hasn't been made since Catherine the Great ordered her emissaries to purchase entire collections from the great estates of Britain, France, and Italy. Conservation efforts have been sporadic at best. We saw pictures stacked in basements more or less at random, covered with dust, many with frames broken. In one attic with broken windowpanes, Susan noticed pigeons nesting on an Empire-style dressing table, a lovely inlaid piece that might have graced the boudoir of a Romanov princess. The Hermitage simply doesn't have sufficient funds to properly curate or conserve its great holdings, and it can afford to pay its gifted curators only pittances as salaries. Dr. Piotrovsky is working hard to improve conditions. It is a difficult and long-range task.

We presented a wish list of paintings we wanted to borrow, and negotiations followed. I began to search for underwriting, because this would be a very expensive exhibition to mount. Not only was it to be a large show, but the distances were considerable, as was the amount of conservation that had to be done. That the show promised to exhibit these Russian treasures in Washington was one benefit to the

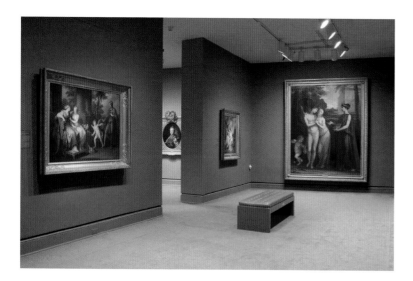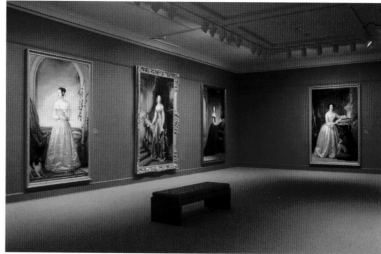

Hermitage; another was our promise to do conservation work. We were able to hire the best Russian conservators, so that the paintings we were to borrow would be in pristine condition.

Fortunately, I had a friend in Adrienne Mars, whose husband, John, was chairman of Mars, the candy company. One day on the phone she asked me how things were going and what plans we had. I told her about the opportunity to stage an exhibition of paintings from the Hermitage. Adrienne said, "We might be able to help you with that. We have a big market in Russia." Generous underwriting by John and Adrienne Mars was soon arranged.

When *An Imperial Collection* opened on Valentine's Day 2003, it culminated a multiyear effort on our part, but it was worth the wait and the work. Dr. Piotrovsky had promised to attend the opening at the young institution that he, the director of one of the Old World's most august museums, had called "a little Russian palace." The night before the opening Russian Ambassador Yury Ushakov and his wife, Svetlana, held a celebratory dinner at the refurbished embassy residence on Sixteenth Street, and thus began one of the most high-profile events in our history. Next morning, when we held a viewing of the exhibition for the press, Dr. Piotrovsky attended. It was the first time our kind lender was able to see the works we had borrowed and conserved. He was deeply moved, and I was touched. As he walked through the exhibition he said, "These came from the Hermitage? I don't believe I have ever seen them before or that they have ever been hung."

I held a luncheon in honor of Dr. Piotrovsky and his beautiful wife, Irina, at my house and included the Ushakovs. I very much enjoyed hearing the two men talk about the history and arts of Russia. While the art hanging in our house was not discussed, it was evident that Dr. Piotrovsky was interested. Before leaving he said with obvious sincerity how much it meant to him to be in our private house, which seldom happened in a busy life that took him to many countries.

An Imperial Collection: Women Artists from the State Hermitage Museum *was a splendid opportunity for NMWA visitors to view major works by women from one of the greatest art collections in the world.*

The exhibition was a great success, as art lovers flocked to NMWA from all over the country. Perhaps most gratifying to me is the fact that when Wally and I returned to the Hermitage in 2006, we found fully a dozen of the paintings we had borrowed in one exhibition hall, still glowing in the subtle brilliance of the conservation that we had provided. We quietly cheered.

Not only had our Hermitage exhibition given thousands of Americans the opportunity to see some of Russia's finest treasures, but the exhibition had benefited its lenders. First, our selection process had identified for the Hermitage staff a number of overlooked works. Second, it demonstrated to Russia's curators and museum-goers the wealth they possessed in paintings by important women artists. Third, *An Imperial Collection* fulfilled our raison d'être in that it gave the public new knowledge of contributions by artists who were women—and whose works were collected by advisers to one of the great patronesses of all time.

<hr>

IN 2006, A WONDERFUL OPPORTUNITY TO COLLABORATE with the anthropology and archaeology museums in Mexico and Peru came to us through the largesse of First Lady Laura Bush. In the 1990s, Mrs. Bush had become a loyal friend of the Museum when she served as honorary chair of NMWA's Texas Committee during her husband's years there as governor. In 2005, on a state visit to Peru, the First Lady saw a major scholarly exhibition entitled *Divine and Human: Women of Ancient Mexico and Peru*. The original idea for *Divine and Human* came from the first lady of Peru, Eliane Karp de Toledo, and the wife of the president of Mexico, Marta Sahagún de Fox. They told Mrs. Bush that they hoped it might come to Washington. So, under the honorary patronage of these three ladies, we began working with the INAH/Conaculta and Museo Nacional de Antropología in Mexico City and with the Ministry of Education of Peru to bring this important exhibition about women in ancient Mesoamerica to the United States. Along the way, we received invaluable help in Washington from Peruvian Ambassador Eduardo Ferrero, Mrs. Veronica Ferrero, and Mexican Ambassador Carlos de Icaza.

Divine and Human broke new ground for us in that the exhibition used archaeological artifacts to tell fascinating stories of women's lives, both on earth and in the cosmos in these ancient, highly developed cultures. The more than three hundred objects, which date from as far back as 200 B.C., included beautifully modeled ceramics, massive carved stone sculptures, intricately fine weavings, and splendid gold and metal jewelry. The mesh of form and imagery was marvelous in these ancient works, and spoke directly and forcefully about women's strengths, even then, as mothers, healers, governors, priestesses, and goddesses.

The press was enthusiastic about the show. Paul Richard led the way in *The*

LEFT: *Through works of sculpture, ceramics, weavings, and jewelry,* Divine and Human: Women of Ancient Mexico and Peru *told fascinating stories of women's lives, both on earth and in the cosmos, in these ancient, highly developed cultures.*

OPPOSITE: *The ground-breaking exhibition* Italian Women Artists from Renaissance to Baroque *brought together some of my favorite painters, sculptors, and printmakers. One of them is Elisabetta Sirani, whose* Melpomene *is in NMWA's collection.*

ELISABETTA SIRANI (1638–1665). *Melpomene, the Muse of Tragedy,* n.d. Oil on canvas, 34¼ x 28 in. (87 x 71 cm). Frame conservation funds generously provided by Jane Fortune.

Washington Post with a review that was as revealing of his view of us as it was of his opinions about art:

> The women it depicts—some are human beings, some goddesses, it's often hard to tell—are unashamedly physical. They do not hide their genitals. They bleed. Their piety is obvious, but also pretty scary. Ritual human sacrifice was not at all uncommon in ancient Mexico and Peru. They're also frankly carnal, assuming physical positions of the Kama Sutra variety. . . .
>
> Did a man or woman carve her? Who knows. Does it matter to the viewer? Perhaps a little, but not much.

Richard went on to recall our primary purpose, which he said was to "redefine traditional histories of art" by discovering "long-neglected" women artists of significant merit. Then he observed: "*Divine and Human* proposes an alternative. Take womanhood as a subject and examine it intensely, and do so open-mindedly to see what grand exhibits might be found along the road."

IN OUR TWENTIETH YEAR, our major spring show was one of our most important and successful, the ground-breaking exhibition *Italian Women Artists from Renaissance to Baroque*. This exhibition brought together works by some of my favorite painters, including Lavinia Fontana, Artemisia Gentileschi, Sofonisba Anguissola, and Elisabetta Sirani. Proudly, Laura Bush toured the exhibition one morning before the opening with me, my daughter-in-law Winton, and Leila Castellaneta, the wife of the Italian ambassador. Mrs. Castellaneta served us a delicious lunch at the ambassador's residence afterward. This show was another feather in our cap, as some of the loans came from Italy's top museums.

Italian Women Artists from Renaissance to Baroque explored the oeuvre of fifteen talented and exceptional women working during the sixteenth and seventeenth centuries. It offered a broad overview of the range of art and the opportunities available to Italian female painters, sculptors, and printmakers. The Italian artists learned to paint from their fathers, brothers, and husbands, who recognized their talent and potential for earning money. Female artists could support themselves and sometimes their families, and they were able to pay for dowries that often help assure more suitable marriages. They excelled as painters of portraits and still lifes, as well as of biblical and mythological subjects. Some brilliantly executed church altarpieces that greatly enhanced their reputations and professional standing. Their achievements elicited admiration and respect—and sometimes jealousy and fierce competition. Elisabetta Sirani may have been poisoned by an envious rival, dying at the age of twenty-seven, at the peak of her career and fame. *Italian Women Artists from Renaissance to Baroque* debunked the myth that women artists were second-class citizens in Italy at the height of the Renaissance. These artists reflected on and interacted with their culture and society, and prevailed against "the conditions of their sex," overcoming the odds and leaving behind a fascinating visual legacy that influenced future generations of artists.

The exhibition profited enormously from the involvement of Vera Fortunati of the University of Bologna. It was also our good fortune that sVo Art, a private

exhibition company based in Versailles, France, approached NMWA to partner with them to organize this exhibition. Through sVo Art we formalized a partnership with Claudio Strinati, director of the Roman Museum Center, who supported this project from the start. In recognition of the importance of this exhibition we received loans from no fewer than twenty-five museums, private lenders, and libraries. The show's scholarly worth can be further measured by the grants it received, including two from the Samuel H. Kress Foundation and another from the NEA.

The annual gala, co-chaired by Charlotte Buxton and Cindy Jones, in April 2007 was a grand celebration of both NMWA's twentieth birthday and the exhibition. Every guest felt the sense of Renaissance splendor. The decorations included a mural of Saint Mark's Square in Venice, which was specially commissioned as a backdrop for the orchestra. It was a spectacular and enchanting night.

<p style="text-align:center">⊶————⊷</p>

IN THE FALL OF 2007, the Museum presented *WACK! Art and the Feminist Revolution*, the largest exhibition in our history and a fitting finale to our twentieth-anniversary year. Encompassing two floors and more than twelve thousand square feet of gallery space, *WACK!* was the first comprehensive exhibition to explore the formation, development, and impact of the women's movement on contemporary art from 1965 to 1980. Organized by the Museum of Contemporary Art (MOCA), Los Angeles, the exhibition included nearly 300 works of art by 118 artists from around the world.

NMWA's galleries were filled with paintings, sculptures, videos, textiles, prints, photographs, and performance relics by icons such as Magdalena Abakanowicz, Lynda Benglis, Louise Bourgeois, Judy Chicago, Rebecca Horn, Ana Mendieta, Alice Neel, Yoko Ono, Niki de Saint Phalle, Howardena Pindell, Yvonne Rainer, Faith Ringgold, Miriam Schapiro, Nancy Spero, and Hannah Wilke. *WACK!* also highlighted important international artists who are not yet well known to American audiences. The international scope of the exhibition reflected the Museum's fervent dedication to women artists around the world.

WACK! had received excellent reviews for its opening run at MOCA in spring 2007, and they were matched by raves in the Washington press when the exhibition moved to D.C. In her *Washington Post* review, Barbara Pollack described *WACK!* as "a landmark" and commended the Museum for bringing the exhibition to Washington. She concluded: "*WACK!* does much more than make history. It gives another generation a chance to see art that was not made for a marketplace . . . but with a determination and belief that art can change the way we live."

WACK! was curated for MOCA by Cornelia H. Butler. Ms. Butler, who is currently chief curator in the Museum of Modern Art's department of drawings, noted both privately and to the press that NMWA was the strongest institutional advocate

WACK! Art and the Feminist Revolution *explored the impact of the feminist movement on contemporary art from 1965 to 1980. Among the works in the exhibition was one by Judy Chicago.*

JUDY CHICAGO (born 1939). *Pasadena Lifesavers Red #5,* 1970. Sprayed acrylic lacquer on acrylic, 60 x 60 in. (152.4 x 152.4 cm). Gift of Elyse and Stanley Grinstein.

for the project; Susan Fisher Sterling had expressed interest in hosting *WACK!* early in the project's planning stages. With Sterling's encouragement buoying her, Butler was confident that she could travel *WACK!* to other institutions. After NMWA, the exhibition continued its tour to the Museum of Modern Art's P.S.1 in New York, its contemporary art center, and to the Vancouver Art Gallery.

When *WACK!* opened in September, dozens of artists whose works were featured in the exhibition came to Washington to celebrate. During conversations at the exhibition's opening and in subsequent telephone calls, e-mails, and letters, the artists noted how much they appreciated the intimate feel of the galleries at NMWA. They felt that the elegant spaces and spacious layout of the show highlighted the formal qualities of their work and reflected the importance of their contribution to contemporary art.

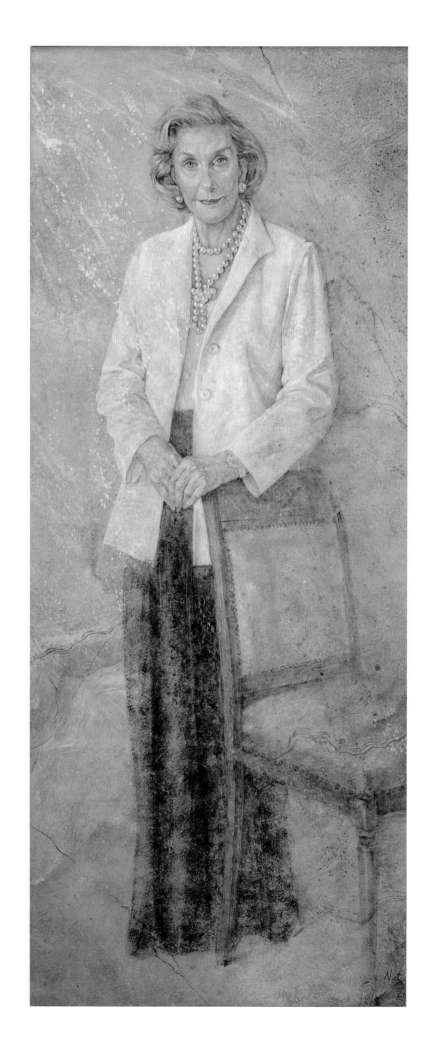

The Legacies and the Future

NATI CAÑADA, *Portrait of Wilhelmina Holladay*, 2007. Oil on wood. 61 7⁄16 x 313½ in. (158 x 80 cm). Gift of the artist.

T HE MUSEUM CANNOT GROW IN PHYSICAL SIZE, but it can surely grow in stature. To make that a certainty and realize my dreams of the future, my ambitious goal is an eventual endowment of more than a hundred million dollars. With the resulting income, we could afford to pay top salaries (thereby assuring a highly qualified staff), to add masterpieces to the permanent collection, and to develop exciting and diverse exhibitions, including innovative ones for which fundraising is difficult. We could also afford to widen our prizewinning educational programs for children. Through our Library and Research Center's collection and databases, NMWA could firmly establish itself as the major center of information on women artists from all over the world and proudly serve an enlarged network of supporters, members, and committees with an outstanding quarterly magazine.

As previously mentioned, the Ford Foundation gave seventy thousand dollars to have professionals determine if we were ready for an endowment drive, and they advised that we conduct a drive for twenty-five million dollars in cash and pledges plus ten million in planned giving. Carol and Climis Lascaris agreed to co-chair the effort, and no one could have been better prepared to lead the drive than two steadfast friends with extensive involvement in the Museum. At the beautiful dinner party, hosted by the Lascarises in my honor, and celebrating NMWA's twentieth anniversary, we were able to announce that we had surpassed both goals of the drive. For the occasion, I received many letters of congratulations, including notes from Philippe de Montebello, Director of the Metropolitan Museum of Art, and Senator Hillary Clinton.

As I write this toward the end of 2007 the endowment and planned giving continue to grow substantially, together totaling more than forty million dollars. Since the bylaws now dictate that no more than 5 percent can be used for the budget and

an excellent investment plan is in place, I dearly hope that the financial future of the Museum is assured, but I know we can do better. We shall start by aiming for fifty million dollars by our twenty-fifth anniversary.

The year 2008 promises to be a rewarding one for the National Museum of Women in the Arts and its constituency. At a January 14 White House ceremony, the Museum received the prestigious National Medal for Museum and Library Services, one of only ten institutions to have been so recognized this year. NMWA was the single art museum praised for its commitment to public service through innovative programs and community partnerships.

Our board of trustees—a wonderful group of women with competence in many areas—has done an outstanding, tireless job of contributing talent, intelligence, money, and time. One great plan they have in the works concerns our physical presence. The median across from the Museum's New York Avenue entrance could become, with the cooperation of the city, a beautifully planned sculpture garden, comparable to New York City's Park Avenue. Outstanding loaned sculptures displayed on handsome permanent bases will lend beauty to the city and greatly enhance our entrance. This could enable women sculptors to have a showplace in the nation's capital. Preliminary research has proved encouraging; magnificent works have been offered, and the city government is supportive.

In celebration of its twentieth anniversary in March 2007, NMWA saluted women who have broken ground in many disciplines, including politics, civil rights, medicine, and the performing arts. Thanks to the initiative and hard work of board member Irene Natividad, the "Legacies of Women" forum held at the Inter-American Development Bank was a memorable event on many accounts. The event made me think about legacies of women in general, and in particular about my personal legacy.

Judy Woodruff, the television journalist, radiated her famous competence as mistress of ceremonies, and she asked the five women being honored in turn where each had found the confidence to start out, and to do what we had done. Madeleine K. Albright, former secretary of state and ambassador to the United Nations, replied quick as a wink, "I faked it," a gambit that I'm sure all of us had used many times over.

Dorothy Height, the civil rights pioneer; Dr. Antonia Novello, the first female surgeon general of the United States and the first Hispanic; Muriel Siebert, the first woman to own a seat on the New York Stock Exchange; and I answered many questions. We all attributed our sense of self-confi-

Madeleine Albright and I after the "Legacies of Women" forum award ceremony. The Museum celebrated women who have broken ground in many disciplines including politics, civil rights, medicine, and the arts.

My grandchildren (left to right), Wallace Fitzhugh Holladay, III "Fitz"; Jessica Scott Holladay "Jessie"; Winton Westbrook Holladay "Brook"; and Addison Cole Holladay, grew up with the Museum and continue to give great joy.

fidence to the women who raised us. For Albright it was her parents, her mother especially; for me it was my grandmother. In every case, there was a woman who nurtured us and saw us on our way. This realization brought an old thought to mind. We women are important in many ways and in many realms. The first, of course, is the very essence of creativity, namely conceiving, gestation, birth, and nurture of children, but creativity has varied expressions, and professional accomplishments are as important for many women as motherhood.

After a short video biography, each of us spoke of our inspirations, goals, and accomplishments: My highest specific achievement is to have founded the National Museum of Women in the Arts. I am proud of having conceived the idea. It has been my privilege to define the Museum's mission, chair its board, and remain one of its leaders. But let us be clear: *I am not the Museum.* And the Museum is not I. The National Museum of Women in the Arts has a life of its own and a purpose that will survive all of us.

For continuing the effort and accomplishing so much during the twenty years of the Museum's existence, credit also deserves to go to all the people who have worked at NMWA, to all the directors, our outstanding curators, librarians, support staff, and excellent security guards; to the many who have served on our board of trustees; to the several hundred who have served on the National Advisory Board, the Business and Professional Women's Council, and the Women's Committee; to members of the State Committees and International Committees; to the thousands of NMWA members in the United States and abroad; and to the hundreds of volunteers who daily work at the information desk, lead tours, and masterly perform an inordinate number of tasks. Credit must be shared with all our donors, who have helped our collection and financial well-being. Always I give special thanks and credit to my husband, Wally, who has aided the Museum financially and has given me unfailing support and love.

I think of my son and my grandchildren—Winton Westbrook Holladay; Jessica Scott Holladay; Wallace Fitzhugh Holladay; and Addison Cole Holladay. Born in Washington, they were aware of the Museum's growth and accomplishments at an early age. I am happy that they are proud and feel a part of it. I believe it is helpful for a family to have roots where they live. If I have given my family roots in this city, then perhaps I have given them a sense of belonging and of knowing who they are.

I am very fortunate that my son Hap (Wallace Fitzhugh Junior) is married to Winton, a wonderful art historian. They have both been interested in the Museum since its inception. She was recently invited to serve on the board of trustees, not by me but by others who recognized her many past achievements and knowledge of art. I am delighted that her involvement will carry on a family tradition.

In recent years I have realized that my engagement with the Museum has made me somewhat of a feminist. In the past, it was not that I did not believe in many of the things that feminists stood for, but I was not actively involved. I cannot fairly say that I have ever suffered great discrimination. But I understand that, probably, if not for the early feminists, Sandra Day O'Connor would not have served on the Supreme Court and NMWA would not be as timely as it is. I arrived at this feminist stance because my point of view changed over the years. I visited many countries and discovered that women were rarely given the same importance as men in art as well as other disciplines. As a result of these experiences I underwent a process of intellectual transformation and developed a heightened awareness of discrimination against women as a whole. I truly feel indebted to the feminists. Among the many honors I have received, I consider among the most special being inducted into the National Women's Hall of Fame in Seneca Falls, New York, in 1996. Equally thrilling was being decorated as a *chevalier* of the Légion d'Honneur by the president of France in May 2006, and being presented with the National Medal of Arts by President George W. Bush in November 2006. The latter is the highest award given to artists and arts patrons by the United States government. The stature of the Museum, which was made by the efforts of thousands, made these possible.

The Museum's prestige fluctuates with every review of an exhibition or article in a leading periodical. I have developed a sixth sense that enables me to evaluate in social and political pursuits how the Museum rates and is perceived at any given time. When French Ambassador Jean-David Levitte so kindly told me I was to receive the Légion d'Honneur I was deeply touched. Of course, I accepted it in the name of the Museum; what surprised me was that it was brought up frequently in discussions and that personally having received it opened many doors. The arts enjoy enormous stature in France but, unfortunately, not in the United States. The arts are frequently left out of school curriculums for budgetary reasons or because they aren't

TOP: *Supreme Court Justice Sandra Day O'Connor has been a longtime friend of the Museum.*

ABOVE: *My induction into the National Women's Hall of Fame in Seneca Falls, New York, in 1996 made Wally and me very proud.*

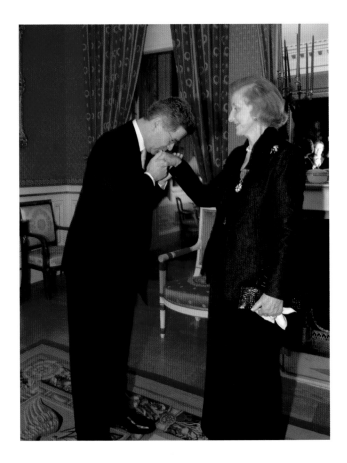

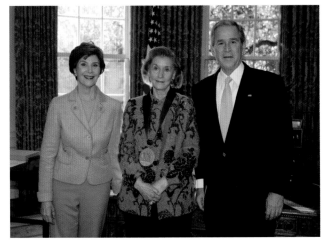

TOP: *I was made a chevalier of the Légion d'Honneur by the president of France in 2006. Ambassador Jean-David Levitte pinned the medal to my jacket in the presence of my family and friends.*

ABOVE: *In 2006 I was given the National Medal of Arts by President George W. Bush. This picture was taken after the White House ceremony with the President and Mrs. Bush.*

considered important. Congress gives the very minimum of government support to culture. While I was delighted to receive the National Medal of Arts because of its reflection on the Museum, the media barely covered it. We are a young country; as time goes on perhaps we shall recognize that the arts are vital to the well-being and education of individuals.

I sometimes find myself declining invitations to speak or be honored by this or that organization. It takes valuable time and energy, typically a day or two to rearrange the calendar, travel, dress for the occasion, "be on," speak, and be the honored guest at a luncheon or dinner. However, I make a determined effort concerning an invitation that will especially promote NMWA and provide an opportunity to reach a new audience. Some organizations, I feel, are simply too august to decline, like the National Arts Club in New York, which chose me as the recipient of its Medal of Honor for Art in 2007. I planned the trip, managed to schedule a few other tasks in Manhattan while I was there, and enjoyed a wonderfully planned affair that introduced many new important people to the Museum.

My experience has been that art attracts good people. I think those who are perceptive to art, love art, and respect the spirituality and creativity of art are on the whole intelligent, sensitive people. I cannot overemphasize the importance of the arts in the life of any society. To quote the lament of National Endowment for the Arts Chairman Dana Gioia during his 2007 commencement address at Stanford University: " [We] live in a culture that barely acknowledges and rarely celebrates the arts or artists. . . . When virtually all of a culture's celebrated figures are in sports or entertainment, how few possible role models we offer the young . . ." I happily and gratefully admit that the Museum has given me far more than I have given to the Museum. It has enabled me to meet wonderful people and have wonderful friends. It has been a large and meaningful part of my life in many, many ways. I consider my legacy to society the creation and founding of the National Museum of Women in the Arts, a crowning jewel in the "shining city upon a hill."

Selected Gifts and Promised Gifts of Wallace and Wilhelmina Holladay to the Museum

ABOVE:
FEDE GALIZIA (1578–1630).
Cherries in a Silver Compote with Crabapples
on a Stone Ledge and a Fritillary Butterfly, n.d.
Oil on panel, 11⅛ x 16⅝ in. (28.2 x 42.2 cm).

OPPOSITE:
ARTEMISIA GENTILESCHI (1593–1651).
Portrait of Sibylle, c. 1612–20.
Oil on canvas, 28 x 23½ in. (71.1 x 59.7 cm).

LOUISE MOILLON (1610–1696).
A Market Stall with a Young Woman Giving a Basket of
Grapes to an Older Woman, c. 1630.
Oil on canvas, 48¼ x 66⅜ in. (125.6 x 168.6 cm).

JUDITH LEYSTER (1609–1660).
The Concert, c. 1631–33.
Oil on canvas, 24 x 34¼ in. (61 x 87 cm).

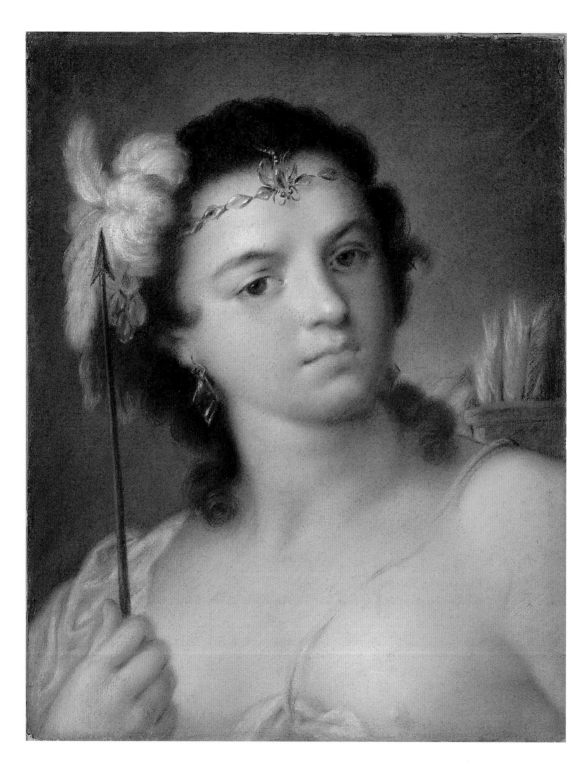

LEFT:

ROSALBA CARRIERA
(1675–1757).
America, c. 1730.
Pastel on paper
mounted on canvas,
16½ x 13 in.
(41.9 x 33 cm).

OPPOSITE:

MARIANNE LOIR
(c. 1715–1769).
*Presumed Portrait of
Madame Geoffrin*, n.d.
Oil on canvas,
39½ x 32¼ in.
(100.3 x 81.9 cm).

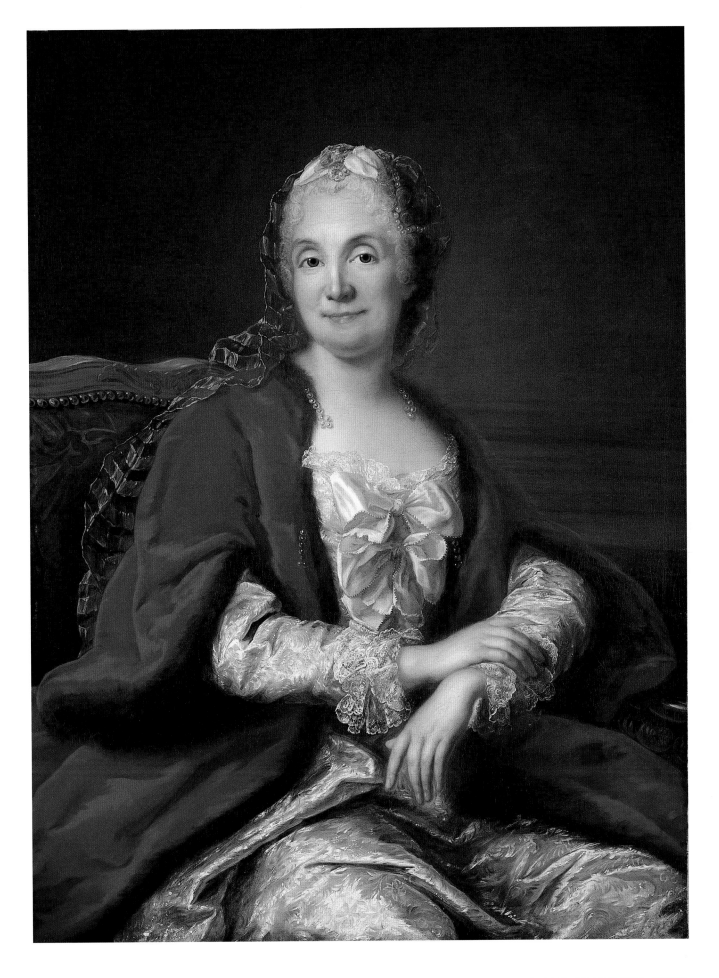

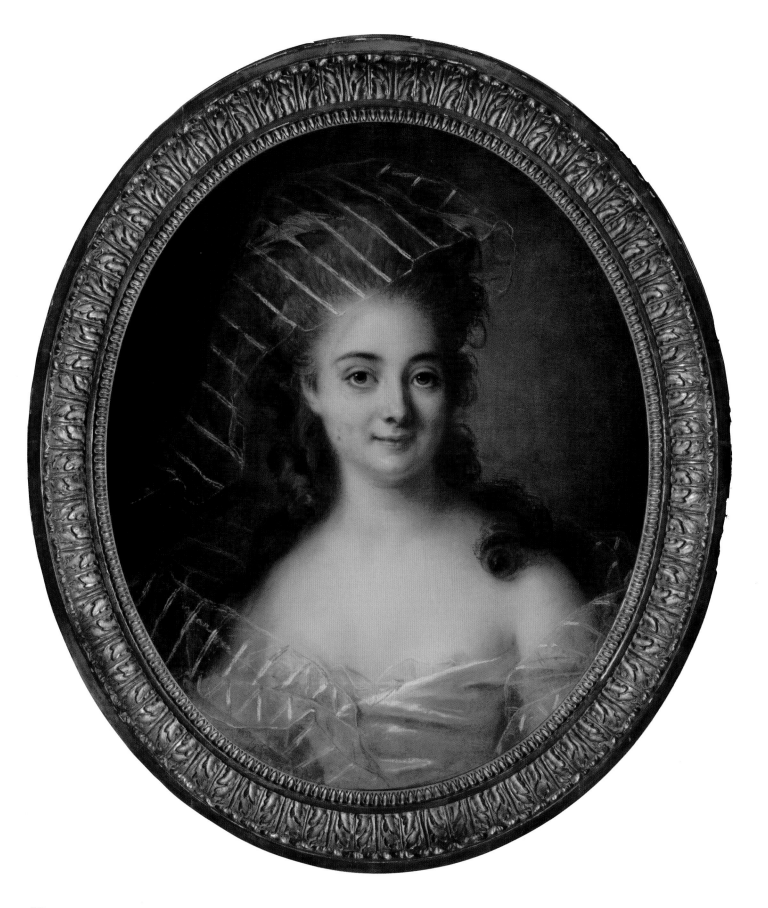

OPPOSITE:
ANNA DOROTHEA
LISIEWSKA-THERBUSCH
(1721–1782).
Woman with a Veil, n.d.
Pastel, 47½ x 23½ in.
(120.7 x 59.7 cm).

RIGHT:
MARIE-GENEVIÈVE
NAVARRE (1737–1795).
*Portrait of a Young
Woman,* 1774.
Pastel on paper, 24 x
19¾ in. (61 x 50.2 cm).

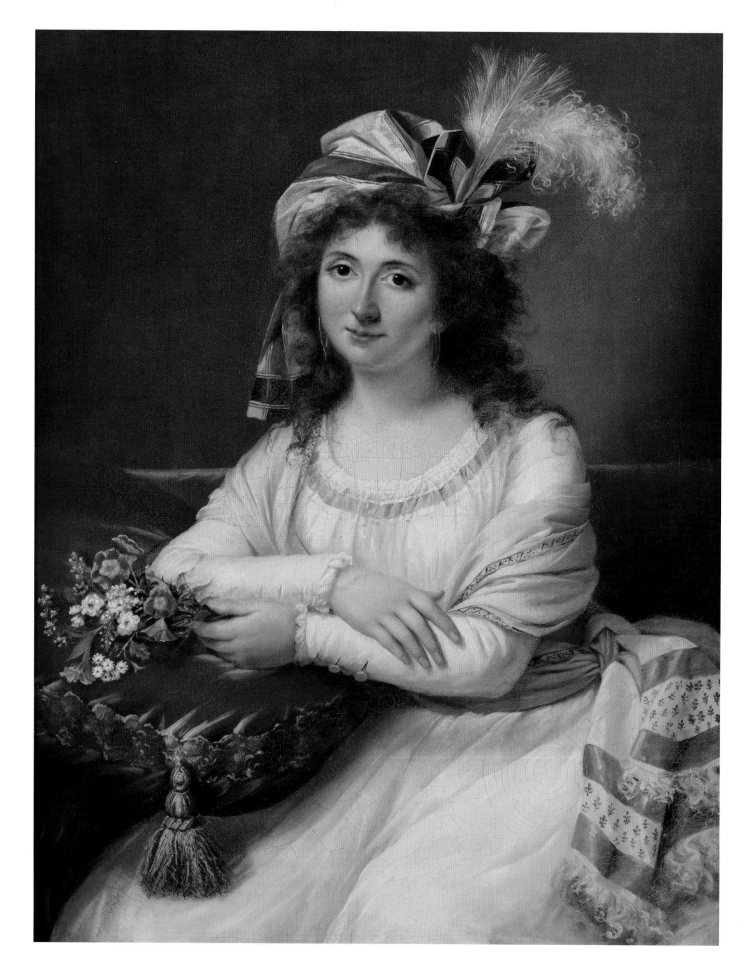

OPPOSITE:
ADÈLE ROMANY
(1769–1846).
Portrait of Madame Louise Vigée, n.d. Oil on canvas, 35½ x 27½ in. (90 x 70 cm).

RIGHT:
ELISABETH-LOUISE VIGÉE-LEBRUN
(1755–1842).
Mlle. Elisabeth Fischbein, from Sketchbook Comprising Thirty-eight Portrait Drawings of Women and Children of the Russian Court, 1795–1801. Graphite and chalk on paper, approximately 7 x 4⅜ in. (17.8 x 11.1 cm).

MARGUERITE GÉRARD (1761–1837).
Prelude to a Concert, c. 1810.
Oil on canvas, 22¼ x 18¾ in. (56.5 x 47.3 cm).

Elisabeth-Louise Vigée-Lebrun (1755–1842).
Portrait of a Young Boy, 1817.
Oil on canvas, 21¾ x 18¼ in. (55.2 x 46.4 cm).

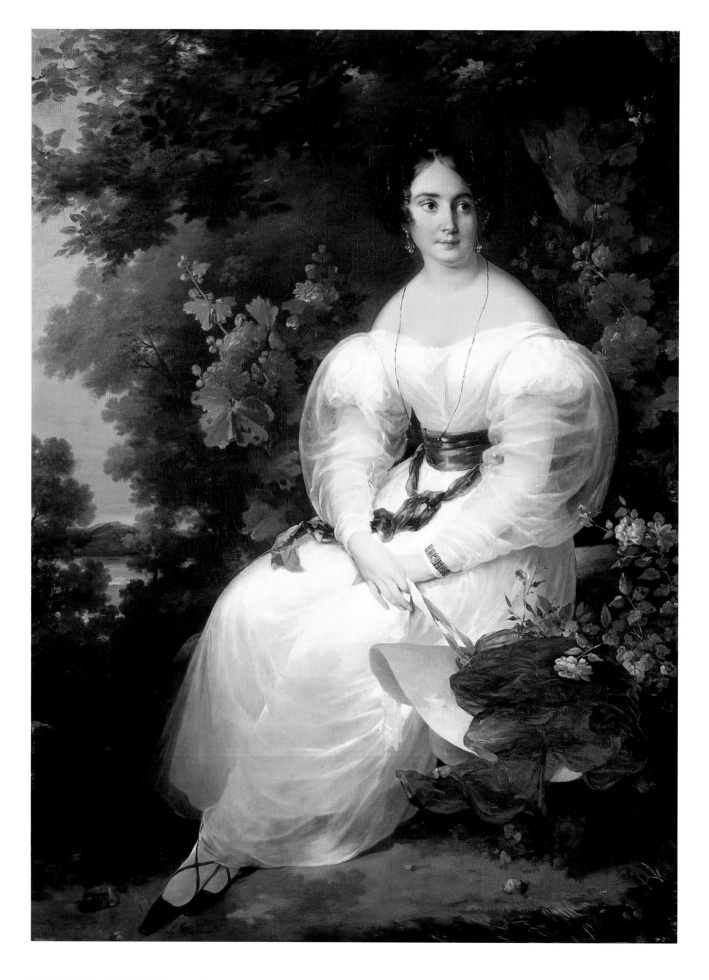

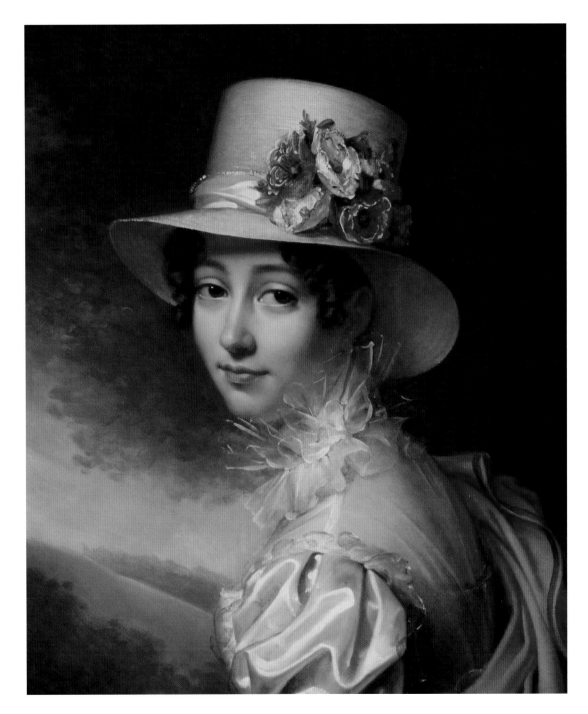

OPPOSITE:
ANTOINETTE-CÉCILE
HAUDEBOURT-LESCOT
(1784–1845).
*Young Woman Seated in
the Shade of a Tree,*
c. 1830.
Oil on canvas, 67 x 45½
in. (170.2 x 115.6 cm).

RIGHT:
ZOË JACQUELINE DU
VIDAL DE MONTFERRIER
(1797–1869).
Portrait de Jeune Fille, n.d.
Oil on canvas, 25⅗ x
21⁷⁄₁₀ in. (65 x 55 cm).

OPPOSITE:
SARAH BERNHARDT (1844–1923).
Après la Tempete (After the Storm), n.d.
White marble, 29½ x 21 in. (75 x 53.3 cm).

ABOVE:
CLAUDE RAGUET HIRST (1855–1942).
A Gentleman's Table, after 1890.
Oil on canvas, 18 x 32 in. (45.7 x 81.3 cm).

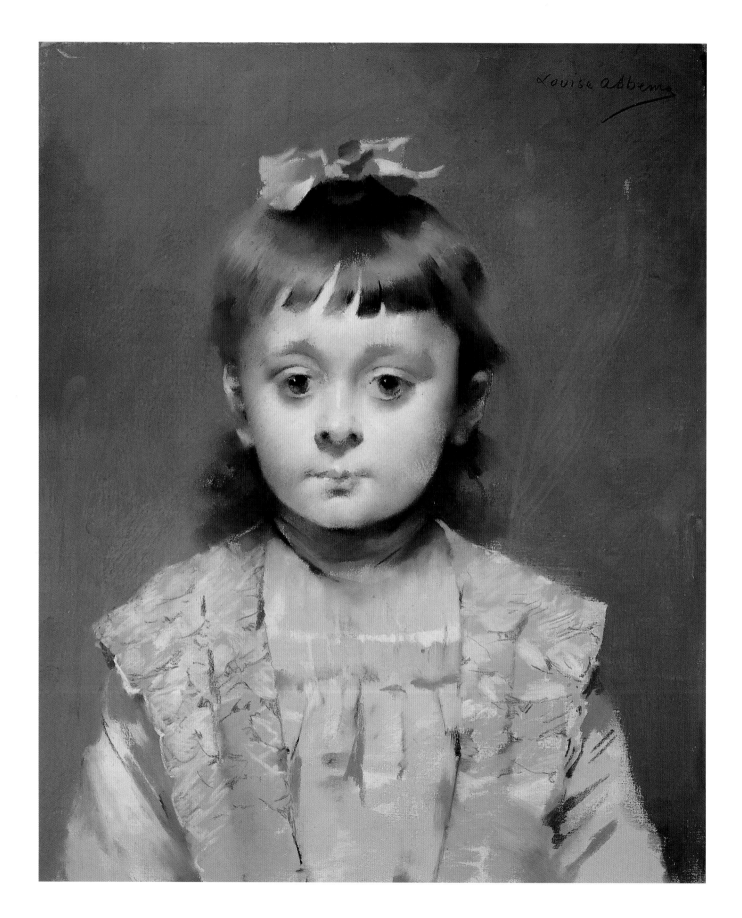

SELECTED GIFTS AND PROMISED GIFTS

OPPOSITE:
LOUISE ABBÉMA (1858–1927).
Portrait of a Young Girl with a Blue Ribbon, n.d.
Pastel on canvas, 18 x 15 in. (45.7 x 38.1 cm).

RIGHT:
EVA WATSON-SCHÜTZE (1867–1935).
The Rose, 1905.
Gum bichromate print, 13⅜ x 5 in. (34 x 12.7 cm).

LEFT:
BESSIE POTTER VONNOH
(1872–1955).
The Fan, 1910.
Silvered bronze,
11⅜ x 4¼ x 4 in.
(28.9 x 10.8 x 10.2 cm).

OPPOSITE:
GWEN JOHN
(1876–1939).
La Petite Modèle, c.1910.
Oil on canvas, 21 x 17½
in. (53.3 x 44.5 cm).

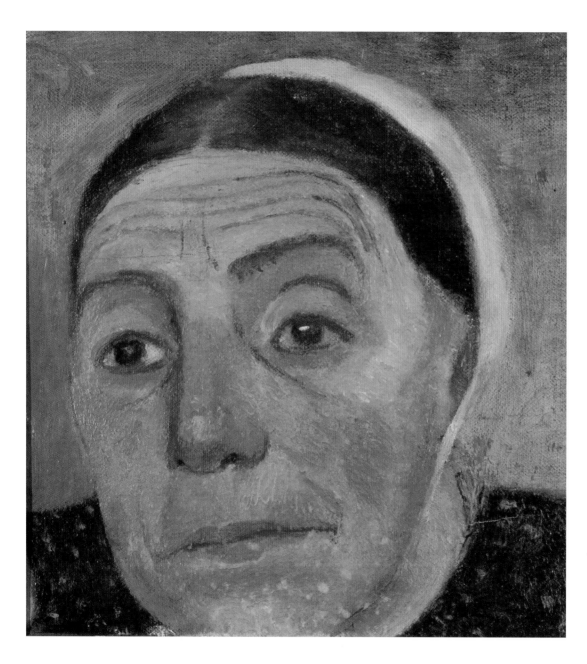

LEFT:
PAULA MODERSOHN-BECKER (1876–1907).
Head of an Old Peasant Woman, n.d.
Oil on panel, 9½ x 9 in. (24.1 x 22.9 cm).

OPPOSITE:
JANE PETERSON (1876–1965).
Docks at Gloucester, n.d.
Gouache and charcoal on paper, 18 x 24 in. (45.7 x 61 cm).

LEFT:
LIUBOV POPOVA
(1889–1924).
*Study for Portrait of a
Philosopher,* 1915.
Gouache, 12 x 9 in.
(30.5 x 22.9 cm).

OPPOSITE:
NINA KOGAN
(1887–1942).
Composition, c. 1921.
Watercolor and pencil
on paper, 19⅞ x 13 in.
(50.5 x 33 cm).

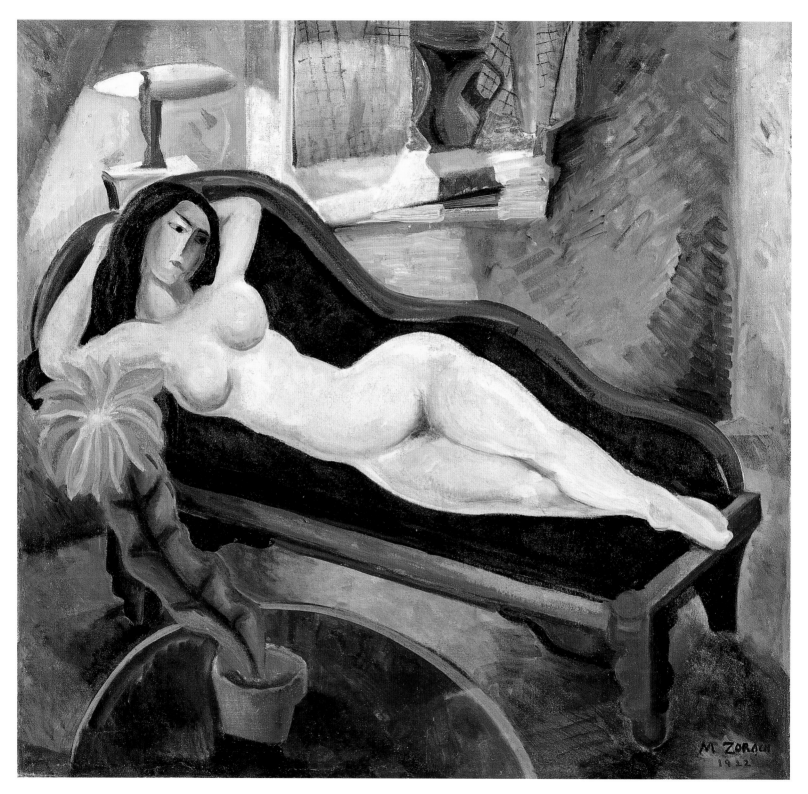

ABOVE:

MARGUERITE THOMPSON ZORACH (1887–1968).
Nude Reclining, 1922. Oil on canvas, 29⅛ x 30¼ in. (74 x 76.8 cm).
Courtesy of The Zorach Collection, LLC.

OPPOSITE:

MALVINA HOFFMAN (1887–1966).
Anna Pavlova, 1926.
Bronze, 13 x 10½ x 6 in. (33 x 26.7 x 15.2 cm).

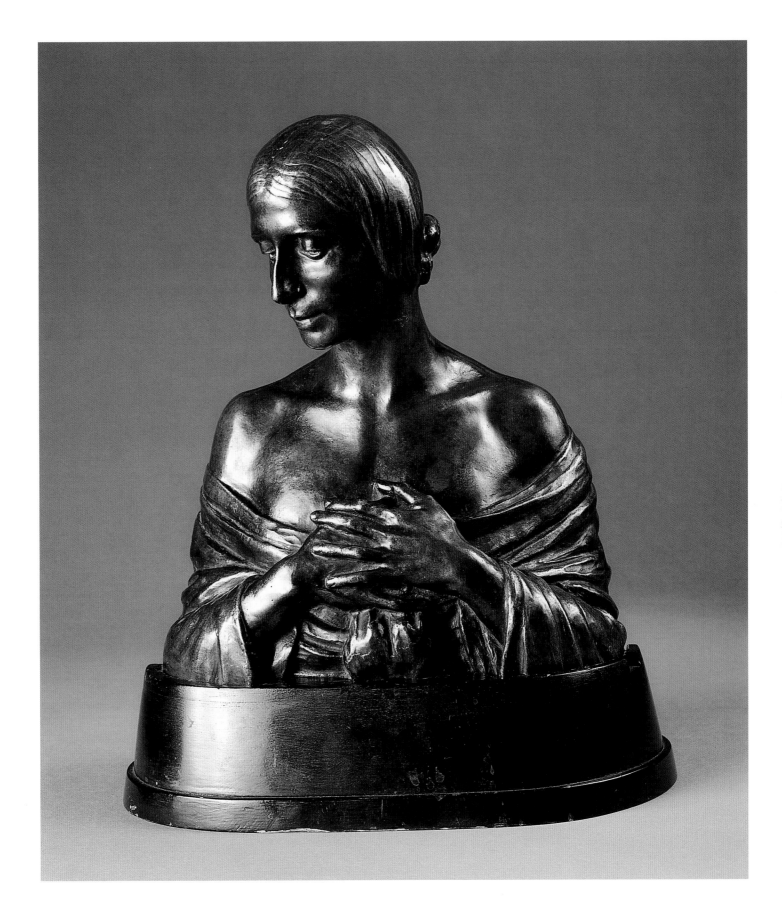

OPPOSITE:
ELLEN DAY HALE
(1855–1940).
The Green Calash, 1927.
Hand-colored etching
on paper, 11⅞ x 7 in.
(30.2 x 17.8 cm).

RIGHT:
BERENICE ABBOTT
(1898–1991).
Betty Parsons, c. 1927.
Vintage silver print, 2 x
2¼ in. (5.1 x 5.7 cm).

LEFT:
MARGARET BOURKE-
WHITE (1904–1971).
*Cement Workers,
Novorossisk,* 1930.
Gelatin silver print, 13⅜
x 9¼ in. (34 x 23.5 cm).

OPPOSITE:
ALEXANDRA EXTER
(1882–1949).
*Costume Design for "Les
Equivoques d'Amour,"*
c. 1933.
Gouache and pencil on
paper, 22⅜ x 17⅛ in.
(56.8 x 43.5 cm).

GABRIELE MÜNTER (1877–1962).
Breakfast of the Birds, 1934.
Oil on board, 18 x 21¾ in. (45.7 x 55.2 cm).

SOPHIE TAEUBER-ARP (1889–1943).
Composition of Circles and Semicircles, 1935.
Gouache on paper, 10 x 13½ in. (25.4 x 34.3 cm).

OPPOSITE:
BEATRICE WHITNEY
VAN NESS (1888–1981).
Summer Sunlight, c. 1936.
Oil on canvas, 39 x
49 in. (99.1 x 124.5
cm). Courtesy of Childs
Gallery, Boston.

RIGHT:
KÄTHE KOLLWITZ
(1867–1945).
The Farewell, 1940.
Bronze on composition
base, 6¾ x 4 x 4½ in.
(17.1 x 10.1 x 10.2 cm).

Louise Bourgeois (born 1911).
Untitled, 1949.
Ink on gray paper, 9⅞ x 15⅝ in. (25.1 x 39.7 cm).

ANNA MARY ROBERTSON MOSES (1860–1961).
Calhoun, 1955.
Oil on pressed wood, 16 x 24 in. (40.6 x 61 cm).

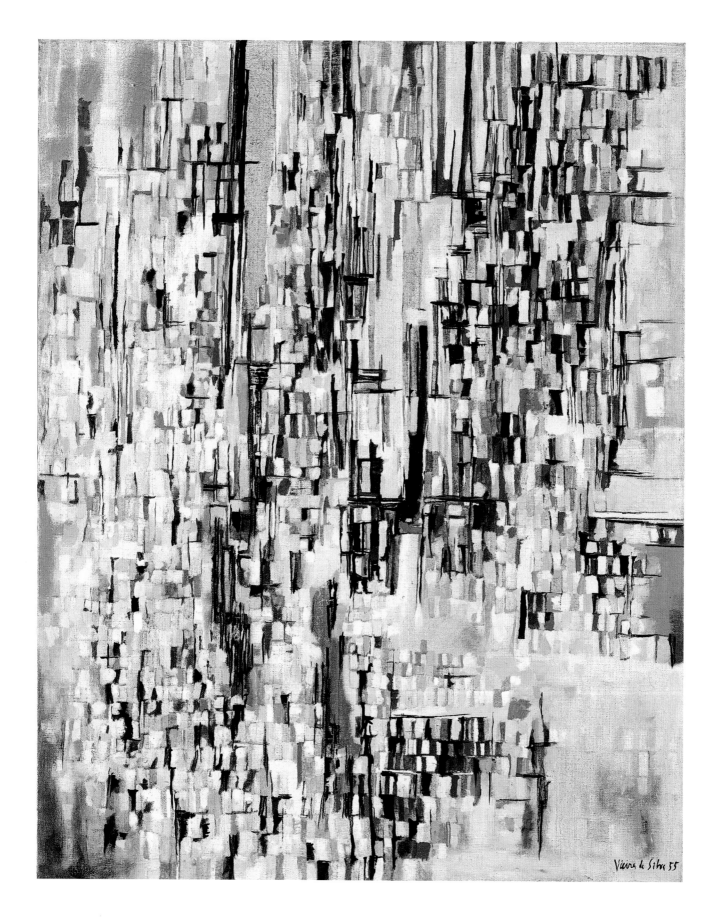

SELECTED GIFTS AND PROMISED GIFTS

OPPOSITE:
Maria Elena Vieira da Silva (1908–1992).
The Town, 1955. Oil on canvas,
39½ x 31¾ in. (100.3 x 80.6 cm).

ABOVE:
Charmion Von Wiegand (1896–1983).
Advancing Magic Squares, c.1958.
Oil on canvas, 12⅛ x 22½ in. (30.8 x 57.2 cm).
Courtesy of Michael Rosenfeld Gallery, LLC, New York.

AGNES MARTIN (1912–2004).
The Wall # 2, 1962.
Oil on canvas, mounted on board with nails, 10 x 10 in. (25.4 x 25.4 cm).

Eva Hesse (1936–1960).
Study for Sculpture, 1967.
Sculp-Metal cord, Elmer's glue, acrylic paint and varnish on Masonite,
10 x 10 x 1 in. (25.4 x 25.4 x 1 cm).

ANNI ALBERS (1899–1994).
Untitled, 1969.
Serigraph on paper, 24 x 22½ in. (61 x 57.2 cm).

BRIDGET RILEY (born 1931).
Cerise, Olive, Turquoise Disks, 1970.
Gouache and pencil on paper, 26¾ x 26⅝ in. (68 x 67.6 cm).

ANNE TRUITT
(1921–2004)
Summer Dryad, 1971
Acrylic on wood,
76 x 13 x 8 in.
(193 x 33 x 20.3 cm).
Gift of the Holladay
Foundation

VALERIE JAUDON (born 1945).
Avalon, 1976.
Oil and metallic paint on canvas,
72 x 108 in. (182.9 x 274.3 cm).

226

OPPOSITE:
JOAN MITCHELL
(1926–1992).
Sale Neige, 1980.
Oil on canvas,
86¼ x 70⅞ in.
(219.1 x 180 cm).

RIGHT:
MELISSA MILLER
(born 1951).
Piggyback, 1984.
Acrylic on paper, 30 x
22 in. (76.2 x 55.8 cm).

Yuriko Yamaguchi (born 1948).
Chance, 1988.
Painted wood and straw, 52 x 70 in. (132.1 x 177.8 cm).

PAT STEIR (born 1938).
Waterfall of a Misty Dawn, 1990.
Oil on canvas, 80 x 125 in. (203.2 x 317.5 cm).
Photo Courtesy of Cheim & Read Gallery, New York.

National Museum of Women in the Arts:
Chronology of Exhibitions

Highlights from Washington's Newest and Oldest Museums: The National Museum of Women in the Arts and the U.S. Capitol Collection 6/21/84–11/14/84

American Women Artists: 1830–1930 4/7/87–6/14/87

A Kansas Collection: A Harvest of the Best from Kansas Artists 4/10/87–5/8/87

Beatrice Whitney Van Ness 1888–1981: The Privilege of Learning to Paint 6/29/87–8/2/87

Minerva J. Chapman 8/14/87–10/11/87

Book as Art I 9/22/87–12/31/87

Louise Dahl-Wolfe: A Retrospective Exhibition 9/22/87–11/23/87

Chalchihuitls: Pre-Columbian Jade and Other Precious Stones 11/10/87–1/10/88

Scents of Time: Reflections of Fragrance and Society 3/5/88–4/22/88

Camille Claudel: 1864–1943 4/25/88–5/31/88

Washington Nevermore: Cityscapes by Lily Spandorf 6/21/88–9/18/88

Women in a Changing World: 1888–1988 6/28/88–8/15/88

Zuka: The French Revolution Through American Eyes 7/19/88–9/25/88

Significant Colorado Women Artists 9/13/88–10/30/88

Irene Rice Pereira's Library: A Metaphysical Journey 10/18/88–1/8/89

Women Artists of the New Deal Era: A Selection of Prints and Drawings 10/18/88–1/8/89

FOREFRONT: Judy Pfaff 11/21/88–1/22/89

Texas Women 12/1/88–2/26/89

Book as Art II 2/1/89–10/31/89

Three Generations of Greek Women Artists: Forms, Figures, and Personal Myths 2/14/89–4/5/89

Nine from North Carolina: An Exhibition of Women Artists 4/24/89–6/11/89

Views from Jade Terrace: Chinese Women Artists, 1300–1912 4/25/89–6/4/89

Washington to Washington: Women in Art Today 5/30/89–7/9/89

Women of the Bible: An Exhibition of Sculpture by Edwina Sandys 6/14/89–7/16/89

Bourke-White: A Retrospective 6/25/89–8/25/89

Great Works: Artemisia Gentileschi 8/28/89–2/25/90

M. Marvin Breckinridge Patterson: The Frontier Nursing Service 9/19/89–11/26/89

Constance Stuart Larrabee: WW II Photo Journal 9/19/89–11/26/89

FOREFRONT: Cheryl Laemmle 9/19/89–1/7/90

Visions of Childhood: Women Illustrators of Children's Books 11/14/89–2/18/90

Ellen Day Hale 12/1/89–2/28/90

Rosa Bonheur: Selected Works from American Collections 12/12/89–3/11/90

FOREFRONT: Judith Shea 1/23/90–3/18/90

Book as Art III 3/6/90–4/30/90

Elisabeth Frink: Sculpture and Drawings, 1950–1990 4/6/90–7/4/90

The State of Upstate: New York Women Artists 5/8/90–7/8/90

Upstate New York Artists' Books 5/8/90–7/8/90

Isabelle Rouault 6/19/90–10/14/90

Artists' Books from LRC Collection 7/9/90–1/31/91

Isabel Bishop 7/24/90–9/9/90

Chansonetta 7/24/90–9/23/90

Four Centuries of Women's Art: The National Museum of Women in the Arts 8/15/90–6/9/91

Lilla Cabot Perry: An American Impressionist 9/28/90–1/20/91

Separate but Equal: Ohio Women Artists 10/2/90–1/6/91

Joan Personette: A Retrospective 10/30/90–2/3/91

The Soul of Ellis Island 11/12/90–5/1/91

A Salute to Women: Artists' Postcards and Albums from International Festivals in Copenhagen and Nairobi 2/11/91–6/14/91

Expanding Visions: Women's Caucus for Art Conference 1991: Washington, D.C. 2/15/91–3/17/91

Ten Danish Women in the Arts 2/18/91–4/8/91

FOREFRONT: Wallace & Donohue 2/21/91–5/5/91

Setsuko Migishi: A Retrospective 4/2/91–5/19/91

Precious Objects: Eulabee Dix and the Revival of Portrait
 Miniature 4/11/91–4/11/92

Ten Contemporary Korean Women Artists 5/21/91–8/25/91

Texas: Reflections, Rituals. Wendy Watriss, Photographer
 6/3/91–11/17/91

Ayako Miyawaki: The Art of Japanese Appliqué
 6/4/91–8/7/91

Book as Art IV 6/17/91–10/25/91

Presswork: The Art of Women Printmakers 9/24/91–12/1/91

Through Sisters' Eyes: Children's Books Illustrated by
 African American Women Artists 11/4/91–4/24/92

Lola Alvarez Bravo: Portraits of Frida Kahlo
 11/25/91–3/15/92

Voices of Freedom: Polish Women Artists and the Avant-Garde,
 1880–1990 12/19/91–3/22/92

A Personal Statement: Arkansas Women Artists
 3/24/92–7/19/92

Stitches in Air: Antique Belgian Lace and Contemporary
 Interpretations 4/10/92–7/19/92

Women Photographers in Camera Work 4/10/92–9/7/92

Käthe Kollwitz: A Self-Portrait 5/3/92–8/16/92

Calligraphic Artists' Books 5/4/92–9/7/92

Glimpse of Joy: Corinne Mitchell 8/7/92–9/7/92

Book as Art V 9/14/92–2/19/93

Breaking the Rules: Audrey Flack, a Retrospective, 1950–1990
 9/29/92–12/17/92

FOREFRONT: Pat Oleszko 10/11/92–1/18/93

Artists + Community: Sylvia Snowden 11/12/92–1/31/93

Carrie Mae Weems 1/7/93–3/21/93

Out of the Land: Utah Women 2/18/93–5/2/93

Sakura: Cherry Blossom Paintings by Yoshiko Ishikawa
 3/4/93–4/11/93

UltraModern: The Art of Contemporary Brazil 4/2/93–8/1/93

Animal Tracks 4/25/93–7/25/93

Claire Jeanine Satin: Bookworks 5/10/93–11/22/93

Artists + Community: Judy Byron 5/27/93–8/15/93

Isadora Duncan and Her Inner Circle: Photographs by Edward
 Steichen and Arnold Genthe 8/2/93–12/5/93

Isadora Duncan: The Dances 8/2/93–12/5/93

FOREFRONT: Hollis Sigler–Breast Cancer Journal: Walking
 with the Ghosts of My Grandmothers 9/2/93–11/14/93

Fleur Cowles: Paintings 9/22/93–11/3/93

Women First for 135 Years: 1858–1993: An Exhibition of YWCA
 Historic Photographs & Memorabilia 10/13/93–11/7/93

The First Generation: Women and Video, 1970–75
 11/20/93–1/2/94

Tennessee . . . from the Mountains to the Mississippi
 12/3/93–2/6/94

Book as Art VI 12/6/93–5/20/94

Judith Leyster: Leading Star 12/20/93–4/3/94

Forces of Change: Women Artists of the Arab World
 2/7/94–5/15/94

New World (Dis) Order 5/12/94–7/17/94

Artists' Sketchbooks: The Intimate Journeys 6/6/94–12/9/94

Generation of Mentors 6/9/94–8/21/94

Eulabee Dix Portrait Miniatures: An American Renaissance
 6/30/94–1/29/95

Picture What Women Do 9/12/94–10/13/94

Esther Mahlangu, South African Muralist: The BMW Art Car
 and Related Works 9/15/94–11/13/94

U.S. Exhibition of the Women's Contemporary Ikebana Society
 9/28/94–10/1/94

Mary Ellen Mark: 25 Years 10/13/94–1/16/95

Children for Children 10/29/94–11/20/94

Artists + Community: Pacita Abad 11/17/94–2/12/95

The Washington Print Club Thirtieth Anniversary Exhibition:
 Graphic Legacy 12/1/94–2/5/95

Book as Art VII 12/19/94–9/8/95

Sofonisba Anguissola: A Renaissance Woman 4/7/95–6/15/95

Artists + Community: Jenni Lukac 4/27/95–7/4/95

Artful Advocacy: Cartoons from the Women's Suffrage
 Movement 8/25/95–1/7/96

Julia Margaret Cameron: The Mia Album 9/2/95–10/29/95

Brave Little Girls 10/2/95–3/22/96

At Century's End: Norwegian Artists and the Figurative
 Tradition, 1880–1990 10/11/95–1/7/96

Latin American Women Artists, 1915–1995 2/8/96–4/29/96

9 Women in Georgia: An Exhibition of Contemporary Art
 2/29/96–5/27/96

From Ziraat Bank's Collection: Exhibition of Paintings by
 Turkish Women Artists 3/6/96–3/10/96

NWMA Board of Trustees

Wilhelmina Cole Holladay, *Chair of the Board*
Mary V. Mochary, *President*
Winton S. Holladay, *First Vice President*
M. A. Ruda Brickfield, *Second Vice President*
Sheila Shaffer, *Treasurer*
Charlotte Clay Buxton, *Secretary*
Margaret Milner Richardson, *Finance Chair*
Martha Buchanan, *Nominations Chair*
Nancy Nelson Stevenson, *Works of Art Chair*
Carol Matthews Lascaris, *President Emerita*
Elizabeth Stafford Hutchinson*, *Vice President Emerita*
Susan Fisher Sterling*, *Director*

Gina F. Adams	Gabriela Febres-Cordero	Heather Miller Podesta
Janice Lindhurst Adams	Sheila ffolliott	Lisa Pumphrey
Caroline Boutté	Karen D. Fuller	Andrea Roane
Virnell A. Bruce	Julia S. Hopping	Kathleen Elizabeth Springhorn
Marcia Carlucci	Alexine Clement Jackson	Mary Anne B. Stewart
Mary Choksi	Cindy Jones	Mahinder Tak
Julie B. Connors	Arlene Fine Klepper	Lily Y. Tanaka
Esther Coopersmith	Christine Miller Leahy	Elizabeth Underhill
Lizette Corro	Frances Matthews Luessenhop	Marjorie Nohowel Wasilewski
Deborah I. Dingell	Marlene McArthur Malek	Ruthanna Maxwell Weber
Martha Lyn Dippell	Bonnie McElveen-Hunter	Alice West
Jan Smith Donaldson	Evelyn V. Moore	
Cyd Miller Everett*	Irene Natividad	Ex-Officio*

National Advisory Board

Noreen M. Andreoli – Chair	Sandra Childers	Fran Elliott
Jean Astrop	Paul T. Clark	Patrice Emrie
Carol C. Ballard	Jean Talbert Clarke	Courtenay Eversole
Gail Bassin	John Comstock	Elva B. Ferrari
Alexandra Mochary Bergstein	Linda Comstock	Suzy Finesilver
Sue Ann Berlin	Holland H. Coors	Christopher Forbes
Catherine Little Bert	Ginger Crews	Jane Fortune
Amy Sosland Brown	Edith C. Crutcher	Katherine Fouts
Margaret Boyce Brown	Joan Avalyn Dempsey	Claudia Fritsche
Rodion Cantacuzene	Ginni Dreier	Barbara S. Goldfarb
Deborah Carstens	Kenneth P. Dutter	Lorraine G. Grace
Eleanor Chabraja	Gerry E. Ehrlich	Lois Lehrman Grass

Medda Gudelsky
Janie Hathoot
Anna Stapleton Henson
Caroline Rose Hunt
Lauren Hutton
Nancy Hersch Ingram
Beverly Perdue Jennings
Jan Jessup
Alice D. Kaplan
Sigrid Kendall
Ondine Angarola Langford
Nelleke Langhout-Nix
Dorothy LeBlanc
Nancy Lindemeyer
Gladys Kemp Lisanby
Joe R. Long
Teresa L. Long

Jill W. Martin
C. Raymond Marvin
Suzanne Mellor
Charles P. Milner
Edwina H. Milner
Eleanor Smith Morris
Vittorio Mosca
Raymond F. Murphy, Jr.
Jeannette T. Nichols
Nancy O'Malley
Marjorie H. Odeen
Katherine D. Ortega
Rose Benté Lee Ostapenko
Antoinette Pearman
Mitzi Perdue
Elizabeth Pruet
Margaret A. Race

Madeleine Rast
Edward Rawson
Elizabeth A. Sackler
Anna G. Schrieffer
Steven Scott
Patti Amanda Spivey
Kathleen Elizabeth Springhorn
Jo Stribling
Rossella Taffa
Cheryl S. Tague
MaryRoss Taylor
Sarah Bucknell Treco
Nancy W. Valentine
Paula S. Wallace
Betty Bentsen Winn

As of June 1, 2008

NMWA Foundation Board

Donors of $100,000 or more to the endowment

Janice L. and Harold L. Adams
P. Frederick Albee and
 Barbara E. Albee
Nunda and Prakash
 Ambegaonkar
Noreen M. Andreoli
Carol C. Ballard
Catherine L. and Arthur A.
 Bert, M.D.
Catharina B. and Livingston L.
 Biddle, Jr.
Clark Charitable Foundation
Hilda and William B. Clayman
Julia B. and Michael M.
 Connors
Kenneth P. Dutter
Gerry E. and S. Paul
 Ehrlich, Jr.
Enterprise Rent-A-Car
FedEx Corporation
Lorraine G. Grace

Barbara A. Gurwitz and
 William D. Hall
William Randolph Hearst
 Foundation
Wilhelmina C. and
 Wallace F. Holladay, Sr.
Julia S. Hopping and
 Steven B. Hopping, M.D.
Caroline Rose Hunt
J.W. Kaempfer
Nelleke Langhout-Nix
Carol and Climis Lascaris
Dorothy and Raymond
 LeBlanc
Fred M. Levin and Nancy
 Livingston, The Shenson
 Foundation, in memory of
 Drs. Ben and A. Jess Shenson
Lucia Woods Lindley
Gladys K. and James W.
 Lisanby

Lockheed Martin Corporation
Joe R. and Teresa L. Long
Dorothy S. Lyddon
Marlene McArthur and
 Frederic V. Malek
Adrienne B. and John F. Mars
Bonnie McElveen-Hunter
The Honorable Mary V.
 Mochary
Irene Natividad
Jeannette T. Nichols
Rose Benté Lee Ostapenko
Lady Pearman
Madeleine Rast
A. Jess Shenson
Clarice Smith
June Speight
Kathleen Elizabeth Springhorn
MaryRoss Taylor
Alice W. and Gordon T.
 West, Jr.

235

Index

Page numbers in *italics* refer to illustrations.